IN SEARCH OF
DOMÍNGUEZ & ESCALANTE

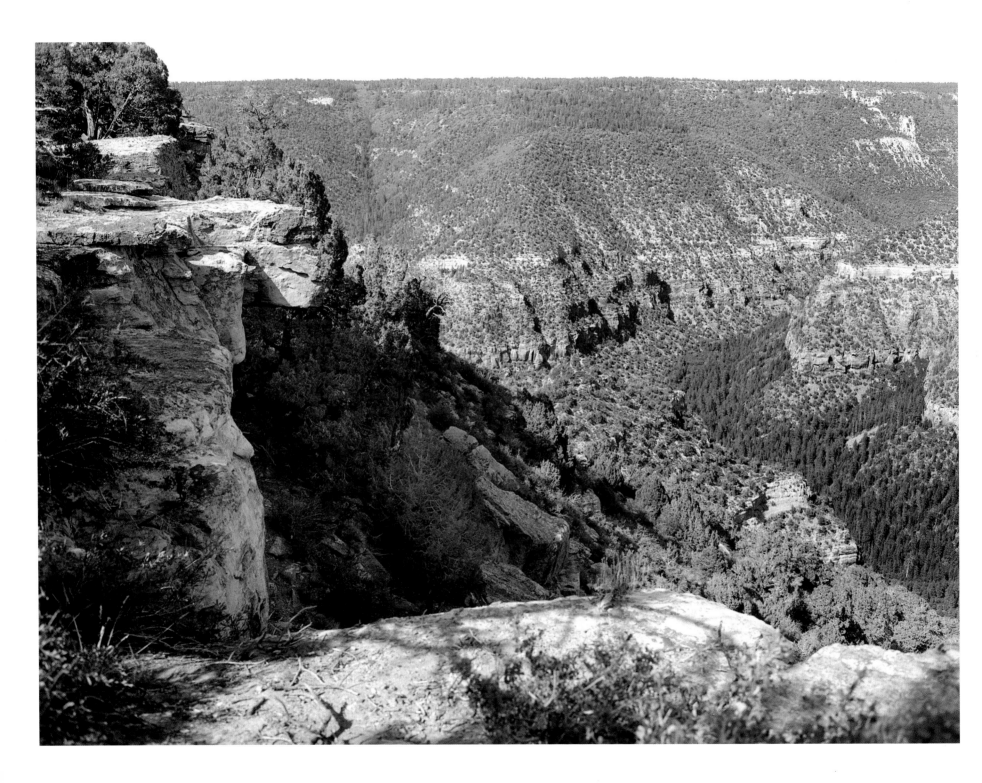

In Search of Domínguez & Escalante

Photographing the 1776 Spanish Expedition through the Southwest

Greg Mac Gregor and Siegfried Halus

Museum of New Mexico Press
Santa Fe

Project director: Mary Wachs
Copy editor: Karla Eoff
Art and production director: David Skolkin
Design associate: Jason Valdez
Composition: Set in Adobe Caslon
Manufactured in China
10 9 8 7 6 5 4 3 2 1

Museum of New Mexico Press
PO Box 2087
Santa Fe, New Mexico 87504
www.mnmpress.org

Library of Congress Cataloging-in-Publication Data
MacGregor, Greg.
In Search of Dominguez & Escalante : photographing the 1776 Spanish expedition through the Southwest/ by Greg Mac Gregor and Siegfried Halus.
p. cm.
Includes bibliographical references.
ISBN 978-0-89013-529-7 (clothbound : alk. paper)
1. Domínguez-Escalante Expedition (1776) 2. Dominguez-Escalante Trail—Pictorial works. 3. Southwest, New—Pictorial works. 4. Southwest, New—Description and travel. 5. Southwest, New—Discovery and exploration—Spanish. 6. Domínguez, Francisco Atanasio, fl. 1776. 7. Vélez de Escalante, Silvestre, d. 1792. I. Halus, Siegfried. II. Vélez de Escalante, Silvestre, d. 1792. Diario y derrotero. English. III. Title.
F799.M24 2011
979'.01—dc22
2010043215

Contents

IMAGES FROM THE EDGE OF AN EMPIRE

by Frances Levine

THE PHOTOGRAPHS IN THIS COLLECTION by Siegfried Halus and Greg Mac Gregor retrace the journey made in 1776 by Fray Francisco Atanasio Domínguez and Fray Silvestre Vélez de Escalante. The journal of their expedition is one of the most important primary sources of the late eighteenth century, describing the native peoples and frontier lands to the north and west of New Mexico. Set against the vast open spaces of the Four Corners and the Great Basin, the Domínguez-Escalante expedition is little known in the larger context of American history, which has all but forgotten that the West, taken by force in 1846, was once the northern extent of a vast Spanish empire.

Halus's and Mac Gregor's photographs are a deliberate body of work, shot specifically on site in the locations visited by the Domínguez-Escalante expedition. They approached the assignment as an expedition in its own right, recording the places and people as they found them. They did not obliterate the passage of time in framing their photographs of the trail. Instead, they embraced and even confronted the passage of time, focusing in some cases on the blighted and littered landscape as it is now.

As the Domínguez-Escalante party made their way, they recorded their encounters with Indians and the reactions of the native people to the friars' ministrations of the Christian faith. Natives provided the valuable logistical information about the country that made the journey a qualified success—even though the expedition was not successful in reaching their ultimate goal of finding a route to Monterey.

Halus and Mac Gregor's journey in the footsteps of the friars revealed both the timeless beauty of the mountains, rivers, and canyon lands of the Four Corners, as well as the scars of our modern age. Through their immense undertaking, we enter the landscape and the legacy of the Domínguez-Escalante expedition.

A Photographic Sojourn:

In the Footsteps of Friars Escalante and Domínguez

by Siegfried Halus

O<small>N</small> J<small>ULY</small> 29, 1776, an expedition left the Presidio de Villa de Santa Fé, known today as the Palace of the Governors, in an attempt to discover an overland route from Santa Fe, New Mexico, to Monterey, California. Fray Francisco Atanasio Domínguez and Fray Silvestre Vélez de Escalante had joined forces to promote the expedition. However, it was Fray Domínguez, the elder of the two, who finally convinced his superiors, along with New Mexico governor Pedro Fermin de Mendinueta, to fund the expedition. Domínguez must have been a persuasive and charismatic man. He was already a seasoned padre, with extensive administrative experience at numerous pueblos, plus he held the position of superior of the New Mexico Franciscan order. Their original departure date was scheduled for July 4, but they experienced their first setback before they had loaded a single pack mule. They were delayed by illness until July 29, when the friars and their eight companions finally embarked on a most difficult journey into uncharted, mysterious territory; at that time, the land before them was beyond any known reaches of

Spanish colonial influence. Today this geographical area is identified as the four states of the American Southwest: New Mexico, Colorado, Utah, and Arizona. Their heroic undertaking was both a research expedition and a mission of faith. They hoped that their journey would help them expand Spain's knowledge of indigenous tribes, discover the locations of precious minerals, and reveal potential sites for future settlements and presidios; they also hoped they would forge a path upon which to deliver and disperse the Catholic doctrine, paving the way for the redemption of numerous native souls.

It must have been the ultimate test of his leadership for Domínguez to leave the familiarity of his homeland and guide this expedition into such hostile wilderness. Rising to meet this challenge, both Domínguez and Escalante accepted many responsibilities in providing for the care and safety of eight other souls. This must have also created, for both friars, an enormous test of faith. Domínguez might have said it was through their keen instincts, youthful vigor, and watchful interaction with those whom they encoun-

tered in the wild that they managed to survive their grueling trek. Escalante would probably have said it was because they willingly placed their fate into the hands of God.

Escalante's expeditionary journal has given us a rare, dynamic window through which we can witness fascinating details of the Spanish colonial period. He described their uncertainty and initial apprehension as they encountered previously unknown tribes. Overcoming these inner fears had to be almost as difficult as encountering physical obstructions in a brutal and unforgiving terrain, such as the monumental, impassable Hurricane Cliffs in Utah. These and other events led to far more than just the first, critical mapping of the Four Corners region. They afford readers of his text a vivid narrative of life in the wilds, through which we might better understand the complexities involved in the expedition's first contact with native people. Escalante clearly framed his observations with the cultural and religious prejudices of eighteenth-century Spanish sensibilities. And while it can be said that the friars' own views were clouded by their strict adherence to Spanish colonial religious dogma, they had no choice but to examine the world around them through a looking glass of the eighteenth-century zeitgeist. What they saw did not always bring them comfort.

In one particular passage, Escalante describes how a native medicine man performed a healing ceremony on an important member of his party, Don Bernardo Miera y Pacheco, who had fallen seriously ill. This event had a disturbing impact on Domínguez and Escalante. Traditional native ceremonies, shamanistic healing, and other rituals involved singing, chanting, dancing, and the invocation of native religious beliefs that the friars condemned as mere superstition or as pagan practices. Devil worship was neither encouraged nor tolerated. Instead of seeing these experiences as multiple opportunities to examine native spiritual beliefs, it was, tragically, their own religious training

that prevented the friars from exploring them further. Such inquiries were not permitted, especially with so-called heathens who practiced such primitive and questionable doctoring of sick members of their own expedition. Instead, Domínguez and Escalante spent considerable time instructing the natives in Christian beliefs, which, they believed, was their duty. The friars defined their efforts as bestowing both salvation and civilization upon all native people with whom they came in contact.

Miera, who emerged improved from the healing ceremony, deserves special acknowledgment as a distinguished and vital member of the party. He was a multi-specialist, with considerable talents, and brought many essential skills to the expedition. He was a respected military leader and a retired captain of the militia of the Villa de Santa Fé, as well as an engineer, a *santero*, a writer, and, most important, a cartographer. As custodian of the astrolabe, which was used in making astronomical calculations, he played an essential part in keeping the expedition on course. Later he made yet another contribution to the venture. He wrote his own account of the excursion, which was sent to the governor of New Mexico and to the king of Spain. This document proved to be a significant addition to Escalante's journal, bringing an additional insightful layer to the entire journey.

Another of Escalante's detailed passages was most unusual, and it holds a mystery that has never been solved. Escalante described meeting a group of bearded Indians whom he portrayed as looking more like Spaniards than any native people. He described them as an emaciated group who were living a primitive, native existence, and who spoke the Ute language, a tongue that Escalante had often heard before. Although these were historically the lands of legend and lore, we must presume Escalante's account to be factual. It should also be noted that Miera drew his masterful map to the highest objective cartographical standards of the day. Adding to the mystery and, perhaps, to the accuracy of the

event, he adorned his map with a drawing that illustrated this strange encounter with these mysterious bearded Indians. The effect is reminiscent of the fabled stories of the Seven Cities of Cíbola, also known as the Seven Cities of Gold, which stirred the imaginations of conquistadores and provoked others to invade these very same lands in search of treasure two hundred years earlier. Perhaps Miera could not resist decorating his map with this drawing. Perhaps he needed to enliven the pragmatic process of mapmaking by creating an allure that might also stir the imagination of those who laid eyes upon his map. Escalante's written record of this encounter, combined with Miera's rendering of it on his map, form a lasting, intriguing enigma in this epic adventure.

From the outset of our own challenging project, Greg Mac Gregor and I agreed to combine our efforts as peers. We kept detailed notes and photographic documentation of our daily travels. During our many days together, we exchanged comments and consulted with each other about our experiences, our discoveries, our successes, and our occasional failures. We became bound by mutual amazement over the difficulties that we encountered as modern pilgrims on the heels of Domínguez and Escalante. We looked east, west, north, and south as we tried to formulate a coherent vision of what these friars must have imagined so long ago as they looked wearily at their own pending passage. As photographers, Greg and I began our project in earnest; we stood in awe, confronting a vast land of scarcity, infinite horizons, and mountain ranges that stretched as far as any eye, or lens, could see. We could hardly suppress our growing curiosity to discover if our photographs would eventually stimulate in others a deeper understanding of Escalante and Domínguez's daring expedition.

Greg and I agreed that we wanted to establish the intimate visual tone and observational style that Escalante's journal often depicted. After all, ours was a project that required objectivity and interpretation, as well as a clear articulation of landscape concerns. We continually studied Escalante's journal. His entries became constant points of departure and arrival for us. We realized that we were striving, just like the friars must have done, to move through the wilderness toward fields that we had yet to find. It was certainly not lost on us that we had undertaken a project that mimicked the enterprise of Domínguez and Escalante.

On a few occasions, especially while photographing a new location, we encountered a site that was difficult to interpret visually. Perhaps it was lacking some visible anchor or notable landscapes. Maybe it was just a scene we

Navajo health center advertisement, Tuba City, AZ.

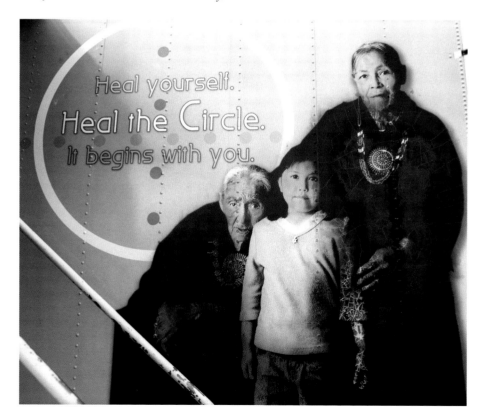

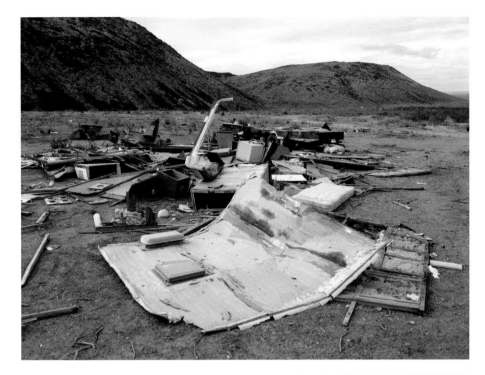

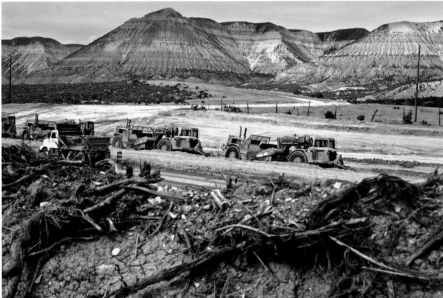

Desert trash near Hurricane, UT.

Oil and gas, new road construction, CO.

could not easily solve photographically. Out of our discussions, we tried to stir our visual resources in an attempt to solve these problems that probably occur more often than most photographers are willing to admit. It was during these reflective moments that I began to value the different qualities we brought to this process.

In time, I understood why the historian Herbert E. Bolton needed to personally retrace this epic 1,800-mile journey. He also needed to walk in Escalante and Domínguez's footsteps to allow time to unfold without pressure or constrictions. He needed to measure his own knowing against rocks, mountains, and rivers. Bolton required a physical and spiritual understanding of what the friars and their entourage must have experienced in order to explore the wonders he would write about in his book *Pageant in the Wilderness*, published in 1950. I can only imagine that he wanted an opportunity to make observations that never entered Escalante's diary. I was certainly, and inevitably, making my own.

There were moments during this project when I experienced a deeper understanding of how the margins between time and place are thinly veiled, and that they can merge in unforeseen ways. This can be said for many parts of the photographic process. While documenting my own era, I became aware of photographically bringing forward the testimony of a previous one. I felt as though I straddled two different worlds, yet I was standing in the shadow of each. Photographs have a way of forging the concrete world into two-dimensional substitutes. We have all been tutored throughout our lives to accept these visual documents as truth. But a photograph can also be read as metaphor, acknowledging that the river I stepped into is

not the river Domínguez and Escalante stepped into, but, metaphysically speaking, the river still holds their memory.

While in Tuba City, Arizona, at a Navajo health center, I photographed a billboard that displayed an arresting image of three generations of Navajo women. The billboard boldly proclaimed: HEAL YOURSELF. HEAL THE CIRCLE. I was immediately reminded of the unique friendship between photographer Laura Gilpin and Elizabeth W. Forster, as they wound their way to Red Rock, Arizona, where Forster had accepted a position as a public health nurse in 1931. It was here that Gilpin returned numerous times to make some of her most memorable portraits of Navajos. On one of her trips, she made an unusually candid photograph, taken in Hardbelly's hogan in 1932. It depicts Forster dispensing digitalis to an ailing elderly Navajo, who is surrounded by his family. This was an unusual photograph for Gilpin to make, since candid shots were not in her repertoire. At that moment she was an empathetic photographer, simply trying to present the realities of traditional native life, while honoring the warm, caring family who surrounded this man. For me Gilpin's photograph approximates what it must have been like for Escalante and Domínguez to deal with and overcome various illnesses on their journey. While illness might have been a deadly savage lurking within, they already were fearful of having to deal with those who wished them harm, who were hiding in the hills around them.

The Colorado Plateau offered difficult terrain and was peopled by numerous tribes who, in some cases, were considered hostile. This caused Domínguez and Escalante great concern and made them very cautious when entering these lands, as they desperately needed to avoid encounters with marauding tribes. They were fortunate to come across a number of smaller bands of Ute who shared their concerns, especially about encountering the fierce, nomadic Athabascan people, known as Apaches, who had filtered into this region approximately a hundred years before Domínguez and Escalante's arrival. Initially the Utes guardedly received the expedition at Grand Mesa, Colorado. In time, however, they eventually exchanged information with them, traded goods, and even sent along members of their tribe as guides.

After his many encounters with tribal groups, Escalante was often inspired to write about them in vivid detail. Those native people have long since turned to dust, but Escalante's journal entries that portrayed them and the land they inhabited have remained unchanged throughout the passing of time. The same, however, cannot be said of the actual landscape. In spite of having Escalante's diary to guide us, it was sometimes difficult to match his descriptions with the land we saw around us; at times, we thought there was not sufficient information in his text to help us

Distant mountain fire, Navajo reservation, AZ.

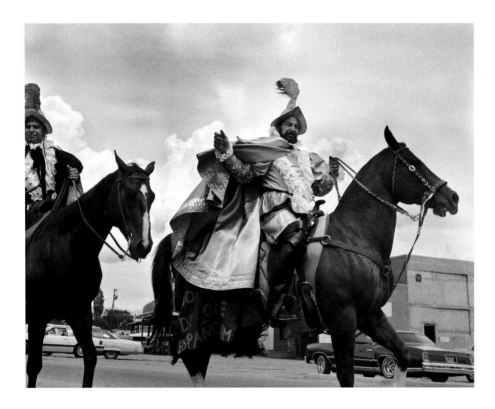

Reenactment of Oñate's 1598 founding of first settlement, Española, NM.

gled to navigate so long ago. We saw numerous signs of environmental damage. Rushing past the windows of my Subaru were the blurred fragments of windblown roadside trash. Outside of the more populated areas, we passed by piles of landfill that no amount of bulldozing will ever make go away. We occasionally passed through an irritating airborne contamination, released from coal-fired electric plants. And as we descended into the Provo valley, smog was settling in a thick overlay, reminding us that we were also contributing to the problem by driving our car into this congested place.

On one of our trips, we sighted, far off in the distance, a large plume of smoke that reached out like a monstrous hand; it suggested some kind of warning, like an enormous smoke signal that gathered against the sky on a scale that could not be ignored. We later ventured into what at first seemed like pristine territory, but instead we found rubbish, discarded vehicles, and other burning evidence of blind human disregard and destruction. Often we both silently wondered what we might find whenever we explored new locations or ventured into new sites. At times we were filled with awe and wonder. On other occasions, like this one, we were filled with smoldering distress.

This photographic document is our way of honoring these two intrepid friars, Escalante and Domínguez, as well as the other members of their party. Their expedition never succeeded in reaching Monterey; it returned to Santa Fe after having experienced great hunger, the onset of winter, and unbelievable deprivation, all of which brought them almost to the point of death. In spite of never achieving their goal of finding an overland route to Monterey, they would probably tell you that their trek of 1,800 miles was, most important, their way of doing God's work. It gave them courage, helped them to unleash their youthful curiosity, and provided a passage of faith upon which they faced the wild unknown. Perhaps the most astonishing fact

recognize where we were, leaving us to ponder our location, perhaps much like the friars themselves. Occasionally, as we came upon places for the first time, we found some sites altered. They had obviously degraded during our modern era, and, sadly, the landscape stood before us with a weary, wounded beauty. Nevertheless, we photographed all the identified sites, making it a point not to reject what we saw, and ultimately coming to terms with the vicissitudes of time.

While following this historic route, we saw many examples of the violence that modern people have inflicted upon the land that Domínguez and Escalante had strug-

of all is that in the face of unspeakable odds not one life was lost on their perilous journey, either among their own courageous band of explorers or among the tribes whom they encountered along the way. Theirs was an expedition of peace in a world of peril, courage in a time of chance, and faith in the face of uncertainty. It can be said that they came full circle, and that the circle was healed.

Photographer's Note:

Methodology and Background

by Greg Mac Gregor

*T*HE STORY OF THE Domínguez-Escalante expedition, widely regarded as one of the great explorations in western U.S. history, has been well studied by scholars over the past century, with four separate translations of the journal into English. In addition two notable books devoted exclusively to the story have been created: *Pageant in the Wilderness*, by Herbert E. Bolton in 1950, and *Without Noise of Arms*, by Walter Briggs in 1976. Every issue of the *Utah Historical Quarterly* in 1943 was devoted to a translation and treatise by Herbert S. Auerbach—the equivalent of a book. The story of the expedition is mentioned and examined in other texts such as *Explorers, Traders, and Slavers: Forging the Old Spanish Trail, 1678–1850*, by Joseph P. Sánchez, and the subject has appeared in many scholarly articles in state historical journals as well as *Spanish Traces*, the publication of the Old Spanish Trail Association—the latter because the expedition would essentially travel a route which would become the beginning section of the Spanish trade trail to California.

Despite these numerous written historical accounts there has been little or no visual record of this historic route.

Without Noise of Arms had twelve watercolor illustrations; *Pageant in the Wilderness* included a scant eleven photographs. In 1976, as part of the Domínguez-Escalante State-Federal Bicentennial Committee, a fourth translation of the journal was created by Fray Angelico Chavez and published as *The Domínguez-Escalante Journal*, edited by Ted J. Warner.

In addition, Dr. David E. Miller of the University of Utah, coordinated a team of scholars who, over a period of several months in 1975, retraced and corrected previous map inaccuracies and then transcribed onto U.S. Geological Survey quadrangle maps the most accurate map made of the route, to such extent that most campsites are identified. I digitally copied the original fieldwork map they created (which is housed at the Utah State Historical Society) and transcribed it onto detailed highway, state, sectional, and county maps (the original was on geologic maps with little or no highway designations). There is no guidebook to this trail other than annotations at the bottom of the various edited diaries and the above-mentioned

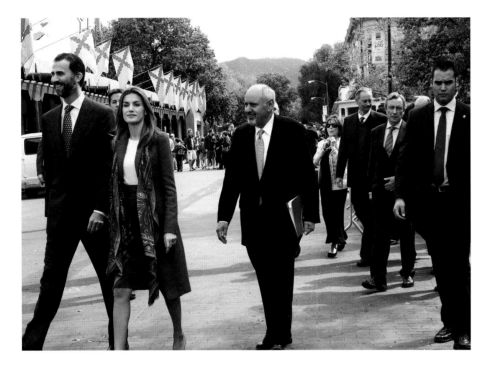

Future king and queen of Spain leaving plaza and Palace of the Governors, Santa Fe, NM.

Examining 1776 expedition inscription, Glen Canyon, AZ.

map. In this regard we found the 1976 Chavez translation the most useful since it took advantage of the most recent research tools.

Compared to other historic trail projects I have been involved with (the Mormon Pioneer Trail, the Lewis and Clark Trail, and the Oregon Trail), this one had a convenient aspect in that it started out in and returned to Santa Fe. Consequently, depending upon the season, it could be researched in either direction, although following the maps backward meant reading the diary backward and the anticipation of what happens next in the story line is lost. We worked in sections of about two to three hundred miles out and back, which allowed us to revisit locations and make photographs we had missed on the outbound direction because of fading light, weather, or just being unable to locate a site. On one occasion we traveled the whole 1,800-mile circle, covering in five days what took the expedition five months. We estimate that we have traveled the entire route the equivalent of four times.

While following this dizzying route using contemporary roads, sometimes paved and other times dirt, one quickly realizes that the intent never was to get to Monterey. In addition it is obvious that the use of native guides was essential. The expedition ended up circumnavigating and sometimes penetrating the huge Colorado Plateau in a crazy-shaped circle that has so many false turns, deep canyons, and unclimbable ridges, that perishing through accident, getting lost, or starvation was much more likely an outcome than survival. In addition to geographic impediments, given the nature of the desert Southwest, much of the route is devoid of game and, often, water.

Escalante Desert, looking south, UT.

Uranium Café, Grants, NM.

The ancient Indian trails the expedition followed were created for safety, water sources, and of course the shortest possible distance. Originally these were foot trails created in pre-horse-travel times, and human feet can travel where horses cannot—for example, the expedition had to abandon the Indian trail through the Malpias lava flow in western New Mexico, the rocks being too sharp and the crevasses hidden. Today's roads cannot go where horses can. Although our highways sometimes were, but mostly were not, on top of the route, they often were close by in the same canyon or ridge. Our technique was to probe into a site from the nearest road. A four-wheel-drive high-clearance vehicle was sometimes useful but not always necessary, though it was unnerving to hear the bottom of my rented passenger car continuously scraped by sagebrush and hitting an occasional rock while traveling thirty miles down the Escalante Desert in search of a site that we never found.

The journal entries often determined what we photographed, such as when coming upon a significant landform, crossing and naming rivers, or encountering native peoples. It was our purpose to faithfully and accurately document the route that the expedition explored as they ventured through the Four Corners area, and by doing so confirm the changes in landscape and human habitations as they are revealed today. When a particular landscape merited photographic comment—such as when a river had been dammed, or a power plant situated on the original route—we did not ignore it but rather included it in order to record the changes that have occurred. The legacy of that expedition is therefore part of our intent.

One cannot help being impressed by the tenacity of these friars. They left during the hottest part of summer and returned in the winter, often caught in snowstorms that halted travel. It appears that all the cattle and some horses were killed for food. By October they ran out of food and were eating seeds traded from Indians, which often caused illness. Killing and eating a skunk was an event for celebration. There were days without any food or water, and sickness began within the first week. By contrast, our travel was enriched by an ice chest of food, air-conditioned cars, motels, and restaurants. Camping at the end of the day's work didn't make sense since rarely was there a campground conveniently located, and often we found ourselves in rough terrain that was unsuitable for camping. We were never lost; with a cell phone's built-in GPS coordinate locator and accurate maps, our biggest

Route 264, AZ.

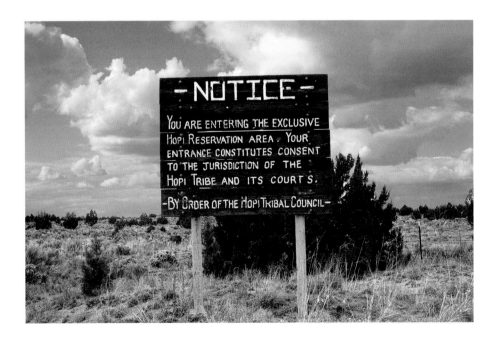

concern was whether we would make it to the next town before restaurants closed and motels filled. Even with guides, the expedition had no idea where they were, and in fact more than once they suspected the guides were leading them into an ambush. We crossed the Colorado River in minutes at Navajo Bridge; it took them twelve days just to find a crossing site once they reached the river, scrambling over canyon country that today's backpacker would find difficult, if not impossible, to traverse.

Much of the route is on federal or public lands, but when we were on private land our technique was to ask permission of ranchers to enter and photograph. Other times, when uncertain who to ask, we would drive the most obvious road to the site and begin working. The lack of trees soon made us visible to the owner, who would arrive in a pickup truck or ATV and ask the standard question: "Can I help you?" Explaining our project would open a useful dialogue, as ranchers are not ignorant of their land's history. When photographing on pueblo land, it was less clear what was or was not allowed. Some will sell a permit for photography that specifies limits, others had signs saying photographs were not allowed during religious ceremonies only. Some say nothing. While on a state highway in Isleta Pueblo, making a photo of a convenience store decorated in hubcaps, a pueblo sheriff stopped and demanded my camera or my film. While photographing an abandoned car on a highway in Santo Domingo, we were told we couldn't be on that road, and in Old Oraibi a child knocked on the car window and told us, "You can't make pictures here." When I asked why, he said, "I don't know." Another time a policeman told me that if it were Monday instead of Sunday he would put me in jail for climbing an adjacent mesa to gain a better view of the Walpi mesa.

In spite of our occasional uncertainty of the expedition's exact location, we found places where we could stand and

imagine the weary and worried caravan passing by within a few feet. One which comes to mind is a narrow passage along the Vermillion Cliffs in Arizona (the entrance to Marble Canyon), where a deep arroyo forces travel against a cliff wall. Even today's highway is funneled through this tiny gap. It is also the site of the most bizarre landforms we encountered on the project: twenty-foot-high toadstool-shaped rock formations—today's Cliff Dwellers, Arizona, now used as an attraction to sell Indian jewelry. The same landforms repeat in a few miles on the approach to Lees Ferry at the Colorado River. Oddly, no mention was made of these geologic wonders in the journal. In most states today this type of roadside attraction would be declared a national monument or at least a state park, but here, in this dramatic canyon-carved country, it's just another landform.

The trail followed by the expedition covered the full gamut of geological terrain. Major western rivers like the Colorado; spectacular sandstone valleys and formations north of Abiquiu, New Mexico; the dense pine-and-aspen forest on top of the Grand Mesa in Colorado; and the Utah deserts. They passed what are now major national parks and landforms: Zion Canyon, Dinosaur National Monument, Paria River Canyon, and the Grand Canyon. However, due to survival anxieties or disinterest—or simply to other priorities—there is a paucity of visual descriptions of these dramatic landscapes in the expedition's diary. They passed by the present-day entrance to Zion National Park, easily seen from Interstate 15 (which is on top of their route) as a significant and huge inviting valley with looming sandstone formations, without comment. Future conversion of souls and subsequent expansion of the Spanish empire, the real purpose, perhaps dictated a "just the facts" spirit in the journal writings. Evidence of this is seen in the one geographic feature that constantly received detailed comment: land which could support future farms and colonization. Careful description of its location, water sources, flatness of terrain, existing foliage, and fishing and hunting potential were noted without fail. Clearly, this was a fact-finding mission, and a poetic response to geography was not necessary.

Since our vision of this project centered on the route traveled and its associated landscape, this lack of geological description was significant and a potential problem. After all, future farm meadows are not very graphic as a photographic subject. A project such as this begins by first reading the journal in order to see if the historic text has its own intrinsic interest. It, in fact, does. Second, is it photographic enough? If not, then the project should be abandoned. In this case the diary's lack of visual description or poetic response to landforms, which sometimes do occur in journals of other expeditions (Lewis and Clark for instance: Lewis wrote four pages of text attempting to describe the overwhelming beauty of the Great Falls in Montana), can lead one to conclude that the route followed by Domínguez and Escalante will be a visual disappointment and difficult to comment on photographically. The reality for us was a delightful surprise, which we hope will be borne out in the pages contained within.

From New Mexico to California:

The Legacy of the Domínguez-Escalante Expedition of 1776

by Joseph P. Sánchez

The Domínguez-Escalante Trail as seen through twenty-first-century eyes contrasts sharply with how Spanish colonials and their Ute counterparts saw the route in 1776. Modern man has obscured much of the route, but the journal that described the expedition has stilled time and exposed the line of march taken by the explorers. Today the journal of the Domínguez-Escalante expedition excites our imaginations, as it did the Spanish colonial frontiersmen who dreamed about wonders that existed in lands northwest of New Mexico.

Just as snowmelt dripping off a rock joins a rivulet rushing down a mountainside, so too does a trampled campsite along a forgotten pathway leave its mark for hundreds of years. In 1776, a muffled sound, made by footsteps passing through dampened leaves, branches, and other forest debris, issued forth a warning of a coming change. In a clearing on the edge of a thickly forested mountain, a small party of New Mexican frontiersmen and two Franciscan friars stood around a mapmaker and watched in anticipation as he took a reading of the sun at high noon with his instruments to record their position deep in Ute country. Hidden in the forest, curious but leery Ute warriors watched them as a whispering autumn breeze swept the land.

As time made its predictable cyclical turn, 1776 resounded with history's clarion cry of the change that was coming to the remote lands northwest of New Mexico. It was a change that began in 1492 when Spanish ships appeared off the island shores of the Americas. It was a change that had been evolving ever since the first explorers under the command of Francisco Vásquez de Coronado in 1540 and the first Spanish settlers led by Juan de Oñate in 1598 stood before the Indian pueblos of the northern Rio Grande in New Mexico. On July 4, 1776, members of the Domínguez-Escalante expedition gathered in the plaza of the Ville de Santa Fé in preparation for the exploration of the land of the Utes. The expedition would alter the lives of many of the tribes living in the region, for Fray Francisco Atanasio Domínguez and Fray Silvestre Vélez de Escalante were harbingers of change. Meanwhile, at that

very moment, a change with far-reaching consequences that would soon manifest itself across the face of North America was taking place as another group of daring men were signing their names to a pact known as the Declaration of Independence. Seventy years later, their Army of the West would stand in the plaza of the Ville de Santa Fé as the new power over the lands that became New Mexico, Colorado, Utah, Arizona, and California.

For more than a century, since the 1670s if not earlier, intrepid New Mexican frontiersmen had dared tread on the land of the Yutas, as they called the Utes. Fearing open warfare with the Utes, Spanish governors, from the time of Oñate, had forbidden trade in Ute country, or on the Great Plains for that matter, without their approval. They realized that the proclivity of traders to drive the best possible bargain at the expense of others could result in a deal gone bad. Surely then the Provincia de Nuevo México would be overrun by warring tribes. Still, there were those who would risk that chance and trade illegally in Ute country.

In 1765, eleven years before the Domínguez-Escalante expedition, Governor Tomás Vélez Cachupin authorized the first official expedition to explore Ute country. The expedition was conceived and sanctioned when Juan María Antonio Rivera reported to his governor that a Ute named Cuero de Lobo (Wolf's Hide) had told settlers at Abiquiu about a mountain of silver far to the northwest. Shortly, Rivera and his men left Santa Fe in search of the Sierra de la Plata, the mountain of silver, in what is now southwestern Colorado and which still bears the semblance of that name. Beyond Abiquiu, the last Spanish outpost northwest of Santa Fe, Rivera eagerly plunged into the relatively unknown Ute country that lay beyond Colorado's Río de Nuestra Señora de los Dolores, the present-day Dolores River.

Rivera's men had hitherto enjoyed a long history of trade with the Utes, albeit without license from their governor. They had paid the price for their transgressions by suffering fines and imprisonment, as well as having their trade goods confiscated. They were also forced to reveal the locations of their rendezvous with the Utes. For decades they had traded with the Utes and had reached the Great Salt Lake via La Sierra de la Sal, now called La Sal Mountains for the salt flats nearby. Indeed, Rivera hired these men because they knew the land—the accessible ravines, valleys, water crossings, and water holes—and spoke the language of the Utes fluently. And, equally important, they were accustomed to the rigors and dangers of the journey.

Over the years, government officials had caught many other New Mexicans trading illegally in Ute country. They confessed to having reached La Sierra de la Sal, or having crossed through forbidding canyon lands with high arches, some of which they named as reference points, or they had crossed large rivers such as the Colorado, or they had reached a salt lake called Timpanogos. Like them, Rivera's men knew the land well and were willing to explore new areas to add to their knowledge of Ute country. In the years following the expedition, some of Rivera's guides returned with others to trade illegally with Ute tribes they had met on their route northward.

On his first expedition in October 1765, Rivera left Abiquiu in a northerly direction beyond Piedra Parada, now called Chimney Rock, in northwestern New Mexico, then veered northwest until reaching the Sierra de la Plata. Although they went directly west from there, they did not reach the Colorado River, known to Spanish frontiersmen since the sixteenth century as the Río del Tizón ("river of the firebrand"). Later, Rivera's men said that they reached La Sierra de la Sal.

Upon his return to Santa Fe, Rivera provided Spanish officials with a report. A few months later, he led a second expedition to Ute country. This time he got as far north as present-day Delta, Colorado, before veering northwest

probably as far as what is now Moab, Utah. On that expedition, he and his men reached the Colorado River. Even though he did not find silver in the Sierra de la Plata, or any semblance of wealth in the area, Rivera did create an interest in what lay beyond the land of the Utes. In the decade that followed the expedition, New Mexicans speculated that Rivera did not go far enough, nor did he go in the right direction.

Eleven summers passed before the next official expedition returned to Ute country. On July 4, 1776, Spanish settlers stood in the warm sun at the plaza of the Ville de Santa Fé and watched the blue-robed Domínguez and his brother in Christ, Escalante, and several others pack provisions and trade items to load on mules for the expedition. A few weeks later, on July 29, Domínguez and Escalante prayed a mass, blessed the men and animals, and amid hugs and handshakes from well-wishers, departed Santa Fe bound for Abiquiu. Their destination was Monterey, California. The padres, however, did have another plan: to explore Ute country for possible mission sites. Moving slowly, the expedition passed Abiquiu and went north beyond the Española valley.

Among the members of the expedition were two lay Franciscan brothers. They were accompanied by Juan Pedro Cisneros, chief magistrate from the Zuñi Pueblo, and the talented cartographer-soldier Don Bernardo Miera y Pacheco, a retired captain of the militia from Santa Fe. Several New Mexican traders, who had previous experience in Ute country, joined the expedition as guides and translators. Escalante identified them as Lorenzo Olivares from the Villa de El Paso; Andrés Muñiz from Bernalillo; Antonio Lucrecio Muñiz, brother of Andrés from Embudo, south of Taos; Juan de Aguilar from Santa Clara Pueblo; Joaquín Laín, a blacksmith from Santa Fe; and Cisneros's servant, Simón Lucero, probably from Zuñi. Of them, Andrés Muñiz, who had been with Rivera

to the Colorado River in 1765, spoke the Ute language. His brother, Lucrecio, had also been with the Rivera expedition and spoke the language of the Utes.[1] More recently, in 1775, Muñiz had, without license, gone with others as far as the Colorado River to trade.

When the expedition left Santa Fe on July 29, it was comprised of ten men. Escalante recounted that the expedition had moved slower than anticipated. Lack of water for the men and their pack animals had forced them to stay as close to the Dolores River as possible. Much to their surprise, in mid-August two men from Abiquiu—Felipe, a mestizo, and Juan Domingo, an Indian of mixed Plains parentage—overtook the expedition. The padres were upset by their presence because they had left New Mexico without the permission of the governor, as was required by law. Worse, they feared that if they sent them back they could be killed or captured and enslaved by wandering Ute bands. So they felt obligated to keep Felipe and Juan Domingo with the expedition. Thus, in the early weeks of the expedition Domínguez and Escalante were responsible for ten other men.

For the moment, on that warm summer day of July 4, as Escalante stood in the plaza of Ville de Santa Fé, he must have thought back to the day he first envisioned the possibility of such an expedition. More than a year had passed since he had returned from a reconnaissance to Hopi. He hoped that he could convince his superiors that a route could be run from Santa Fe through what is now northeastern Arizona along the south side of the Grand Canyon and beyond to the western bank of the Colorado River, which he would cross on his way to California.[2] After all, in 1774 a lone Franciscan, Fray Francisco Tomás Hermenegildo Garcés, guided by Indians who would only lead him from one tribal boundary to the next, had crisscrossed the Mojave Desert from Tubac in Arizona before veering northeast across the Colorado River to Oraibi. He had shown that it

was possible to traverse the territories of hostile tribes along a route south of the Grand Canyon. At Oraibi, Garcés left Escalante a note saying he had safely made the journey. Thus, Escalante knew that it was possible to get to California by following a similar route west of Oraibi.

On his first visit to Hopi in the summer of 1775, Escalante met a Cosnina Indian who, through an interpreter, had drawn directions in the dirt to his land west from Oraibe.[3] The Cosnina had given Escalante invaluable information about the land beyond Hopi, which would help him plan the expedition to Monterey.

In June 1775, Escalante returned to Hopi and attempted to reach the Río Grande de los Cosninas (the Colorado River). Finding the Cosninas unfriendly, an intimidated Escalante did not accomplish his goal, although he spent eight days there. He noted their location, defenses, herds of cattle stolen from New Mexico, waters, and subsistence of the tribe as well as their population.[4] But Escalante decided against passing through their land because of their hostile nature.

Escalante described Hopi as he saw it in 1775. He said that Hopi was comprised of seven pueblos, almost in a direct line from east to west on three mesas. On the narrow western end of First Mesa's summit were three pueblos. The first one was inhabited by the Tanos, whose language, Teguas, was different from that of the Hopi. The other two pueblos, one a stone's throw from the first and the other a musket-shot distant, were Hopi-speaking. More than three hundred families lived in the three pueblos on First Mesa.

West of First Mesa stood Second Mesa, also called Gualpi. The first pueblo of Second Mesa was called Mossasnabi; the second was Nipaolabi, already in ruins and abandoned. The people of Nipaolabi had moved to Nangopai, the newly built third pueblo. Escalante observed that the people of Second Mesa appeared more prosperous than those of First Mesa, for they possessed more horses and sheep.

Mighty Old Oraibi, stronger and larger than the others, stood on Third Mesa. In 1775, eight hundred families lived there. They had many horses and cattle, and a great number of sheep. Six large cisterns supplied its large population with water. It was a formidable place.

Hopi sat among hostile tribes that at any moment could attack them. On the east, the Navajo bordered Hopi with its three mesas; on the west and northwest were the Cosninas; on the north, the Utes; on the south, the Gileño Apaches; and on the southeast, the Mescaleros.[5]

Escalante, however, was not so much concerned with the tribes that surrounded Hopi but with the Hopi themselves. Despite their professed loyalty to the crown, the Hopi were rebellious and had obstinately refused to acknowledge their obedience to Spanish authority as well as to the Christian religion.[6] Escalante proposed establishing a fort to maintain peace between the Spaniards and the Hopi. He felt that the fort would also deter Apaches from raiding in the area. Once the Hopi were pacified and converted to Christianity, their land could be used to march against the Cosninas.[7]

Escalante hoped that his route to Monterey would receive a more receptive ear if he suggested an alternative that was not fraught with the complications of crossing the land of hostile Cosninas and Apaches. Thus, he proposed that the expedition to Monterey would be easier through the land of the Utes. Besides, Escalante reasoned, the Port of Monterey was at "37° and some minutes" and Santa Fe was in a "latitude of 36 degrees and 11 minutes." Between them lay the land of the Utes, who were at peace with the Spaniards.[8] The expedition could effectively march northwest to reach Monterey.

Then there was the question of the "lost" tribe of Spaniards, who Escalante believed lived as Indians. He

argued that they could be somewhere along the proposed route toward the northwest. Earlier, in 1765, Rivera had hoped to find them. The Domínguez-Escalante expedition, however, did encounter bearded Indians among the Utes. Of the sighting, Escalante wrote in 1778:

> from the misunderstood stories of the heathen Indians, many [Spaniards] were persuaded that on the other side of the Colorado River, which with the Gila enters the Gulf of California, live a nation similar to the Spanish, wearing long beards, armor, like our ancient kind, with breast plate, iron helmet and shoulder-piece; and these, no doubt, are the bearded Yutas of whom the Reverend Father Custodian [Domínguez] and I speak in the diary of the journey which we made through those lands in the year 1776; who live in rancherías and not in pueblos. They are very poor; they use no arms, other than their arrows and some lances of flint, nor have they any other breast-plate, helmet or shoulder-piece...[9]

About that time, Miera, who had finished one of his maps, included a sketch of "bearded Indians." Escalante's visit to Hopi in 1775 had stimulated excitement about a possible route to Monterey. He now put his proposal of a northwesterly route to the test. As the expedition departed Santa Fe, he pondered its possibility.

Significantly, the actual leader and true organizer of the expedition was Domínguez. He bore the burden of responsibility in planning, making critical decisions on the trail, disciplining members of the party, and assuring the success of the expedition. In the end, it fell on his shoulders to explain to his superiors whether the expedition was a success or a failure.[10] Escalante was subordinate to Domínguez. He had the "task to act as amanuensis," that is, as the scribe or diarist of the expedition.[11] Perhaps that is why

Escalante is perceived to be the leader of the expedition. Yet, in all actuality, both men collaborated in the writing of the diary. Also, Escalante was better known than Domínguez was to contemporary authorities in New Mexico. Still, posterity granted Escalante recognition for having written the diary and consequently, but erroneously, credited him as the leader of the expedition.[12]

As a missionary, Francisco Atanasio Domínguez was well respected. Born in Mexico City around 1740, he joined the Franciscan order at the Convento Grande in Mexico City at age seventeen. In 1772, he served in Veracruz as commissary of the Third Order. He was assigned to New Mexico in 1775 as the *visitador*, or inspector, of the Custody of the Conversion of St. Paul, New Mexico's mission field. The office of canonical visitor was given only to the most qualified clergyman, a reputation well earned by the esteemed Friar Domínguez.[13]

As the ecclesiastical inspector of the missions of New Mexico, Domínguez was ordered to make a thorough and detailed report of the spiritual and economic status of the missions inclusive of geographical and ethnological information. On September 4, 1775, he arrived in El Paso, the ecclesiastical headquarters of the Custody of the Conversion of St. Paul. After a six-month sojourn, he left El Paso and arrived in Santa Fe on March 1, 1776. In the spring of that year, Domínguez inspected the missions from Santa Fe to Taos Pueblo. In late spring, he visited the missions south of Santa Fe on the Río Abajo (the lower Rio Grande). His report on the missions is, today, an important historical source.

During those months, he made preparations to meet other objectives of his instructions, which included finding a route from Santa Fe to Monterey. On April 15, Domínguez ordered Escalante, the missionary at Zuñi Pueblo who had made a proposal to find a route to Monterey, to join him in Santa Fe. Their friendship was immediate. After consulting each other on the best route to

California, they enlisted the service of Miera and several other frontiersmen who had been to Ute country.[14]

Although he rarely used his first name, Francisco Silvestre Vélez de Escalante was born in 1749 in Treceño, Santander, Spain, to Clemente Nicolás Vélez de Escalante and María Josefa Fernández de los Ríos.[15] He died in 1780 in Parral, Chihuahua, Mexico. Little is known about his early life, but by age seventeen, having committed himself to the life of a missionary, he took the Franciscan habit at the Convento Grande in Mexico City. Escalante arrived in New Mexico sometime in the early 1770s.[16]

Like Domínguez and Escalante, Bernardo Miera y Pacheco would earn a place in the annals of New Mexico and the greater Southwest. The talented Miera was a mathematician, cartographer, soldier, politician, and artisan. As a *santero*, a wood-carver of saintly figurines, he made many of the icons for the altar and *retablo* of La Castrense, the military chapel in the Santa Fe Plaza.

A native of Burgos in Spain, Miera arrived in El Paso del Norte in 1743.[17] While there, he participated in five campaigns against hostile Apache. In 1754, he and his family moved to Santa Fe. Soon afterward, Miera served as *alcalde* (mayor) and *capitán de guerra* (captain of war) at Pecos and Galisteo. There, he gained experience in campaigns against the Comanche.

During that time, he journeyed to Hopi and drew a map of the Navajo country. In 1760, he prepared a general map of the Provincias Internas of New Spain, which Nicolás de Lafora, the cartographer of the Marqués de Rubí's expedition, used on their inspection of New Mexico. After his term as alcalde, Miera became the cartographer of the Domínguez-Escalante expedition.

As they marched out of Santa Fe, Domínguez, Escalante, Miera, and the other seven men found themselves on the threshold of an immortality that only Clio, the goddess of history, can offer mankind. The diary of the expedition not only would record the events as they occurred but would preserve them for all time. It was an errand into the wilderness on an epic scale. Before them was a big sky that hovered over mountains, ridges, rivers, and tribes, most of whom had never before seen a white man.

Domínguez and Escalante's diary gives modern man clues about where they walked, where they camped, and whom they encountered on their northwest passage. The diary is a timepiece suspended in a space of five months. Yet it is a historical document that verifies that the event did, in fact, take place. Times, places, and people mentioned in the diary have all passed, and the continuity of a changing time, place, and people assured that the scenes of 1776 would be replaced by what modern man sees presently. Were it not for the diary, the expedition would have met the same fate as the illegal traders whose lives and adventures were not recorded. Surely the expedition would have been relegated to oblivion or, at best, a mention here and there that such an event had taken place.

The first phase from Abiquiu to the Uncompahgre Plateau and beyond to the Colorado River closely followed the route taken by Rivera and his men in 1765. The diary of the Domínguez-Escalante expedition clarifies in rich detail the route taken, with small variation, by Rivera in his two expeditions to the northwest. The entries for that section offer a window to the past that shares the historical values known in 1765 and 1776. With exquisite detail, Escalante wrote the account of the expedition as it walked into the pages of history.

In time, the interests of the Spanish empire were well served by the knowledge gained by Domínguez and Escalante. Over the next seventy years, the land that had been explored by the friars would witness a number of events that would continue to tantalize the minds of Spanish officials about a possible route to California, and which would lead to the settlement of southern Colorado and

Utah. In the late 1770s, the pacification of present southern Colorado by Juan Bautista de Anza occurred. The last surviving men who had served with Rivera and with Domínguez and Escalante guided Anza's troops to southern Colorado. Indeed, as Anza noted, in the campaign against the Comanche in 1779, there were three men who had been with Rivera in 1765 and Domínguez and Escalante in 1776. Of their experiences near the Colorado River, Anza wrote:

> The same settlers mentioned, who explored the seven rivers referred to, by order of Governor Don Tomás Vélez, affirm that on all of them, which are very fertile, they observed that in ancient times they were well populated with Indians, this being demonstrated by the large size of the formal pueblos of three stories and other remains. Among these was [evidence] that the settlers themselves had practiced the art of taking out silver, as their ore dumps and other remains of their use were found. They assured me moreover they delivered these fragments to the aforesaid governor, who, according to other reports, sent them to the city of Mexico.[18]

Who were the New Mexicans? Anza does not say.

Up to the end of the Spanish colonial period, the route to California from New Mexico continued to stir considerable interest among officials who wished to consolidate the frontier. The dream inspired by the Domínguez-Escalante expedition of 1776 had persisted, but it had cooled somewhat when the two friars proposed expanding the New Mexico mission frontier to Ute country. Indeed, Governor Pedro Fermin de Mendinueta was taken aback when Miera rode south to Chihuahua to propose that three new settlements and three new presidios be established to consolidate Spanish control of the area between New Mexico, California, Nueva Vizcaya, and Sonora. One presidio and settlement proposed by Miera would be established at the Lake of the Utes, and another on the San Juan River near what is now Four Corners.[19] The plan with all of its details and machinations would come to naught.

In the late 1770s, the scholarly Father Juan Morfi, who served as secretary to Commandant Teodoro de Croix, revived the California route by proposing that Anza, newly appointed governor to New Mexico, explore the possibility of such a trail. Morfi suggested that Anza should, on his way to New Mexico, march from Sonora along the north bank of the Colorado and rendezvous with Escalante at a point in the territory of the Sabuagana Utes. Escalante would, meanwhile, explore the Colorado and the upper Rio Grande on his way from New Mexico to meet Anza. Once united, the two would then proceed to Santa Fe by way of Hopi and the Navajo provinces, making careful observations about the land and people for future plans to settle the area. Morfi proposed, furthermore, that a line of presidios along the Colorado River should be established to protect the route from Santa Fe to Monterey.[20]

One major obstacle stood in the way of Morfi's plan: the Apache and Comanche affinity to wage war against Spanish New Mexico. In 1779, Croix, commandant general of the Provincias Internas, a large geographic area defining the northern frontier of New Spain, reviewed the deplorable situation in New Mexico in regard to increased raids by Comanche bands. Realizing that the Spanish military effort could not stop Comanche raiders, he reasoned that the best result would be a lessening of the raids through improved defenses and well-timed punitive expeditions into *comanchería* with Ute and Apache allies, traditional enemies of the Comanche. When Anza was appointed governor of New Mexico, his primary objective was to establish a route between Santa Fe and California via

Sonora. But his purpose in New Mexico would take on a completely different direction as Comanche raids increased. The choice of Anza for the governorship of New Mexico was excellent from the point of view of the colonial administration of the area; he was an able and experienced frontier soldier-administrator.[21]

Anza's defeat of the Comanche in 1779 opened the area of southern Colorado and northern New Mexico to settlement. By 1780 Comanche tribesmen were ready to negotiate a peace with Anza. The settlement of southern and western Colorado by Hispanics from New Mexico would generally follow along the lines of established routes such as those run by Domínguez and Escalante toward Ute country and that blazed by Anza in his campaign against the Comanche. The pacification of southern Colorado had only just begun; decades would pass before it was completed. Meanwhile, Hispanic traders from Santa Fe continued to use known trails and routes into western and southern Colorado to trade with the Utes. Often they went northwest toward Utah and the Great Basin. Meanwhile, Spanish colonial desire for a route to California from New Mexico waned but was not forgotten.

Much has changed since Domínguez and Escalante and their men explored the region between Santa Fe and Timpanogos. Today the Domínguez-Escalante expedition route and its descendant, the Old Spanish Trail, live in the lore of Native Americans, Hispanics, and Anglo-Americans of New Mexico, Arizona, Utah, Nevada, and California. Similarly, within the historical context, its past and present are commemorated in literature and geography, with place-names, historical markers, and publications maintaining its presence.

Although historical markers indicating the route of the Domínguez-Escalante expedition abound in Utah, Colorado, and New Mexico, it was not until 1976, when the United States celebrated its bicentennial, that a regional interest arose in seeking ways to preserve known portions of the trail. Many proposals were entertained by entities in Utah and New Mexico to "do something" about commemorating the trail and its variants. One significant action taken by the Domínguez-Escalante State-Federal Bicentennial Committee, organized in 1973, was the publication of *The Domínguez-Escalante Journal*, translated by Fray Angelico Chavez and edited by Ted J. Warner. Although previous versions had been published by Herbert S. Auerbach (1943) and Herbert E. Bolton (1950), the timing of the reissuance of the journal appeared to be the long-lasting contribution of the committee. In 1995, the publication was reprinted with a foreword by Robert Himmerich y Valencia. The journal continues to be the premier document about the historical evolution of the region.

Perhaps the most significant outcome of the bicentennial in relation to the Domínguez-Escalante expedition was the beginning of a grassroots constituency to preserve the trail. During the bicentennial, tourism seemed to drive proposals for bike and hiking trails, and scenic overlooks for viewing certain vistas along the route or its variants. Other ideas were proposed, including reexploring the route, but they ultimately came to naught. With sometimes uncaring and hasty development of the area that crisscrosses the historical pathway, the fate of the route hangs in the balance. The Domínguez-Escalante Trail is a legacy that deserves recognition as a national treasure, for it represents the tricultural prehistorical and historical development of the United States. Indeed, the route of the Domínguez-Escalante expedition is a part of our national story.

Notes

1. For a complete listing of all participants in the expedition, some of whom joined Domínguez and Escalante while the exploration of Ute country was in progress, see Ted J. Warner, ed., *The Domínguez-Escalante Journal: Their Expedition Through Colorado, Utah, Arizona, and New Mexico in 1776*, translated by Fray Angelico Chavez (Salt Lake City: University of Utah Press, 1995), vii–viii.

2. Herbert S. Auerbach, ed., "Escalante's Letters to Fray Fernando Antonio Gómez, Custodian of the College of Queretaro, and to the Governor of the Province," in *Father Escalante's Journal with Related Documents and Maps* (Salt Lake City: Utah State Historical Society, 1943), 15.

3. "Brief of a letter from Fray Silvestre Vélez de Escalante, written at the Mission of Nuestra Señora de Guadalupe de Zuni on April 30, 1776, addressed to Fray Isidro Murillo, Provincial Minister," in Auerbach, 12.

4. Ibid., 15–16.

5. Ibid., 16–17.

6. Ibid., 17.

7. Ibid., 19.

8. Ibid., 22.

9. Ibid., 23, n11.

10. Warner, xv.

11. Eleanor B. Adams, "Fray Francisco Atanasio Domínguez and Fray Silvestre Vélez de Escalante," *Utah Historical Quarterly* 44 (winter 1976): 53.

12. Warner, xv.

13. Eleanor B. Adams and Fray Angelico Chavez, trans. and annotated, *The Missions of New Mexico, 1776* (Albuquerque: University of New Mexico Press, 1956), xiv–xv.

14. Ibid., xv.

15. Libro de Bautizados, Parroquia Santa María de Treceño, Año 1736 al 1781, Archivo Diocesano, Santander, Spain.

16. Adams and Chavez, xiv.

17. The letter, dated at San Phelipe El Real de Chiguagua, October 26, 1777, is reprinted in Herbert E. Bolton, *Pageant in the Wilderness* (Salt Lake City: Utah State Historical Society, 1950, reprinted 1972), 243–50.

18. Alfred B. Thomas, ed. and trans., *Forgotten Frontiers* (Norman: University of Oklahoma Press, 1932), 127.

19. Bolton, 343–46.

20. Juan Morfi, Memorial (undated, probably written in 1777), quoted in Charles Edward Chapman, *Founding of Spanish California: The Northwestward Expansion of New Spain, 1687–1783* (New York: The Macmillan Company, 1916), 398–402.

21. Adams and Chavez, 154.

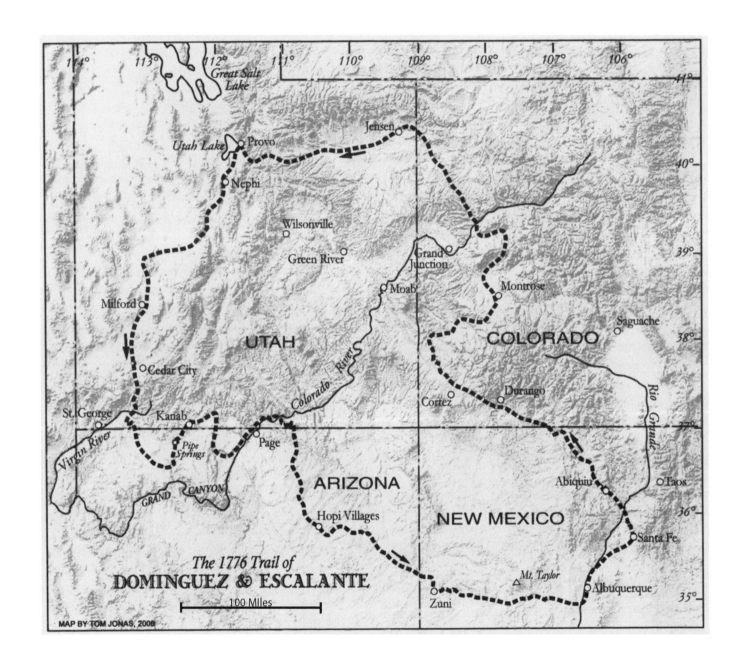

Great Salt Lake

114° 113° 112° 111° 110° 109° 108° 107° 106°

41°

Jensen

40°

Utah Lake ○ Provo

○ Nephi

○ Wilsonville

39°

○ Green River

Grand
Junction

○ Moab ○ Montrose

Milford ○

UTAH

COLORADO

38°

Colorado River

○ Saguache

○ Cedar City

○ Durango

Cortez ○

37°

St. George
Kanab ○

Page ○

Virgin River

Pipe
Springs

Abiquiu ○ ○ Taos

ARIZONA

Rio Grande

GRAND CANYON

36°

Hopi Villages ○

NEW MEXICO

○ Santa Fe

The 1776 Trail of
DOMINGUEZ & ESCALANTE

△ Mt. Taylor

○ Albuquerque

35°

─────── 100 Miles ───────

○
Zuni

MAP BY TOM JONAS, 2008

Prologue

*T*HE FOLLOWING LETTERS are predeparture excerpts from correspondence sent by Fray Francisco Atanasio Domínguez and Fray Silvestre Vélez de Escalante to their superiors, Provincial Fray Isidro Murillo and Fray Fernando Gomez. One cannot help but note the extraordinary coincidence of the planned departure date of July 4, 1776, in Domínguez's letter.

Acknowledgment is made of the significant news of Father Francisco Tomás Hermenegildo Garcés, who one month earlier had successfully found a direct route from California to the Moqui (Hopi) mesas, thus dispelling the long-held and unsubstantiated claim by Escalante that this route passed through hostile Indian territory and was therefore impractical—the main reason for finding a northern route. Among his arguments and descriptions of these hostiles he writes: "They are warriors, thieves, and savages, because they eat the human flesh of those they kill in their campaigns." For Garcés the opposite was true, he was guided from the Colorado River to the Hopi by friendly Cosninas, who anxiously awaited the return of the Spanish for conversion to Christendom and along with it protection from their enemies. The rational for heading north from Santa Fe and then west to California was therefore changed to instead discovering the people who inhabit these lands along with future sites for Spanish settlement.

Escalante also comments that this northern route will allow them to either discredit or confirm a long-standing report of the existence of Spanish people living just west of the Colorado River (Río del Tizón) on the California border. One theory at the time claimed that they were ancestors of lost Spanish soldiers. In addition, both Escalante and Garcés express doubt that reaching Monterey was likely.

FRAY FRANCISCO ATANASIO DOMÍNGUEZ,
FROM *The Missions of New Mexico*, 1776

We are leaving this capital for the north-northwest with the aim of finding out, if possible, what nations in addition to the Yuta [Ute] inhabit the regions between here and Monterey in the aforesaid direction, even though it may involve a round-about route because it is necessary to go down to reach said port. And on our way back [we hope to discover] the tribes who dwell from west to east as far as Cojnina, where we intend to go in order to strengthen the people of this nation in their good intention of becoming Christians, and in order to give the most careful and accurate report possible about the region they inhabit and the sites it may offer adapted to and convenient for settlements. Also, if no insuperable obstacle intervenes, we will proceed direct to Moqui [Hopi], exploring as much as possible the country in between and the environs of Moqui in order to give information about any suitable sites there may be to which the Moqui pueblos can be moved in case of their conversion, or to establish another, or others, which may be available…

The date was set for the fourth of this month of July, for we had already seen the interpreters and the few men we needed. But on June 20 the troop of this Royal Presidio went out in pursuit of the Comanche enemies who [had] killed ten at the post of La Ciénega, and I sent Father Fray Silvestre with them to exhort and confess the soldiers. This scouting expedition lasted ten days in a row, and although Father Fray Silvestre returned tired and worn out, after three days he again set out for Taos on urgent business which I could not attend to without neglecting to finish other business that summoned me to San Agustín de Isleta.

From there I had to hasten to Taos, because so acute a pain in his side seized Father Fray Silvestre there that it put him in great distress. When I reached Taos, the father was already out of danger, but without strength enough to travel. Therefore I ordered him not to leave for the Villa of Santa Fe until a week had passed.

Our journey was put off because of these necessary and unavoidable delays. And in the interval the Reverend Father Fray Francisco Garcés came from the mouth of the Colorado River to the pueblo of Oraybi in Moqui. He wrote from there to the father… Father Fray Silvestre and I conferred about this new development, and since the Reverend Father Garcés states in his letter that he came to Moqui from the mouth of the Colorado River, we believed that our journey would still be useful. For even if we should not attain our end, which is to discover a route to Monterey from this kingdom, the knowledge we could acquire of the lands through which we traveled would represent a great step forward and be of great use in the future. Moreover, we intend to return via Cojnina [Cosnina] in order to confirm that nation's good decision to become Christian and to divorce it completely (if God favors us) from the Moquis, who are so strongly opposed to their conversion and that of the others…

Now I only advise you that this very day, Monday, July 29, we are leaving this Villa of Santa Fe on our journey, and we leave happy and full of hope, trusting only in your fervent prayers and in the fact that you as our father will have our brethren in that Holy Province of mine remember us in their sacrifices and prayers, for we do not forget them or your Very Reverend Paternity in ours…

Your most useless subject and most favored son, who esteems you, etc., kisses your Very Reverend Paternity's hands.

—FRAY FRANCISCO ATANASIO DOMÍNGUEZ, UNDATED

Fray Silvestre Vélez de Escalante,
from *The Missions of New Mexico*, 1776

The method, if I am not mistaken, which would be suitable would be for his Majesty to bear the expenses of twenty men, or a few more, giving them the same amount daily as the soldiers of this land for three months at least, in order that, led by some intelligent person who would take the enterprise to heart, they might reach said Monterey and reconnoiter the intervening provinces. There are men of valor here, unencumbered by wives and children, who would undertake the journey for the said daily wage alone. There is also a paisano *here, called Don Bernardo Miera, clever enough for the affair, and even I would sacrifice myself for such an undertaking. Here it is believed that the Spaniards or white people whom the Yutas say they have seen many times may be descendants from those 300 soldiers whom Captain Alvarado left when he entered by the Río Colorado at the beginning of the conquest. I do not give great weight…*

Monterey is more than [400] leagues from this capital. The direction in which the intervening territory can be crossed is not known, for although there is some information about the country the Yutas occupy as far as the Río del Tizón [Colorado] and about the tribes who are on the other bank of this river, it is not all credible, for long experience has shown that not only the infidel Indians, but even the [Indian] Christians, in order to raise themselves in our esteem, tell us what they know we want to hear, without being embarrassed by the fal-

sity of their tales. With regard to the proposal I made to my prelates, which is that the said discovery could be accomplished with twenty men, I state that I proposed this number as sufficient to find out whether the Spaniards whom the Yutas and others say are on the other side of the Río del Tizón are really there and who they are…

…and although I am not without hope of reaching Monterey, all I explained in the above opinion is the truth; for although I say that it has never seemed possible of attainment with so few men, I do feel that there is enough probability of success in the latter to risk expense to the royal treasury, which must always be incurred in the least doubtful matters; not because in going without noise of arms (which usually terrifies the tribes encountered on the way, and therefore there must be a sufficient force or none at all) I may not have conceived some probable hope that God will facilitate our passage as far as befits His honor, glory, and the fulfillment of the will of the All High that all men be saved. The shortness of time and the many very necessary occupations of this day permit me to say only this.

I shall be gratified that your Paternity enjoys good health and that God keeps you in it many years in His grace. Santa Fe July 29, 1776

Our Very Reverend Paternity, your least subject kisses your Reverend Paternity's hand.

—Fray Silvestre Vélez de Escalante

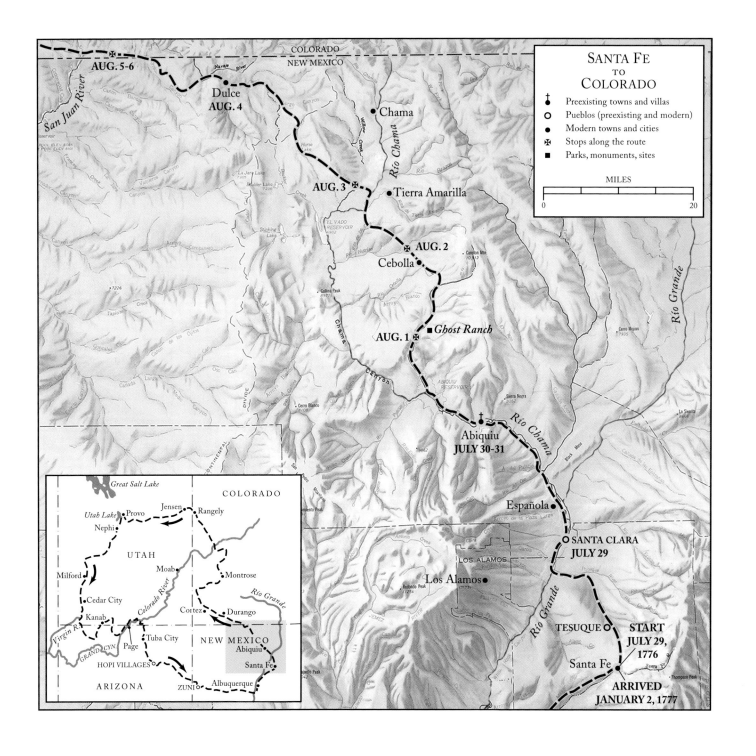

SANTA FE
TO
COLORADO

† Preexisting towns and villas
○ Pueblos (preexisting and modern)
• Modern towns and cities
✹ Stops along the route
■ Parks, monuments, sites

MILES
0 20

COLORADO
NEW MEXICO

AUG. 5-6

San Juan River

Dulce
AUG. 4

Chama

AUG. 3

Tierra Amarilla

Rio Chama

EL VADO RESERVOIR

AUG. 2

Cebolla

■ *Ghost Ranch*
AUG. 1

Rio Grande

Abiquiu
JULY 30-31

Rio Chama

Española

○ SANTA CLARA
JULY 29

LOS ALAMOS

Los Alamos

Rio Grande

TESUQUE ○ **START
JULY 29,
1776**

Santa Fe

**ARRIVED
JANUARY 2, 1777**

Great Salt Lake

COLORADO

Utah Lake • Provo Jensen • Rangely

Nephi

UTAH

Milford

Moab • Montrose

Cedar City Colorado River

Kanab Cortez • Durango Rio Grande

Virgin R. Page Tuba City NEW MEXICO
GRAND CYN. Abiquiu

HOPI VILLAGES ○ Santa Fe

ARIZONA ZUNI ○ • Albuquerque

CHAPTER 1

Santa Fe to Colorado: July 29–August 6

*A*s in most early exploration routes, the Domínguez-Escalante expedition would follow water sources, an obvious necessity for both animals and humans. Leaving Santa Fe on July 29, 1776, they headed north, following the sometimes dry Tesuque River until it joined the Rio Grande near the base of the Jemez Mountains where present-day Los Alamos is located. They passed through Tesuque and San Ildefonso pueblos, reaching Santa Clara Pueblo on the first night for their encampment. Distances reported in the diary are expressed in leagues (the Spanish league was about 2.63 miles), so about twenty miles were traveled that first day. Fifteen to twenty miles would be a typical day's march and the norm on their five-month journey. How the number of leagues traveled was determined is not stated in the journal. No mechanical device was mentioned so it is assumed that distances were estimated from experience. In those days it was claimed that on level ground travel by horse could reach twenty leagues in one day (fifty-plus miles). Land-

forms, rivers, springs, and campsites noted in the diary have been useful in checking on the accuracy of their travel estimates. The Santa Clara Pueblo and today's city of Española are situated near the juncture of the Chama River and the Rio Grande. The next day they followed the Chama to the most northern Spanish mission of Abiquiu.

Among the original ten members of the expedition was Andrés Muñiz, who had traveled with the Juan María Antonio Rivera exploratory group in 1765, which had gone as far as the Gunnison River in Colorado. He served as chief guide and interpreter, having a good command of the Ute (Yuta) language. Ute and its various dialects was the primary language spoken among natives throughout Colorado and across Utah, into what is now Provo. From Utah south to the Hopi mesas in New Mexico, communication was difficult as the dialects were confusing and native guides were either not available or had deserted. An important member of the expedition, Don Bernardo Miera y Pacheco (a sculptor, painter, rancher, armor maker,

ex-captain of the militia, civil magistrate, and engineer), would serve primarily as astronomer and cartographer. His map of the region would be the finest example of cartography to date, for the first time placing the Colorado River in the correct position.

The ages of the expedition members ranged widely: Escalante was twenty-five; Domínguez, thirty-five; Miera, in his mid-fifties; and Don Juan Pedro de Cisneros, alcalde (mayor) of Zuñi Pueblo where Escalante served as priest, was the oldest at about sixty. The remaining members were young men, presumably in their twenties. They would receive a daily payment of six and a half reals, which was one-eighth of a peso. One peso would buy two chickens, half a pound of chocolate, or a string of chilies. The friars and Miera received no pay. Upon returning to New Mexico, Miera petitioned the king of Spain for a salaried captaincy or command of a New Mexico militia as well as a promotion for his son (all of which were denied). Cisneros's interest is not easily explained, other than as a personal adventure. He received no pay consistent with the custom of early Spanish exploration, which was based upon self-finance.

Throughout the diary mention is made of "the companions"—who are not always noted by name but are clearly the younger enlisted men—a term which for the reader might imply a somewhat secondary "tagalong" role. As the story of the journey deepens, however, it is clear that their role is much more. True, the leader and decision maker was Domínguez, but he was a priest with little frontier survival knowledge. The country they entered was unknown, and how to travel, hunt, pack, and survive, along with animal husbandry, dealing with Indians, and marksmanship with firearms were the skills of a frontiersman. Added to this one must assume they had a taste for adventure.

The companions' contribution to the success of the expedition cannot be underestimated, although they are rarely praised in the diary (perhaps some material in the original field notes was later taken out when the diary was copied for presentation to higher authorities). The diary does mention constant explorations by the companions, as they went ahead of the main party—sometimes gone for days, sometimes assumed lost—exploring solutions for the present travel predicament. Their role in locating a crossing site at the Grand Canyon was heroic.

There was no list of inventory recorded and so it has been pieced together from diary notations. These included sugar, flour, corn, chocolate, tobacco, ropes, adz, chisel, axes, crowbars, and a little barrel for water. There was no mention of cooking pots. Miera brought an astrolabe, a device for measuring latitude and longitude. There were also gifts or trade goods for Indians: white glass beads, woolen cloaks and cloth, red ribbons, hatchets, and hunting knives. There must have been a compass and crude tools for blacksmithing, as well as flint and a magnifying glass to make fire. Based upon previous expeditions and adjusting for the size of the entourage, it is assumed that they started with thirty horses, ten mules, and twenty head of cattle. Since no mention is made of slaughtering the cattle it is possible there were none, one reason being the anticipated necessity of crossing deep, swift rivers, more easily done with horses and mules than cattle. Each person would have had one musket and possibly a lance. There are other unanswered questions posed by the journal. What they ate was barely mentioned except when they ran out of food and had to trade for grass seed, corn, or tuna (a type of prickly pear)—lack of food was mentioned more often than eating. Other than stating that they killed six horses, shot two buffalo and one skunk, and caught two fish, no other mention of hunting game appears.

Travel continued north along the Chama River, through what today is the Abiquiu Reservoir, past Ghost Ranch, then leaving the Chama River to avoid impassable canyons with overland detours until rejoining the river at

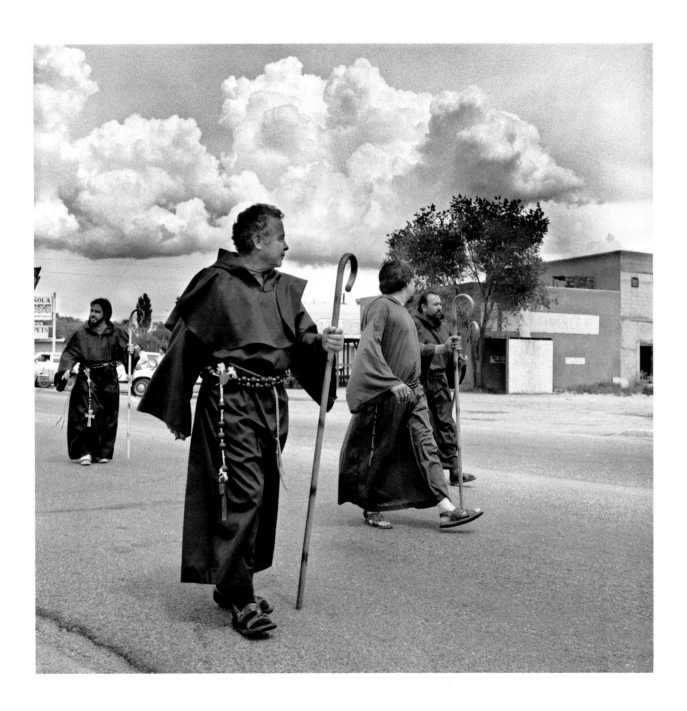

REENACTMENT OF OÑATE'S 1598 FOUNDING OF FIRST SETTLEMENT, ESPAÑOLA, NM.

(July 29, 1776) Audience at the reading of "Instructions to Peralta," establishing the Villa de Santa Fé in 1610, with Palace of the Governors in background; departure point for the Domínguez-Escalante expedition, Santa Fe, NM.

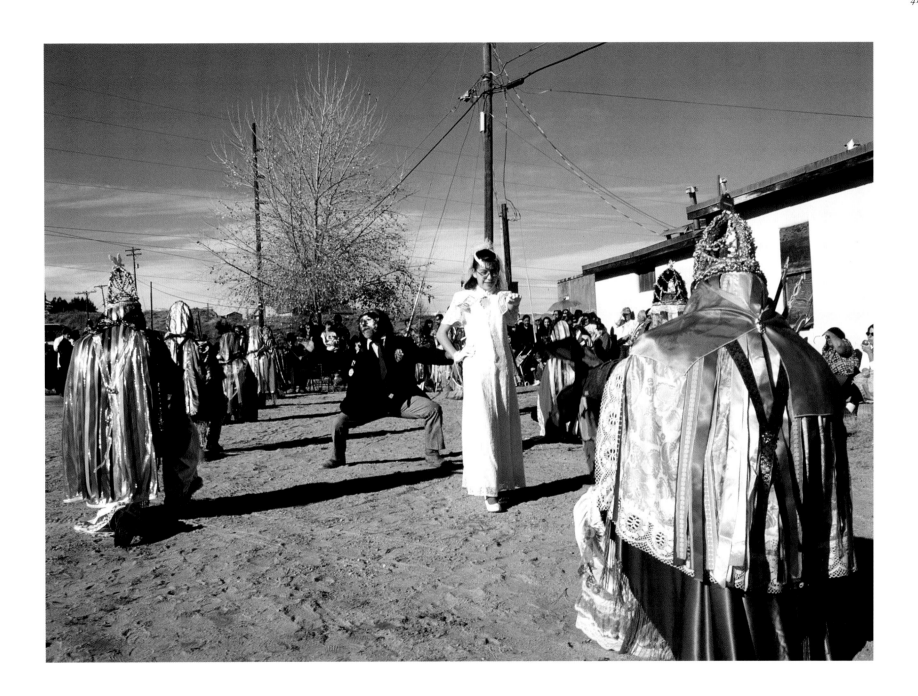

(July 29) Matachine dance, en route to San Ildefonso Pueblo, NM.

(July 30) Confluence of the Chama and Rio Grande, San Juan Pueblo, NM.

present-day El Vado Reservoir. From this point on, a small stream was followed to the Continental Divide. The downslope led through today's Lumberton and Dulce, the regional center of the Jicarilla Apache Nation. A confusing hilly overland route of about twenty miles then leads to the San Juan River and Colorado border. Travel time since leaving the Palace of the Governors on Santa Fe Plaza was just seven days.

Abiquiu Pueblo

Fray Francisco Atanasio Domínguez,
from *The Missions of New Mexico*, 1776

The triangular eminence on which the pueblo stands is rather high. It is in the open and has no others near it in the east, north, and west…But all along the south the view is blocked by a mesa and other hills, although they are not very near. Therefore, some milpas that lie to the east at the foot of the hill where the pueblo is can be watered by a stream which runs from southwest to east between the mesas and hills. Its water is very dirty because it carries the earth from the said hills and from some little mounds beyond them.

In addition to the fact that the said hill is open to the directions mentioned, it is very broad on top, and from all points there is a view of everything to be seen in these directions. The pueblo consists of a large square plaza with a single entrance to the north between the convent and the corner of a tenement. There are three tenements in front of the church and convent, and the latter buildings enclose the plaza on the north. As a result the pueblo is visible from the church and convent, with the cemetery inside the plaza. The approach to the pueblo is a rather steep slope on the north side of the hill on which it stands. At its foot there are two little springs of very good water, and since it is good, it is used for drinking. The houses in which the Indians live are arranged in accordance with their poverty and lack of interest.

On the open sides the pueblo has many good farmlands, which are irrigated by the river they call Chama…It runs from north-northwest to southeast, and has very fine meadows on both banks, with corresponding groves of beautiful poplars. The lands are extremely fertile, but their owners, the Indians, are sterile in their labor and cultivation, so they do not yield what they might with attention, and as a result so little is harvested that the Indians are always dying.

Those who have taken root here and their progeny speak Spanish in the manner described with regard to the Santa Fe genízaros, for they all come from the same source, and these were taken for this pueblo. There is nothing to say about their customs, for in view of their great weakness, it will be understood that they are examples of what happens when idleness becomes the den of evils…The Indians of Abiquiu…were brought up among Spaniards and they are therefore Hispanicized…But even though…they are weak, gamblers, liars, cheats, and petty thieves.

census: 46 families with 136 persons

August 1–3

PENITENTES

The Penitentes of New Mexico and southern Colorado originated from a lay order of Saint Francis of Assisi. They function as a brotherhood, usually established in rural communities, caring for those who are in need, infirm, or elderly. They safeguard their religious artifacts and ritual materials and hold meetings in a building called a *morada*. Historically, the Penitentes reenacted the Crucifixion and Passion of Christ during the week of Lent, especially on Good Friday; men flagellate themselves with whips made of yucca, carry heavy crosses, and emulate the pain and suffering of Christ in his last hours. Penitentes believe that sin is expiated by suffering, and forgiveness can be obtained by self-inflicted flagellation and pain. The Catholic Church does not condone these practices, thus forcing them underground. They eventually evolved into a secret society.

(August 1)
After having celebrated the holy sacrifice of the Mass, we set forth from the pueblo of Santa Rosa de Abiquiú toward the west along the bed of the Chama River and traveled in it a little less than two leagues…we halted for siesta on the north side of the valley of La Piedra Alumbre, near Arroyo Seco. They say that on some mesas to the east and northeast of this valley, alum rock and transparent gypsum are found…Today a good shower fell upon us, and we traveled seven leagues.

(August 2)
…we came to a small plain of abundant pasturage which is very pleasing to the sight, because it produces some flowers whose color is between purple and white and which, if they are not carnations, are very much like carnations of that color. Here there are also groves of small limes, a red fruit the size of the blackthorn. In freshness and taste it is very similar to the lemon, so that in this country it is used as a substitute for lemons in making refreshing drinks. Besides these fruits there is the chokecherry, much smaller than the Mexican variety, and another berry which they call manzanita, whose tree resembles the lime though the leaf is more like that of celery and the size of the berry is that of ordinary chickpeas. Some are white and others black, the taste being bitter-sweet and piquant but agreeable…we arrived at a small stream called Río de Cebolla, where…we took a siesta.

(August 3)
We went…to the Río de Chama. Then, along its pretty meadow we went up to the north about a mile, crossed it, and halted for a siesta on the opposite bank. The ford of the river is good, but on the banks near it there are large hidden sinks, with small stones on the surface, in one of which Don Juan Pedro Cisneros' horse was completely submerged. The meadow of the river is about a league long from north to south, and is of good land for crops with opportunities for irrigation. It produces much flax and good and abundant pasturage, and there are also the other advantages necessary for the founding and maintenance of a settlement…We continued through the valley toward the northwest and entered a small grove of pines where a loaded mule strayed away and did not reappear until sunset…Today five leagues.

(July 30) Penitente morada, Abiquiu, NM.

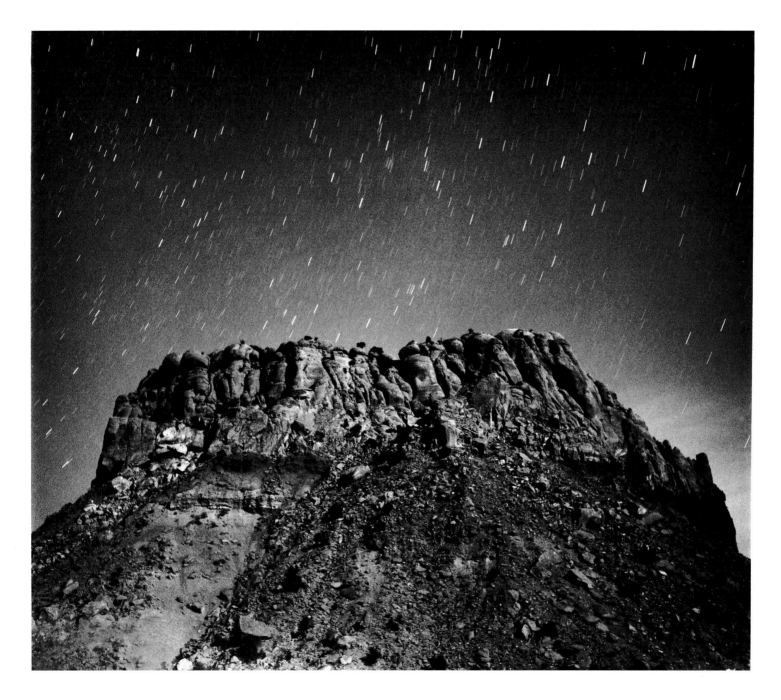

(July 31) Ghost Ranch mesa formation at night and campsite location, NM.

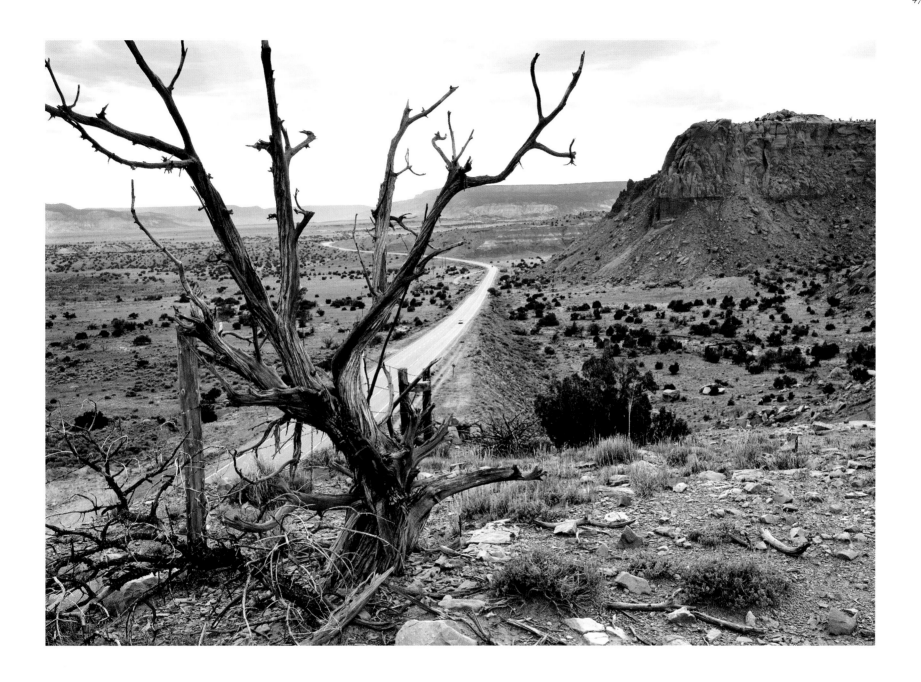

(July 31) Highway 285 looking north and Chama River valley, near Ghost Ranch, NM.

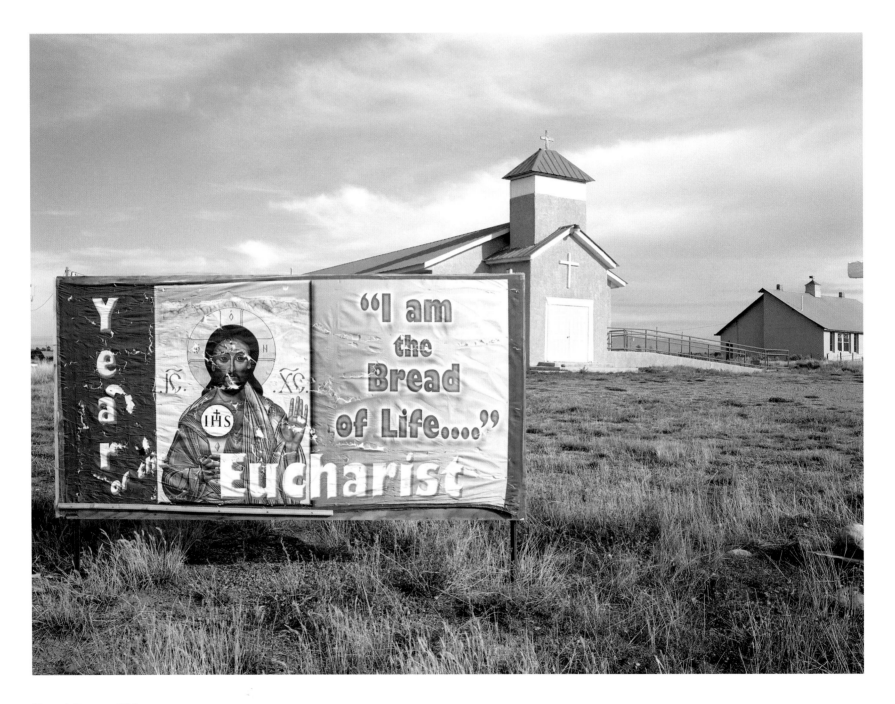

(Aug. 2) Cebolla, NM.

Tierra Amarilla,
the Place of Yellow Earthen Clay

The expedition traveled very near the present-day village of Tierra Amarilla. The friars described this fertile region as suitable for farming and pastoral use. In 1832 the Mexican government established the Tierra Amarilla Land Grant. In 1848, when Mexico ceded much of its northern territory of New Mexico, Arizona, Colorado, Utah, and California to the United States, the Treaty of Guadalupe Hidalgo was signed, guaranteeing continued ownership of original ancestral Spanish and Mexican land grants.

Today this small village is best known for the daring raid and capture of the Tierra Amarilla courthouse on June 5, 1967. Reies López Tijerina and his supporters organized the attack to demand that the government acknowledge their rights to the original land-grant claims. The New Mexico lieutenant governor's response was to call out the National Guard and send armored vehicles with a large contingency of state troopers to quell what was called a rebellion. The resulting loss of lives and manhunt did not bring about any changes to these festering issues. These claims, to date, have not been resolved; there is still considerable pain and resentment associated with the loss of traditional ancestral lands.

(August 5)
We set out from camp in the Cañon del Engaño toward the southwest and having traveled half a league arrived at Río de Navajó, which rises in the Sierra de la Grulla and runs from northeast to southwest to this point, where it turns back toward the north for a little more than three leagues, and then joins another river which they call the San Juan…Having crossed the river we continued with difficulty toward the south in the same canyon, and after going about a league we turned to the southwest for a quarter of a league, then three quarters of a league to the west through canyons, over hills, and through very difficult brush. The guides lost the trail and even seemed to have forgotten the very slight knowledge which they had appeared to have of this country…Today eight leagues.

(August 6)
In the afternoon we left the camp of Nuestra Señora de las Nieves, going downstream toward the west, and having traveled two and one-half leagues over bad terrain, we camped on the bank of the river. Don Bernardo Miera had been having stomach trouble, and this afternoon he became much worse, but God willed that before daybreak next morning he should be improved, so that we might continue on our way. — Today two leagues and a half.

Passing through present-day Dulce, the Navajo River was crossed. Shortly afterward, the guides lost the trail, and a difficult overland trek to the San Juan River was traversed. The guides were members of the Rivera expedition who had traveled this route twice in 1765 seeking silver and gold deposits, however they would frequently get lost in the days ahead. Miera, a veteran of previous ventures into the Spanish West, would have stomach ailments the entire way. The San Juan River enters a broad valley, which presently contains irrigated crops. Farther downstream it is dammed into the huge Navajo Reservoir and finally empties into the Colorado River.

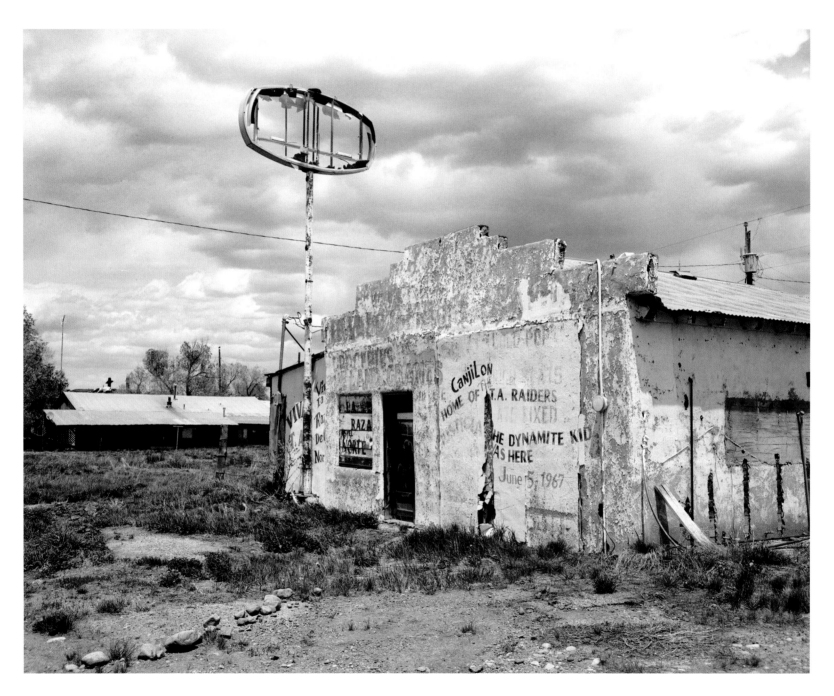

(Aug. 3) Abandoned building and graffiti from 1967 courthouse raid, Tierra Amarilla, NM.

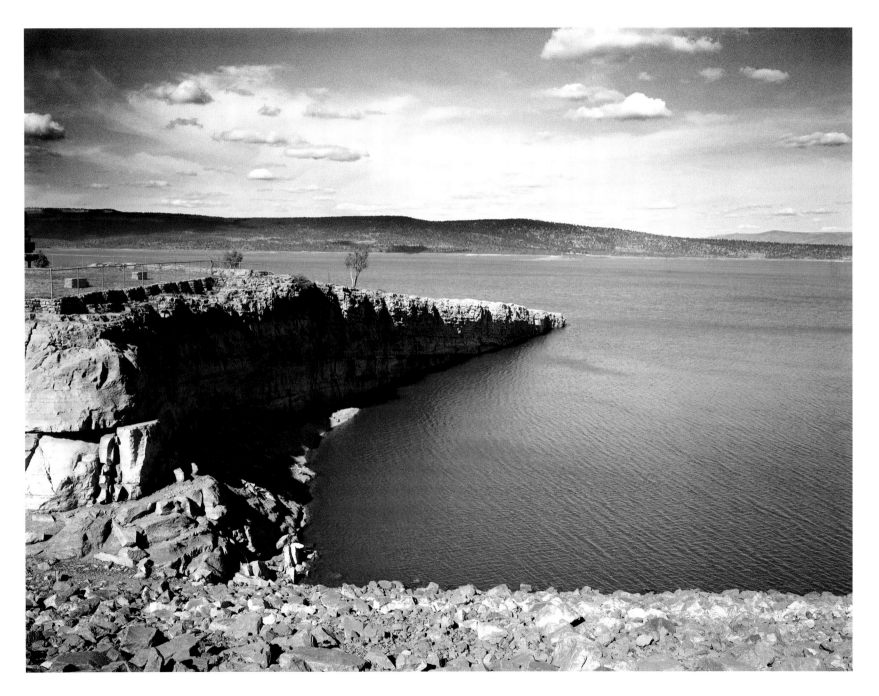

(Aug. 3) Trail site through Heron Reservoir, NM.

(Aug. 4) Jicarilla Apache Nation game and fish headquarters, Dulce, NM.

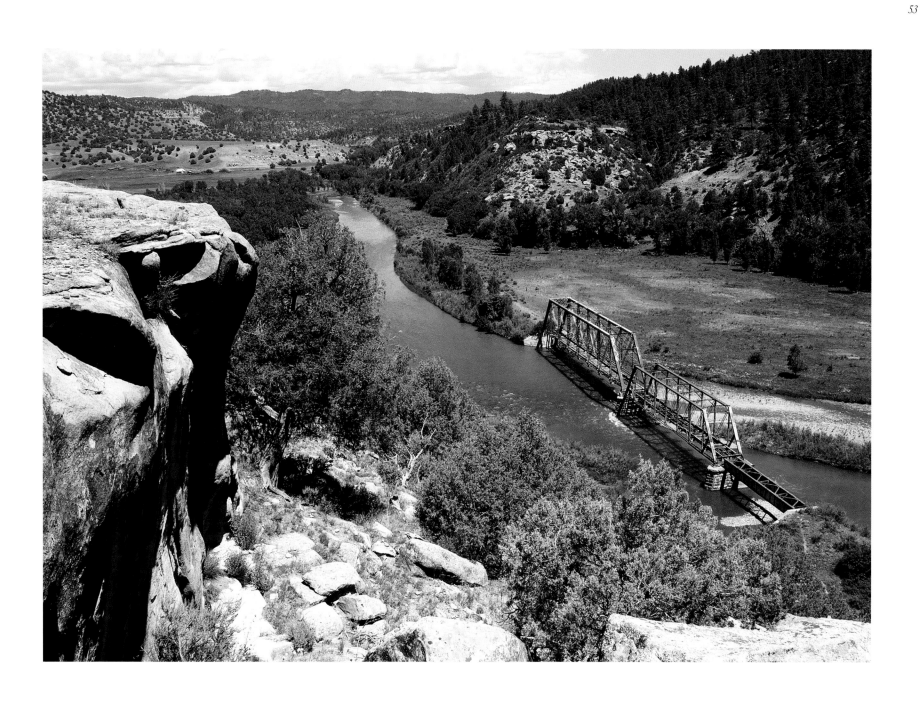

(Aug. 6) San Juan River and abandoned Denver and Rio Grande Railroad trestle, Archuleta County, CO.

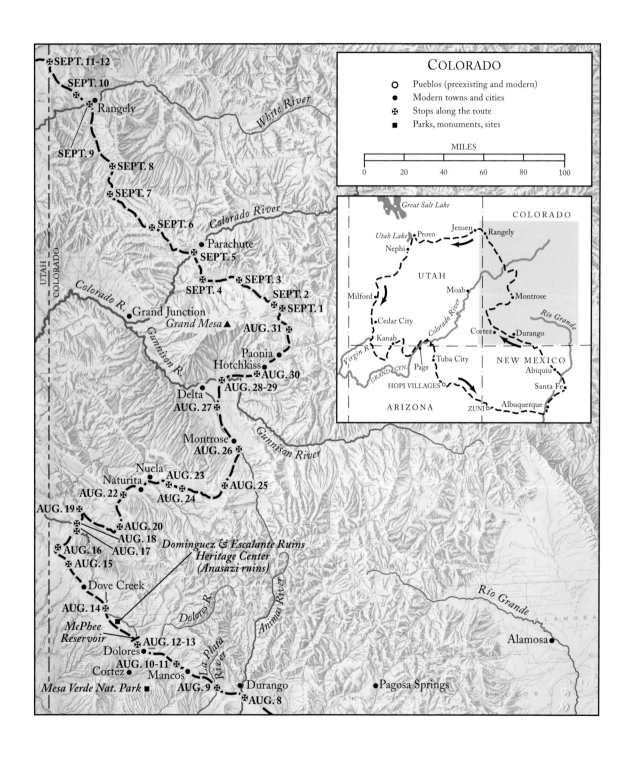

SEPT. 11-12

SEPT. 10

Rangely

SEPT. 9

SEPT. 8

SEPT. 7

SEPT. 6

White River

Colorado River

Parachute

SEPT. 5

SEPT. 4

SEPT. 3

SEPT. 2

SEPT. 1

Colorado R.

Grand Junction

Grand Mesa ▲

AUG. 31

Gunnison R.

Paonia

Hotchkiss

AUG. 30

AUG. 28-29

Delta

AUG. 27

Montrose

AUG. 26

Gunnison River

Nucla

AUG. 23

Naturita

AUG. 25

AUG. 22

AUG. 24

AUG. 19

AUG. 20

AUG. 18

AUG. 16

AUG. 17

AUG. 15

Dominguez & Escalante Ruins
Heritage Center
(Anasazi ruins)

Dove Creek

AUG. 14

McPhee
Reservoir

Dolores

AUG. 12-13

Cortez

AUG. 10-11

Mancos

Dolores R.

La Plata River

Animas River

Durango

AUG. 9

Mesa Verde Nat. Park ■

AUG. 8

Rio Grande

Alamosa

Pagosa Springs

COLORADO

○ Pueblos (preexisting and modern)
● Modern towns and cities
✠ Stops along the route
■ Parks, monuments, sites

MILES

0 20 40 60 80 100

Great Salt Lake

COLORADO

Utah Lake • Provo Jensen Rangely

Nephi

UTAH

Moab

Montrose

Milford

Colorado River

Rio Grande

Cedar City

Kanab

Cortez Durango

Virgin R.

Tuba City

NEW MEXICO

Abiquiu

GRAND CYN. Page

Santa Fe

HOPI VILLAGES

ARIZONA

ZUNI ○ Albuquerque

UTAH | COLORADO

COLORADO: AUGUST 8–SEPTEMBER 13

*A*QUICK GLANCE at the map reveals that the route followed through Colorado—with its countless turns, moving ever north, sometimes eastward, and occasionally back south—resembles that of a lost expedition. This essentially was the situation. For unexplained reasons, the guides who had accompanied them from Santa Fe—and who had been on the 1775 expedition with Rivera—became temporarily lost as early as the fourth day of travel and completely lost just north of present-day Durango while attempting to follow Rivera's route. Obtaining native guides soon became essential, something that was not easily achieved since, unlike the stationary Pueblo Indians of New Mexico, the Ute were a nomadic people, scattered in the valleys and foothills of the Rocky Mountains and living in small groups.

Colorado was entered by following the San Juan River valley westward, with the diary noting increasing possibilities for farming and settlement along the ever-widening valleys of this major river. The San Juan River today enters the massive Navajo Reservoir, created by the Navajo Dam,

at Arboles. Several ruins of ancient Pueblo cultures are located in this area but went unnoticed by the expedition, including Mesa Verde. Illnesses began to strike—first Miera and, shortly after, Domínguez—the main cause being the oftentimes questionable drinking-water sources of side streams, rivers, and muddy springs. These illnesses would cause delays or necessitate canceling the day's departure altogether. Leaving the San Juan they headed over a straight path just south of Ignacio, now the center of the Southern Ute Nation, along the way crossing the Los Pinos and Florida rivers until reaching present-day Durango and the generous Animas River. They passed over what today is rich farm and ranch land created in part by the water in the nearby Navajo Reservoir and the relatively more ample summer rainfall and water table beneath.

Leaving the Animas River, the route climbed northward into the foothills of the San Juan Mountains passing through what is now Hesperus, Mancos, Dolores, Dove Creek, and Egnar, eventually joining the Dolores River ("river of sorrows"), aptly named as it begins with an invit-

ing and easily traveled valley and increasingly enters canyons that are so deep, with such vertical walls that exit is impossible. In places it resembles the Grand Canyon in Arizona. The expedition left and reentered this river three times as it became impossible to follow the valley. They needed it for water, which was very scarce on the arid plateau above. At one point on the plateau the thirst-crazed animals abandoned the party at night and got lost heading back in the direction of home looking for water.

Miera also disappeared for an extended period of time, looking on his own for a final passage off the plateau and back down to the river, which he did find.

The Dolores begins near Telluride and drains north-ward until joining the Colorado River. It is by no means a straight and direct route as it turns and twists through canyons. Once back on the river the guides were lost and spent days wandering in false detours searching for a way out of the river and eastward. Today, Disappointment Valley marks a portion of the route. Scrambling through Gypsum Valley and over the pass, they reached the San Miguel River near present-day Nucla and Naturita. This was Ute country and one member was encountered and persuaded to guide them over the timber-thick Uncompahgre Plateau into the valley and fertile land of what is now Montrose County.

Continuing northward along the Uncompahgre River until it joins the Gunnison at present-day Delta, they then turned east, passing through Austin, Hotchkiss, and Paonia, based on information that there was a summer encampment of the Sabuagana Utes, visitors from the Timpanogatzis Nation who lived to the west by a large lake, now known as Utah Lake. These Indians were not nomadic but lived in settled communities, presenting an opportunity to Christianize sedentary Indians and create a possible future settlement and Spanish resupply station on the way to Monterey. Thus another northerly detour—

the expedition was already two hundred miles north of the latitude of Santa Fe, which is the same as Monterey. At today's Bowie, they ascended the Grand Mesa to the encampment and in fact obtained two guides who would lead them to the "fish eaters" at the lake. A native guide was clearly necessary since from here the route went into and over a confusing series of mountain valleys and passes which were so illogical that they suspected that the route was a trick by the guide to lead them into an ambush.

Heading even farther north, the Colorado River was encountered and crossed near Parachute. This river was first seen in 1540 by García López de Cárdenas of the Vásquez de Coronado expedition on its mission to conquer Cíbola and its nonexistent Seven Cities of Gold. However, this occurred much farther downstream, and to Domínguez and Escalante it was not clear that it was even the same river. Continuing north along Roan Creek Canyon, the route joined Douglas Creek and went through Douglas Canyon, finally joining the White River at Rangely. Passing through these future oil and gas fields, the route continued over hilly, ever arid country and exited Colorado near present-day Dinosaur, the eastern entrance to Dinosaur National Monument, three hundred miles north of the latitude of Monterey.

(August 8)

We set out from the Río de los Pinos…and having traveled four leagues we arrived at the Río Florido…It rises in the same sierra but farther west. It flows in the same direction, from north to south, and where we crossed it there is a large meadow of good land for crops with facilities for irrigation. The pastures in the meadow were good…Having crossed the Río Florido we traveled west two leagues and west-northwest somewhat over two leagues more. We then descended a

stony but not very long slope and arrived at *Río de las Animas* near the western point of the *Sierra de la Plata*, in which it rises. Crossing it, we camped on the opposite bank. This river is as large as the *Río del Norte* [*Río Grande*], carries somewhat more water at this point, and is more rapid because here the current has a greater fall.

(August 9)

We left the *Río de las Animas*, climbed the west bank of the river which, although it is not very high, is quite difficult because it is very stony and in places very rugged. We went through the small forest at the top, which must extend a little more than a quarter of a league. Then we entered a valley with abundant pasturage…turned west by northwest, and after going three leagues through a leafy forest and good pastures, we arrived at the *Río de San Joaquín*, otherwise called *Río de la Plata*… It rises in the same west end of the *Sierra de la Plata* and flows through the canyon in which they say there are veins and outcroppings of metal. But, although years ago several persons came from New Mexico to examine them by order of the Governor, who then was Don Tomás Vélez Cachupín, and carried away ore, it was not learned with certainty what metal it was. The opinion formed previously by some persons from the accounts of various Indians and of some citizens of this kingdom that they were silver mines, caused the mountain to be called *Sierra de la Plata*…The climate here is excessively cold even in the months of July and August…We did not go forward today because, since the animals did not eat well last

night they were somewhat weak when they arrived, and also because a heavy and prolonged shower forced us to halt.

(August 10)

Father Fray Francisco Atanasio awoke troubled by a rheumatic fever which he had felt in his face and head since the day before, and it was desirable that we make camp here until he should be better, but the continuous rains, the inclemency of the weather, and the great dampness of the place forced us to leave it…we turned to the northwest, went on a league and then swung west through valleys of very beautiful timber and abundant pasturage, roses, and various other flowers…we were again caught in a very heavy rain, Father Fray Francisco Atanasio became worse and the road impassable, and so, having traveled with great difficulty two more leagues to the west, we had to camp on the bank of the first of the two little rivers…otherwise called *Río de los Mancos*. The pasturage continues in great abundance.

(August 11)

Notwithstanding the severe cold and the dampness from which we suffered, we were not able to move our camp because Father Fray Francisco Atanasio awoke very weak from the trouble mentioned and with some fever. For this reason we were not able to go to see the veins and metallic stones of the sierra, although they were nearby, as we were assured by a companion who had seen them on another occasion.

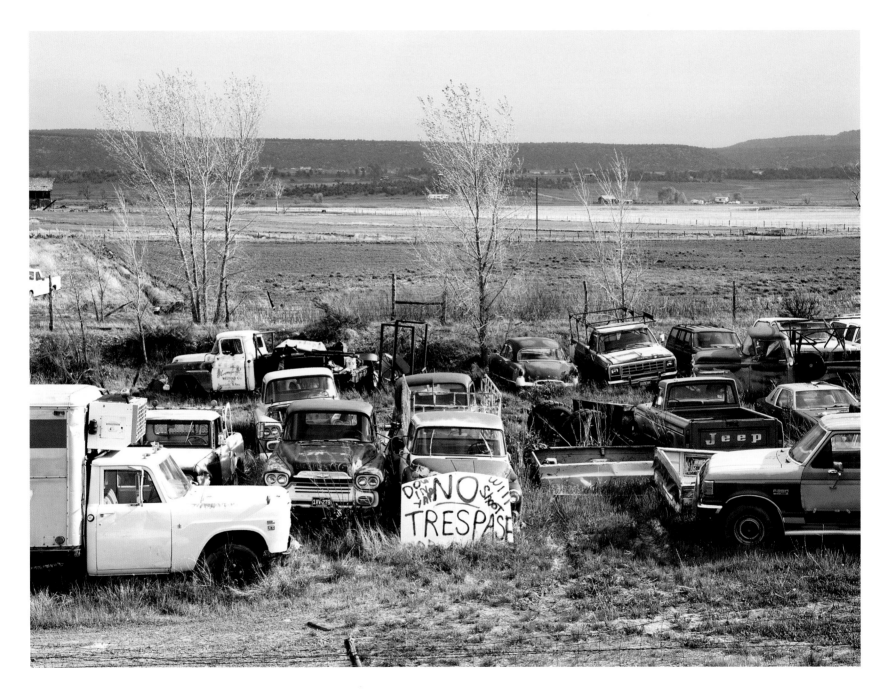

(Aug. 7) Junkyard near Los Pinos River and Ignacio, Montezuma County, CO.

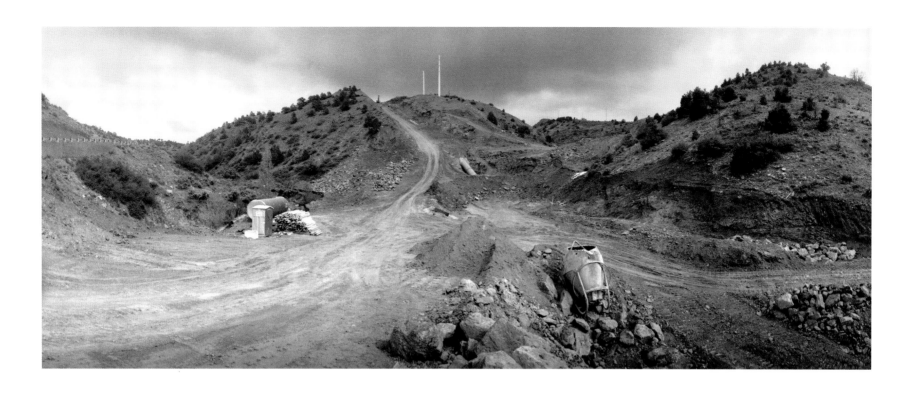

(Aug 8) Trail route and construction road to Ridges Basin, site of future commercial water reservoir by Ute Nation, Durango, CO.

(Aug. 8) Kayakers at sewer-plant rapids near crossing site of Animas River, Durango, CO.

(Aug. 10) Summit Reservoir and Mesa Verde cliffs,
Domínguez and Escalante Memorial Highway, Montezuma County, CO.

Anasazi Ruins and McPhee Reservoir

The Dolores River enters canyon country at the town of Dolores and remains locked in with few exits until joining the Colorado River. Downstream from this view is the McPhee Dam named after a logging settlement built in 1926 and abandoned after it was destroyed by fire in 1948.

The ruins seen here are at the Anasazi Heritage Center, which is located above the section of river where the expedition reported seeing ruins. Excavation was begun in 1976 and after completion two ruins were named for the friars. It is not known whether these are the same ones seen by the expedition from the river below, but they are credited with the first written report of Pueblo settlements in Colorado. Recovered from the Domínguez site, which is closer to the river, were 6,910 turquoise, jet, and shell beads; a shell-and-turquoise frog pendant and mosaics; two fine ceramic vessels; and six bone scrapers. It was believed to have been built around AD 1120, a period of flourishing Pueblo cultures in the Four Corners area. The stone architecture and building style suggest that it was related to the Chaco culture centered in New Mexico. The site is managed by the Department of the Interior, BLM Office.

(August 13)

We remained in camp, partly so that the Father might improve a little and be able to go forward, and partly to observe the latitude of this site and meadow of the Rio de los Dolores where we were…On an elevation on the south bank of the river in ancient times there was a small settlement of the same form as those of the Indians of New Mexico, as is shown by the ruins which we purposely examined. Father Fray Francisco Atanasio felt better, and we decided to continue our journey next day.

(August 14)

…This afternoon we were overtaken by a coyote and a genízaro of Abiquiú, the first named Felipe and the second Juan Domingo. In order to wander among the heathen, they had fled from that pueblo without the permission of their superiors, protesting that they wished to accompany us. We did not need them, but to prevent the mischief which either through ignorance or malice they might commit by traveling alone any longer among the Yutas if we tried to send them back, we accepted them as companions. —Today eight and a quarter leagues.

(August 16)

More than half of our animals were missing for, since they had not had any water, they strayed away looking for it, and found it near the road in the middle of yesterday's march. Finally they appeared, arriving when it was already late, and for this reason we did not leave Agua Tapada until half past ten in the morning… We entered a canyon which at first was wide and in which we found a much-used trail. We followed it, and having traveled another fourth of a league to the north, we found a water hole which to us appeared to be sufficient for both men and animals; and because it was on the east side of the trail and hidden in a dense grove of piñon and juniper, we called it Agua Escondida…Two wells were made so the animals might drink, and all did so, although not with very great satisfaction. While we reconnoitered the terrain on both sides in order to continue this afternoon, Don Bernardo Miera went on alone through this canyon without our seeing him. Because of the impossibility of continuing the journey we stopped and sent another companion to tell him to return before he got lost. But he got so far ahead that they did not return until after midnight to the place where the rest of us were waiting, greatly worried on account of their tardiness.

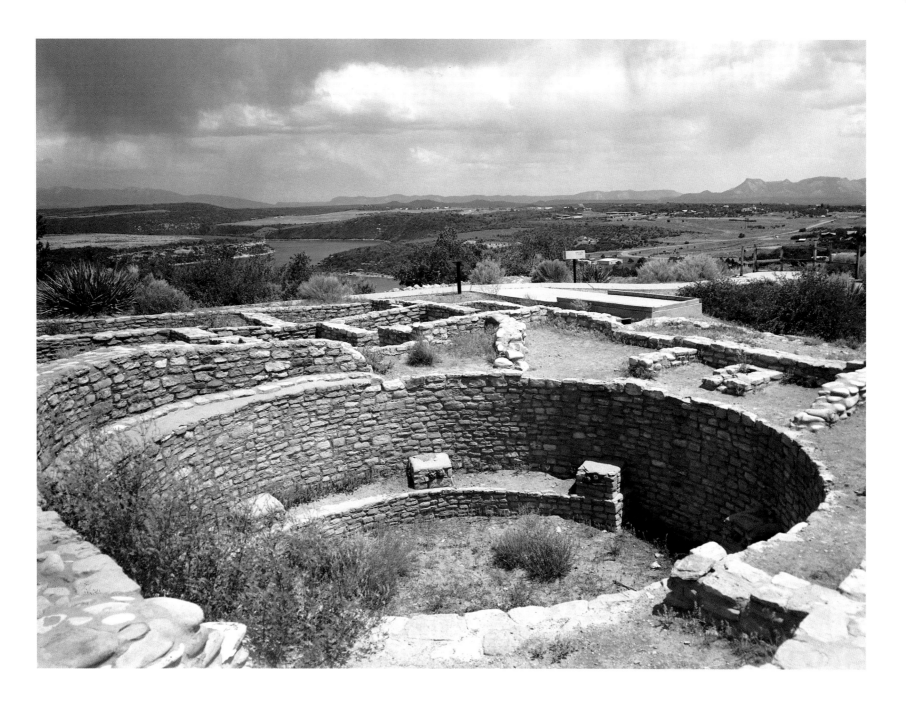

(Aug. 13) Escalante Ruins and Dolores River, looking south from Anasazi Heritage Center, CO.

(Aug. 14) Narraguinnep Reservoir diversion canal from McPhee Reservoir,
Highway 491 at Roundup Junction, Montezuma County, CO.

(Aug. 15) Highway 491 near Dove Creek, CO.

DOLORES RIVER AND DOLORES CANYON

The Dolores River has its source in the San Juan Mountains near present-day Telluride and drains northward through ever-deeper canyons, eventually reaching and joining the Colorado River. Lured into following the Dolores River for its abundant source of water, and leaving and rejoining it three times, the deepening canyons eventually became impossible to exit. The guides, who had supposedly seen this river eleven years earlier on the Rivera expedition, were understandably lost.

(August 17)

We set out from Agua Escondida, and about half past three in the afternoon came for a third time to the Río de los Dolores…Because of the varied and agreeable appearance of the rocks on either side which, being so high and rugged at the turns, make it appear that the farther one goes the more difficult it is to get out, and because Don Bernardo Miera was the first one who traveled it, we called this canyon Laberinto de Miera… On reaching the river we saw very recent tracks of Yutas. For this reason we thought one of their rancherías must be nearby, and that if they had seen us and we did not seek them they might fear some harm from us and be alarmed. Moreover, since we hoped that some one of them might guide us or give us information, enabling us to continue our journey with less difficulty and labor than we were now suffering because none of the companions knew the water holes and the terrain ahead, we decided to seek them…Following the tracks upstream about three leagues, they learned that the Indians were Yutas Tabehuaches, but they were not

able to find them…They say this Río de las Paralíticas is so called because the first of our people who saw it found in a ranchería on its bank three Yuta women suffering from paralysis.

(August 18)

Very early in the morning two companions went to find a way by which we could leave the bed of the river, which here has high and very stony mesas on both sides…But it was impossible to learn where we might proceed except by the bed of the river in which, on account of the many stones and because it was necessary to cross it many times, we feared the animals would bruise their feet…we traveled downstream a league to the north and camped, in order that the companions might go to explore farther than they had gone this morning. About eight o'clock at night they returned saying that only by the bed of the river would we be able to emerge from this impassable network of mesas and that only with difficulty. Therefore we decided to continue by the bed of the river.

After escaping from the Dolores River Canyon and making an overland trek, the expedition then joined the San Miguel River near Nucla and Naturita, which they followed upstream to Cottonwood Creek. At Cottonwood Creek they encountered an Indian who would serve as their guide over the densely forested Uncompahgre Plateau to present-day Montrose. The distance traveled from Santa Fe was now about four hundred miles.

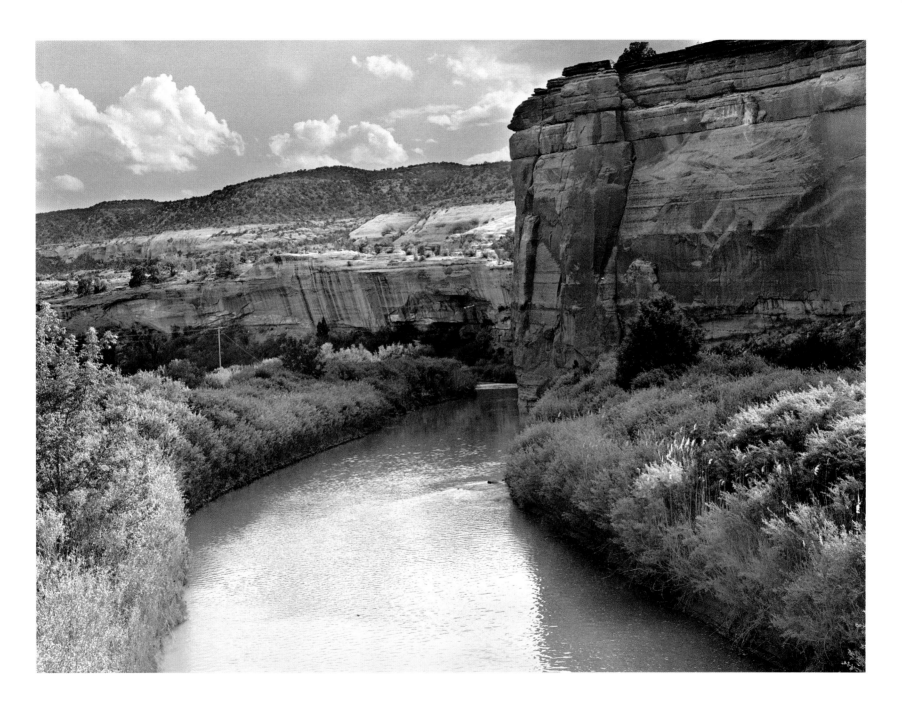

(Aug. 17) Third entry site on the Dolores River, near Slick Rock, San Miguel County, CO.

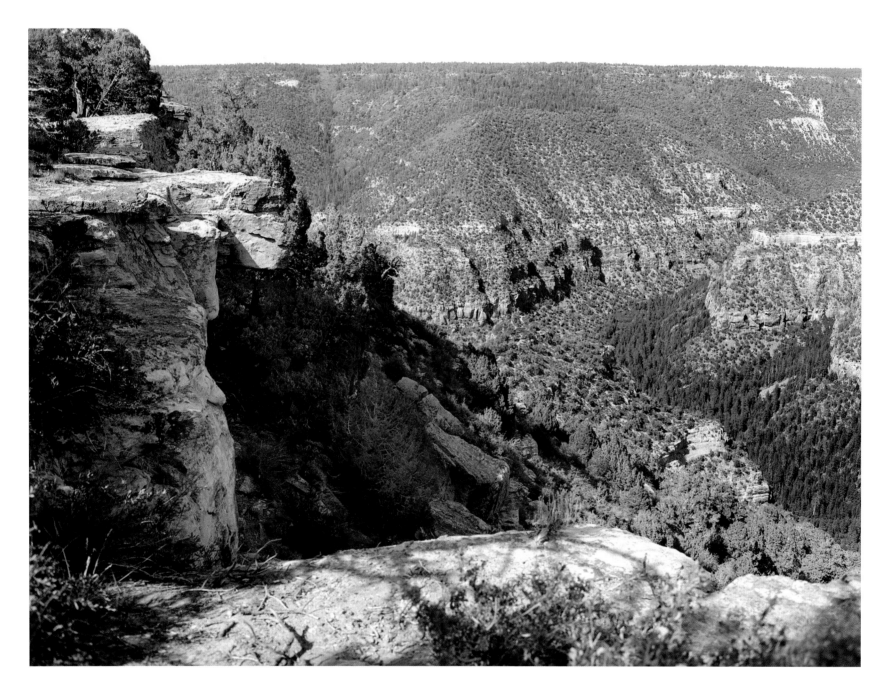

(Aug. 17) Dolores River Canyon overlook, San Juan National Forest, CO.

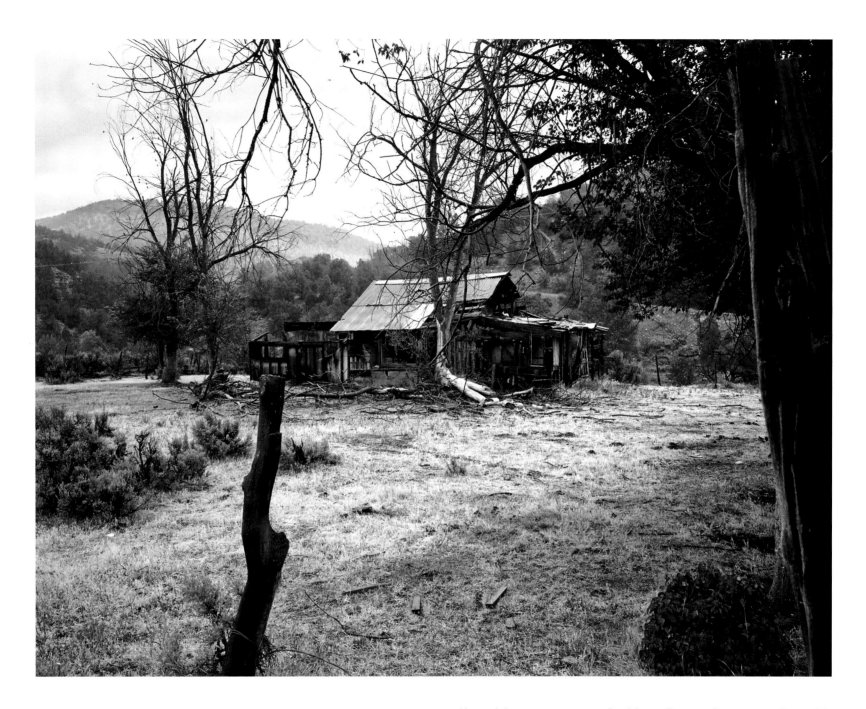

(Aug. 24) Abandoned house on San Miguel River at Cottonwood Creek, CO.

(August 23)

... We were overtaken by a Yuta Tabehuache, who is the first Indian we have seen in all the distance traveled to here since the first day's march from the pueblo of Abiquiú... We gave the Indian something to eat and to smoke, and afterward through an interpreter we asked him various questions concerning the land ahead, the rivers, and their courses. We likewise asked him the whereabouts of the Tabehuaches, Muhuaches, and Sabuaganas. At first he appeared ignorant of everything, even of the country in which he lived, but after he had recovered somewhat from the fear and suspicion with which he talked to us, he said the Sabuaganas were all in their own country, and that we would soon encounter them: that the Tabehuaches were wandering dispersed through this sierra and its vicinity... We asked him if he would guide us to the ranchería of a Sabuagana chief said by our interpreter and others to be very friendly toward the Spaniards and to know a great deal about the country. He consented on condition that we should wait for him until the afternoon of the next day. We agreed to this, partly so that he might guide us, and partly that he might not suspect us of anything which might disturb him and the rest.

(August 24)

Before twelve o'clock the Yuta reached the place where we were awaiting him, accompanied by his family, two other women and five children, two at the breast and three from eight to ten years old, all good looking and very agreeable. They thought we had come to trade, and therefore they had brought tanned deerskins and other articles for barter. Among other things, they brought dried berries of the black manzanita... We informed them, although they were not fully convinced, that we did not come for the reason they thought, and that we did not bring goods to trade. In order that they might not regard us as explorers whose purpose was to conquer their land after seeing it, nor impede our progress, and, thinking that from the Cosninas a report of the journey of the Reverend Father Fray Francisco Garcés might have spread to the Yutas Payuchis and from these to the rest, we told them that a Padre, our brother, had come to Cosnina and Moqui and from the latter place had returned to Cosnina. Thereupon they were entirely quieted, sympathized with us in our trouble, and said they had not heard anything about the Padre. We gave food to all of them, and the wife of our guide presented us with a little dried venison and two plates of dried manzanita berries, which we paid for with flour. After midday we gave the Yuta what he requested for guiding us: that is to say, two hunting knives and sixteen strings of white glass beads. He gave these to his wife who with the others went to their ranchos.

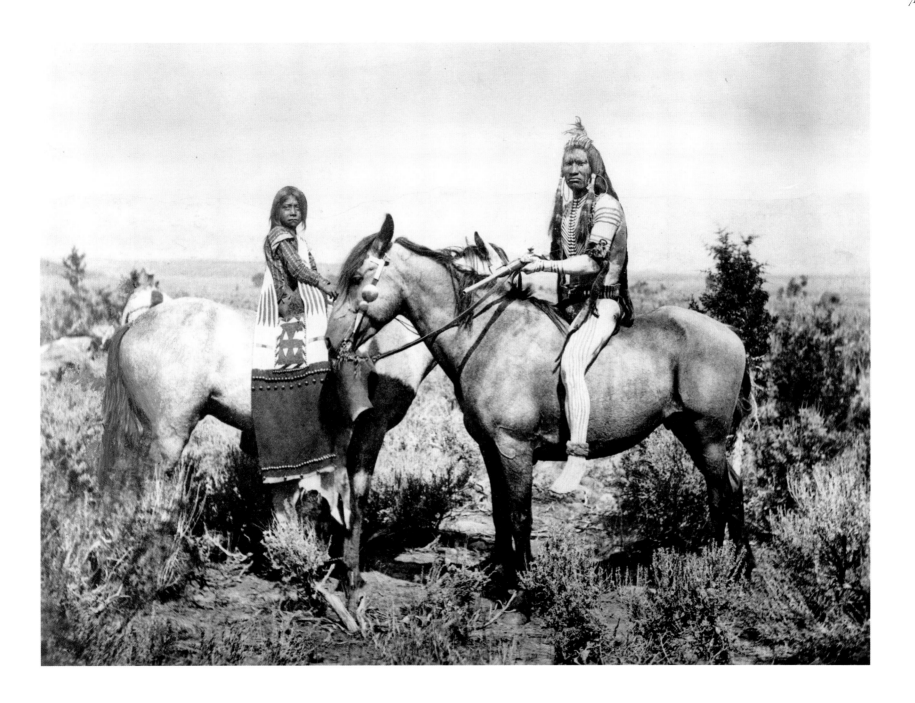

UTE WARRIOR AND HIS BRIDE, 1873. PHOTO BY J. K. HILLERS, COURTESY NATIONAL ANTHROPOLOGICAL ARCHIVES, SMITHSONIAN INSTITUTION (1535).

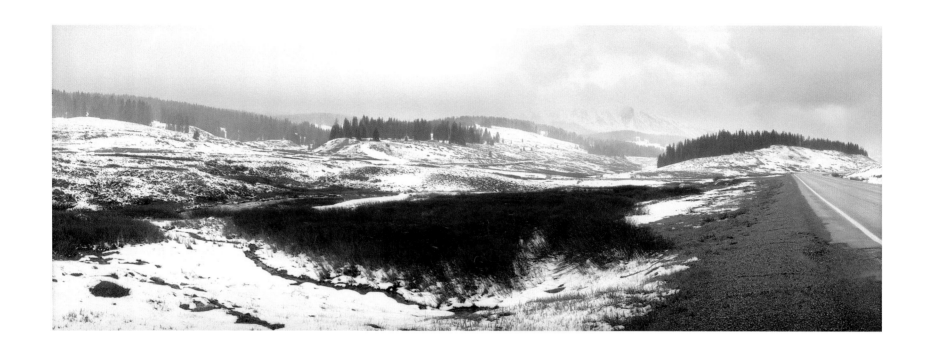

(Aug. 25) Crossing the Uncompahgre Plateau in late spring, Route 62, Ouray County, CO.

(Aug. 26) Reconstructed Tabehuachi Ute tepee and campsite location, Ute Indian Museum, Montrose, CO.

(Aug. 26) On trail, cattle feedlot, Montrose, CO.

(Aug. 29) Campsite location on Gunnison River where five Ute Indians shouted from low cliffs, Austin, CO.

(August 29)

About ten o'clock in the morning we saw five Yutas Sabuaganas on a hill on the other side shouting loudly. We thought they were those whom the guides had gone to seek, but as soon as they reached us we saw they were not the ones we had sent for. We gave them something to eat and to smoke, but after a long conversation, whose subject was the disputes which they had this summer with the Cumanches Yamparicas, we were unable to get out of them a single thing useful to us, because their aim was to frighten us by setting forth the danger of being killed by the Cumanches to which we would expose ourselves if we continued on our way. We refuted the force of the arguments with which they tried to prevent us from going forward, by telling them that our God, who is the God of everybody, would defend us in case of encounters with these enemies.

(August 30)

In the morning the interpreter Andrés and the guide Atanasio arrived with five other Sabuaganas and one Laguna. After we had served them with plenty of food and tobacco we informed them of our purpose, which was to go to the pueblo or pueblos of the Lagunas (the Yutas had told us that the Lagunas lived in pueblos like those of New Mexico) telling them that since they were our friends they should give us a good guide to conduct us to those people, and that we would pay him to his satisfaction. They replied that to go to the place we desired to reach, there was no other road than the one that passes through the midst of the Cumanches, who would prevent us from passing or would even kill us, and finally that none of them knew the country between here and the Lagunas. They repeated this many times, insisting that we should turn back from

here. We tried to convince them, first with arguments, then with flattery, in order not to displease them. Then we presented to the Laguna a woolen cloak, a hunting knife, and some white glass beads, telling him we were giving these things to him so he would accompany us and continue as our guide to his country. He agreed and we gave him the present. Seeing this, the Sabuaganas quit raising objections, and now some of them confessed that they knew the road. After all this, they insisted that we should go to their ranchería, saying that the Laguna Indian did not know the way. We knew very well that this was a new excuse to detain us and to enjoy for a longer time the favors we were conferring upon them, for to all who came, and today there were many, we gave food and tobacco. But in order not to give them any occasion to be displeased, and not to lose so good a guide as the one we had obtained, we consented to go.

(August 31)

. . . one of the Yutas Sabuaganas who came with us from Santa Monica today gorged himself so barbarously and with such brutish manners that we thought he would die of over-eating. Finding himself so sick, he said that the Spaniards had done him an injury. This foolish notion caused us great anxiety, because we knew that these barbarians, if by chance they become ill after eating what another person gives them, even though it may be one of their own people, think this person has done them harm, and try to avenge an injury they have never received. But God was pleased that he should be relieved by vomiting some of the great quantity he could not digest. —Today nine leagues.

(Aug. 30) Fabricated skeleton on trail site through Hotchkiss, CO.

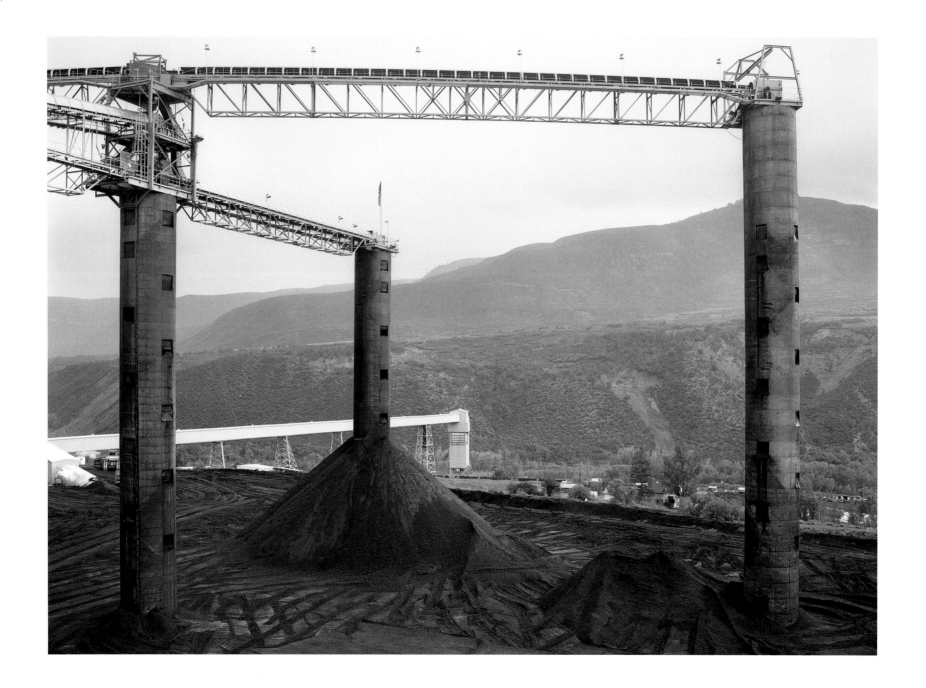

(Aug. 31) Coal mine where Indian gorged on food, Bowie, CO.

September 1–2

THE GRAND MESA

There were several encounters with large bands of Indians along the route, the first being on top of the Grand Mesa located just north of present-day Paonia and uphill from the nearby coal mine located at Bowie along the north fork of the Gunnison River. Records indicate that Spanish explorers in the 1600s had knowledge of this river, but where it was encountered was unclear. For the expedition further progress required a guide. Meeting an Indian along the Gunnison River, whom they named Sylvestre (after Escalante), and whose home was on the shores of Utah Lake, they secured an agreement that this Laguna would guide them to his homeland. First they must ascend the mesa to meet the band of Sabuagana Utes with whom he was visiting, as he only knew the trail home from there. Once on the mesa they met a force of eighty horse-mounted, armed Utes from a camp of thirty tents. The following extensive journal entry depicts a savvy group of natives who refused to allow the Laguna to serve out his agreement, and used guile, cunning, and lies to discourage any further exploration into their lands. In addition the text relates that they knew of the power of the Spanish settlements to the south and didn't want a negative report of their contact to reach the "great captain" (governor) in Santa Fe should the expedition perish. Stubborn determination by the friars eventually freed up Sylvestre as a guide and secured a second Laguna guide, a boy they named Joaquín, to take them across Utah. Young Joaquín became inseparable from Domínguez, even passing by and leaving behind his homeland after reaching the lake. He continued the rest of the trip to Santa Fe, where he was baptized.

(September 1)

We set out from San Ramón toward the north, and having traveled three leagues through small valleys with abundant pasturage and thick groves of dwarf oak, we met about eighty Yutas all on good horses, most of them being from the ranchería to which we were going. They told us they were going to hunt, but we concluded that they traveled together in this way partly to make a show of their large force and partly to find out whether any more Spanish people were following us, or if we came alone. Having known since the previous night that we were going to their ranchería, it was not natural that all of those men would leave it at the same time when they knew that we were coming, unless they were moved by the considerations we have just indicated.

We continued with only the Laguna and descended a very steep slope. We entered a very pretty valley in which there is a small river having all along its banks an extensive grove of very tall and straight royal pines, among them being some cottonwoods which seemed to emulate the straightness and height of the pines.

As soon as we halted Father Fray Francisco Atanasio went to the ranchería with the interpreter, Andrés Muñiz, to see the chief and the rest of those who had remained. He entered the chief's tent, and having greeted him and embraced him and his sons, he begged him to assemble the people who were there. He did so, and when as many of either sex as could come had assembled, he told them of the Gospel through the interpreter. [All listened with pleasure, especially six Lagunas who also assembled] . . . amongst whom our guide and another Laguna were conspicuous. As soon as the Father began to instruct them, the new guide interrupted him, warning the Sabuaganas as well as his

own compatriots "that they must believe whatever the Father told them because it was all true." The other Laguna indicated the pleasure and attention with which he heard the announcement of his eternal salvation in this way. Among the listeners there was a deaf person who, not understanding what was being talked about, asked what it was the Father was saying. Thereupon this Laguna told him, "the Father says that what he is showing us (it was an image of Christ crucified) is the one Lord of all, who lives in the highest part of the heavens, and that in order to please Him and go to see Him, it is necessary to be baptized and to beg His pardon." He illustrated these last words by touching his breast with his hand, an action admirable in him, because he had never before seen either the Father or the interpreter. Seeing the pleasure they manifested at hearing him, the Father proposed to the chief who at this time ruled the ranchería, that if on conferring with his people they should accept Christianity, we would come to instruct them and arrange for them a mode of living to prepare them for baptism. He replied that he would propose it to his people, but during the whole afternoon he did not return to give a report on which to base a well-founded hope of their acceptance of the proposal. The Father, being rejoiced by the expression of the Lagunas, asked what this last one was called (we had already named the guide Silvestre), and learning that they called him Oso Colorado [Red Bear] he instructed all of them, explaining the difference between men and beasts, the purpose for which each was created, and the evil they did by naming themselves after wild beasts, making themselves thereby equal and even inferior to them. Then he told the Laguna that hereafter he should be called Francisco. The others, hearing this, began to repeat this name, although with difficulty, the Laguna being pleased that they should call him by this name. It

happened also that when the Father gave the name of Captain to the one who was ruling the ranchería, this person replied that he was not the chief, and that the real chief was a youth, a good looking fellow who was present. And when the Father asked if the chief was already married, he replied in the affirmative, saying he had two wives. This mortified the youth…and he tried to convince them that he had only one wife, from which it is inferred that these barbarians have information or knowledge of the repugnance we feel for a multiplicity of wives at one time. Thereupon the Father took occasion to instruct them on this point, and to exhort them not to have more than one. After all this, he bought from them a little dried buffalo meat, giving them glass beads for it, and when he asked them if they wished to trade some horses for some lame ones which we had, they answered that they would exchange them in the afternoon. This done, the Father returned to the camp.

A little before sunset the chief, some old men, and many of the others, came to where we were. They began to urge us to turn back from here, setting forth anew and with greater force the difficulties and dangers to which we would expose ourselves if we went forward. They declared that the Cumanches would not permit us to do so, and protested that they were not telling us this to prevent us from going where we desired, but because they esteemed us greatly. We reciprocated these good wishes and told them that the one God whom we adore would arrange everything and would defend us, not only against the Cumanches but also against all others who might wish to injure us, and that being certain that His Majesty was on our side, we had no fears on the score of what they told us. Seeing that their pretexts were of no avail, they said that since we did not pay any attention to the warnings they had given us, and insisted on going forward, we must write to the Great

Captain of the Spaniards, (as they call the Señor Governor) telling him that we had passed through their territory, so that if we had any mishap, and did not return, the Spaniards would not think they had killed us. This was the idea of some of our companions who desired to go back or remain with them. We replied to them that we would write the letter and leave it with them, so that when any of them should go to New Mexico they might carry it. They replied that they could not take it, and that we must send it by some one of our men. We said that none of our men could go back nor remain with them. Finally, since they found no other way of keeping us from going forward without declaring themselves our enemies, they said that if we would not turn back from here they would not trade with us for our lame horses. To this we replied that even though they should not trade we must go forward, because under no circumstances could we turn back without knowing the whereabouts of our brother, the Father who had been among the Moquis and Cosninas and might be wandering about lost. To this they replied, inspired by those of our men who understood their language and were secretly conspiring against us, that the Fathers could not get lost because they had painted on paper all the lands and roads. They again insisted, repeating all the foregoing arguments to get us to turn back from here. Seeing our unshakable determination, they repeated that they were urging us not to go forward because they loved us, but that if we persisted they would not prevent it, and that next morning they would exchange horses. After nightfall they took their leave, not without hope of overcoming our determination next day. According to what we noticed, they were given this hope by Felipe of Abiquiú, the interpreter Andrés, and his brother Lucrecio, they being the ones who, either through fear or because they did not wish to go on, had secretly connived with the Sabuaganas ever since they learned they were opposed to our plan.

By this we were caused much grief, and even more by the following: before we left the town of Santa Fé we had warned the companions that no one who wanted to come with us on this journey could carry any kind of merchandise, and that those who would not agree to this must stay at home. All promised not to carry anything whatever, nor to have any purpose other than the one we had, which was glory to God and the salvation of souls. For this reason they were given whatever they requested for their equipment and to leave for their families. But some of them failed to keep their promise, secretly carrying some goods which we did not discover until we were near the Sabuaganas. Here we charged and entreated everybody not to trade, in order that the heathen might understand that another and higher motive than this had brought us through these lands. We had just told the Sabuaganas that we did not need arms or soldiers, because we depended for our security and defense on the omnipotent arm of God, when Andrés Muñiz, our interpreter, and his brother Lucrecio, showed themselves to be so obedient, loyal and Christian that they traded what they had kept hidden, and with great eagerness solicited arms from the heathen, telling them they were very necessary to them because they were going to pass through the lands of the Cumanches. By this conduct, greatly to our sorrow, they manifested their little or entire lack of faith and their total unfitness for such enterprises.

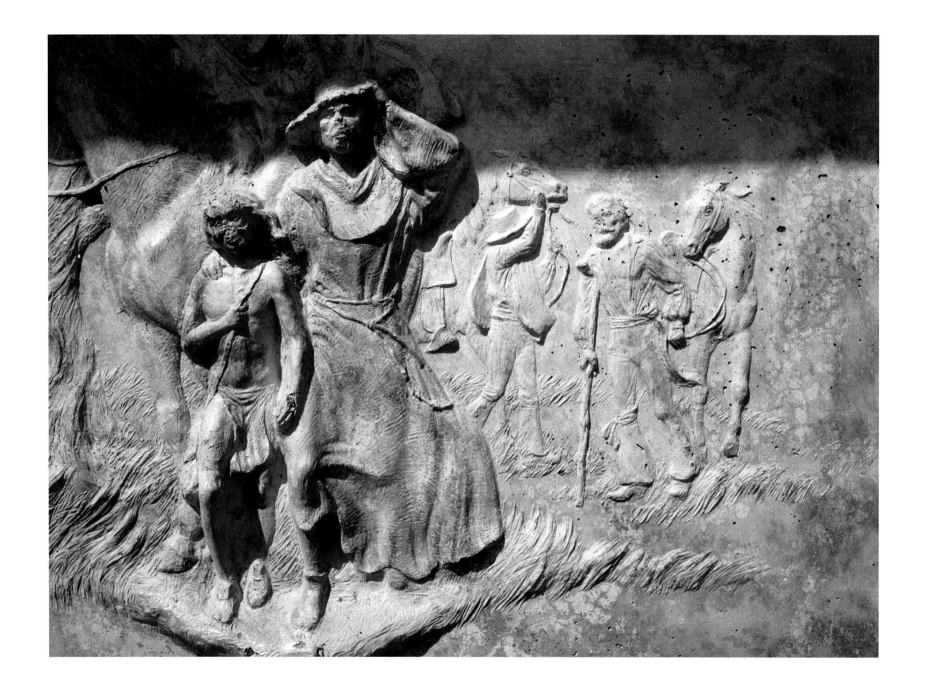

(Sept. 1) Vandalized plaque of Fray Domínguez and Laguna Indian boy,
Joaquin, Domínguez and Escalante Information Center, Strawberry Reservoir, UT.

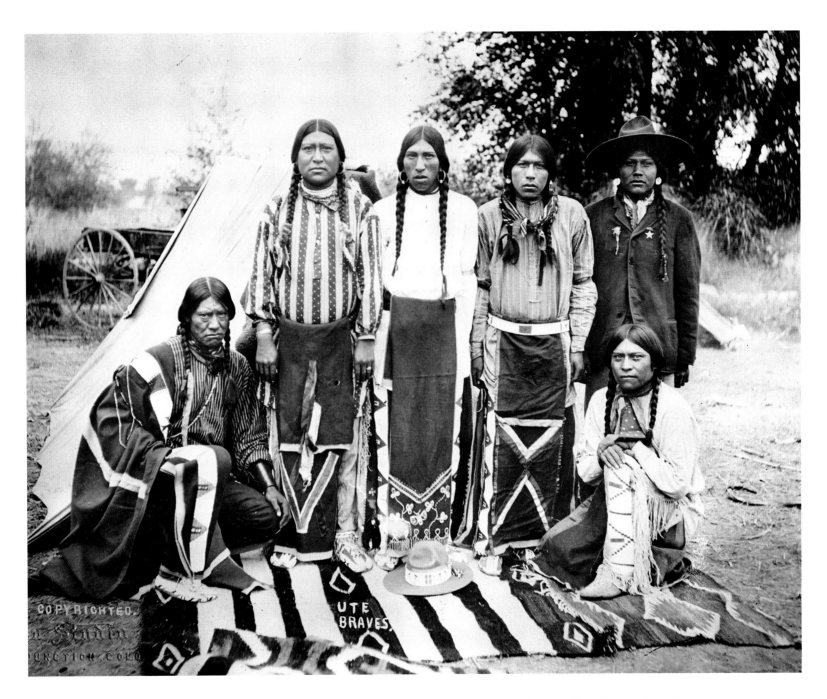

Ute Indians, date unknown. Photo by Dean Studios, Utah State Historical Society.

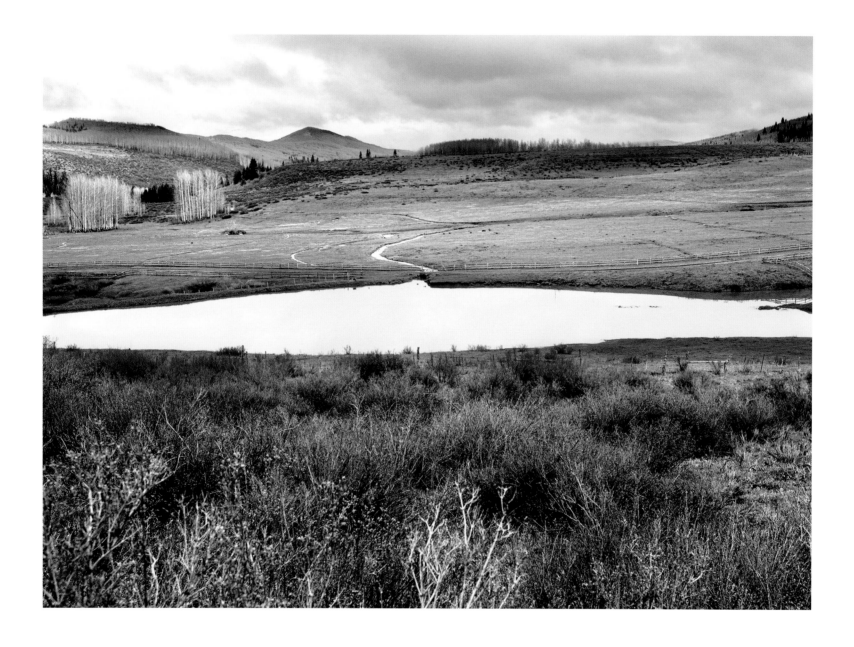

(Sept. 2) Site of encounter with eighty Ute Indians, West Muddy Creek, Grand Mesa, CO.

(SEPT. 2) UTE TEPEE WITH ANIMAL SPIRITS, MONTROSE, CO.

(September 2)

Early in the morning the same Indians, even more of them than yesterday afternoon, assembled at the camp. They again urged the arguments set forth above, adding another serious difficulty, for they dissuaded the Laguna completely from his intention of guiding us, and made him return to us what we had given him to persuade him to accompany us to his land. After having argued more than an hour and a half without inducing the guide to take back what we had given him and to keep his word, or the rest of them to stop opposing us, we told them, with the anger justified in such a situation, that the Laguna had consented voluntarily to accompany us as far as his land. Furthermore, since they had raised such objections, we knew perfectly well that they were taking away our guide and trying to prevent us from going forward. We told them, however, that we would not go back, do what they might, for even without a guide we would go on, but that if the Laguna refused to accompany us they would learn immediately that we no longer considered them our friends. There-upon they yielded and the above-mentioned youth, brother of Chief Yamputzi, talked to the rest, saying that since they had consented to our going forward and the Laguna had promised to guide us, it was useless to impede us any longer, and therefore they should stop talking about the matter. Another, also said to be a chief, followed with the same exhortation. Then all of them told the Laguna that now he could not avoid accompanying us, but he, because of what they had previously told him, now did not wish to do so. But after much urging and coaxing he accepted his pay, although with some ill grace, and agreed to go with us. The rancheria now pulled up stakes and traveled toward the place where Chief Yamputzi had been when we left the disagreeable campsite of San Antonio Mártir. We did not know what direction we ought to take because the guide, regretting the arrangement, did not want to go on or to show us the way. He remained at the site of the rancheria with the horse we had given him pretending to look for a saddle, while we continued by the route taken by the Sabuaganas, although unwillingly because we wanted to get away from them. We told the inter-preter to get the guide immediately and try to encourage him. He did so and all the Yutas having left, the guide now told the interpreter the road we must take and sent him to take us back to the rancheria where he was. Here we found him saying goodbye to his countrymen who were remaining with the Sabuaganas, who charged him to conduct us with care, telling him how he was to proportion the days' marches. Besides the guide Sil-vestre, we found here another Laguna, still a youth, who wished to accompany us. Since we had not previ-ously known of his desire we had not provided him with a horse, and so to avoid any further delay Don Joaquín Laín took him behind him on his horse.

Very gladly we left the trail the villagers were taking, and with the two Lagunas, Silvestre and the boy, whom we named Joaquín, we continued our jouney…Tonight it rained heavily.

September 5–13
From Grand Mesa to the Utah Border
Plates TK–TK

True to his agreement the guide Silvestre led the expedition off the Grand Mesa and the long journey to Utah Lake began with the expedition blindly following. Passing through present-day Vega Reservoir and Vega State Park and next descending into the valley watered by Plateau Creek, they passed through what is now Collbran and

Plateau City. At Molina they ascended a pass and reached the Colorado River on September 5 at Una, just south of Parachute. Journal entries indicate prior knowledge of the river, most likely learned from Rivera's report. The large boulders mentioned are now being removed from the river by a commercial sand and gravel operation.

Continuing north after crossing where Interstate 70 now runs, near De Beque, they entered Roan Creek canyon, an illogical route as judged by some members of the party and thought to be a trap set by Silvestre, who was still under suspicion and who would demonstrate suspect actions later as well. Crossing the pass at the top of Roan Creek they descended to Douglas Creek canyon, where pictographs were noted—these are still visible today. Both Roan Creek and Douglas Creek canyons today have new roads being created to access natural gas and oil reserves. After Rangley, water was only available at obscure hidden springs known by Sylvestre, one of which was named Musket Shot because the two springs were located at that distance apart. Today, just over the Utah State border, there is a turnoff on Highway 40 to Musket Shot Springs.

(September 5)

. . . after crossing a small chamise patch we arrived at a river which our people call San Rafael and which the Yutas call Río Colorado. We crossed it and halted on its north bank in a meadow with good pasturage and a fair-sized grove of cottonwoods. On this side there is a chain of high mesas, whose upper half is of white earth and the lower half evenly streaked with yellow, white, and not very dark colored red earth. This river carries more water than the Río del Norte…The water reached above the shoulder blades of the animals, and some of them which crossed above the ford swam in places. From what we could see the river has many large stones, consequently if it should be necessary for any group of men to cross, it would be very desirable to ford it on good horses. —Today five leagues.

(September 6)

. . . we overtook the others, who having traveled two leagues northwest had stopped. They were disgusted with the guide because, leaving a road which went west upstream and appeared according to reports more direct, he led us by another which, entering a canyon, goes directly north…The companions who knew the Yuta language tried to convince us that the guide Silvestre was leading us by that route either to delay us by winding around so that we could not go on, or to lead us into some ambush by the Sabuaganas who might be awaiting us. In order to make us more distrustful of the guide, they assured us that they had heard many Sabuaganas in the ranchería tell him that he must lead us by a road which did not go to the Lake, and that after he had delayed us for eight or ten days in useless wanderings, he must make us turn back. Although it was not entirely incredible that some of them might have said this, we did not believe that the guide could ever have agreed to it nor even that it had really happened, because up to now none of our companions had told us a thing about it…We well knew that if we went to the north we would have to take a more circuitous route. But when Silvestre said he was leading us by that route because on the other there was a very bad hill, we wished to accept his opinion. But all the companions except Don Joaquín Laín insisted on taking the other road, some because they feared the Cumanches too greatly and without foundation, and some because that route did not conform with their own opinions, which were considerably opposed to ours.

(Sept. 5) Where expedition met and crossed Colorado River, Una, CO.

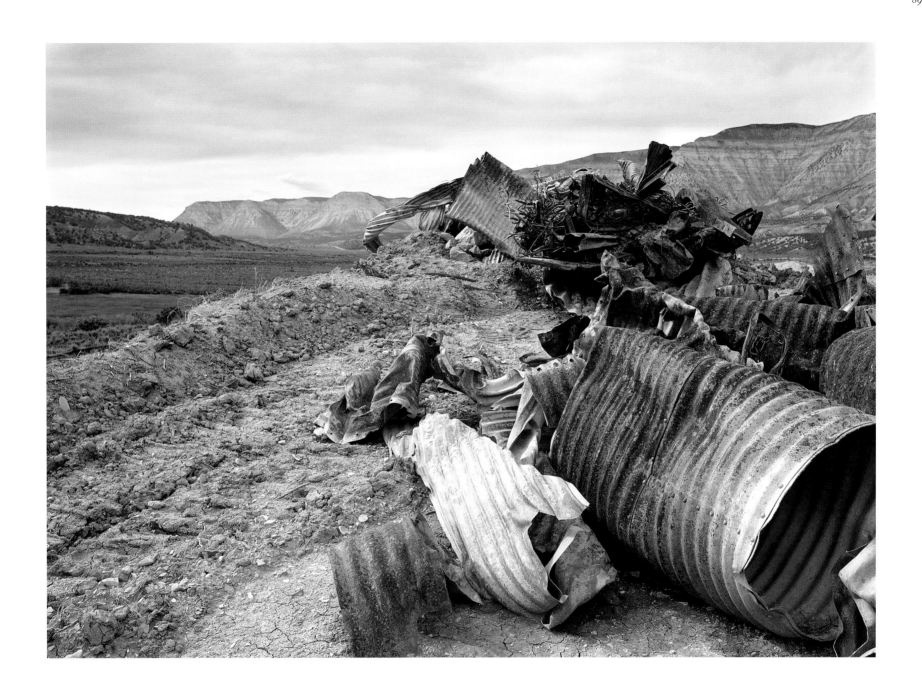

(Sept. 6) Trail site, looking north into Roan Creek Canyon, Garfield County, CO.

(September 9)

We set out from the campsite of Santa Delfina down the same canyon, went half a league northwest, then swung north-northwest. Having traveled in the canyon nine leagues in all in this direction, over a very well beaten trail with only one bad stretch…we emerged from the canyon. Half way down this canyon toward the south there is a very high cliff on which we saw crudely painted three shields or chimales and the blade of a lance. Farther down on the north side we saw another painting which crudely represented two men fighting. For this reason we called this valley Cañon Pintado…On the same side of this canyon near the exit a vein of metal can be seen, but we did not know the kind or quality, although one companion took one of the stones which roll down from the vein, and when he showed it to us Don Bernardo Miera said it was one of those which the miners call tepustete, and that it was an indication of gold ore. On this matter we assert nothing, nor will we assert anything, because we are not experienced in mines… —Today ten leagues.

(September 11)

As soon as it was daylight we set out from El Barranco toward the west-northwest, and having traveled a league and a half through arroyos and ravines, some of them deeper than those of yesterday, we found in one of them a small spring of water from which the animals were unable to drink…In the distance we saw a cottonwood grove and asked Silvestre if the watering place to which he was leading us was there. He said "No," that this was an arroyo, not a river, but that it might have water now. Thereupon we went toward it

and found plenty of running water for ourselves and for the animals, which were now very much fatigued from thirst and hunger, and a pack mule was so worn out that it was necessary to remove the pack which it carried…

A short distance from the ravine we saw a recent buffalo trail. In the plain we saw it again where it was fresher, and observed that it ran in the same direction in which we were going. By now we were short of supplies because we had found it necessary to travel so far and because of what we had distributed among the Sabuaganas and the other Yutas. And so, a little before reaching the arroyo two companions turned aside to follow this trail. A little after midday one of them returned, telling us that he had found the buffalo. We despatched others on the swiftest horses and having chased it more than three leagues they killed it, and at half past seven at night returned with a large supply of meat, much more than comes from a large bull of the common variety. In order to prevent the heat from spoiling it for us, and at the same time to refresh the animals, we did not travel on the 12th, but camped at this place…Tonight it rained for several hours.

(September 13)

… We continued in the same direction for a quarter of a league along a well beaten trail near which, toward the south, rise two large springs of fine water, a musket shot apart, which we named Las Fuentes de Santa Clara and whose moisture produces much good pasturage in the small plain to which they descend and in which they disappear.

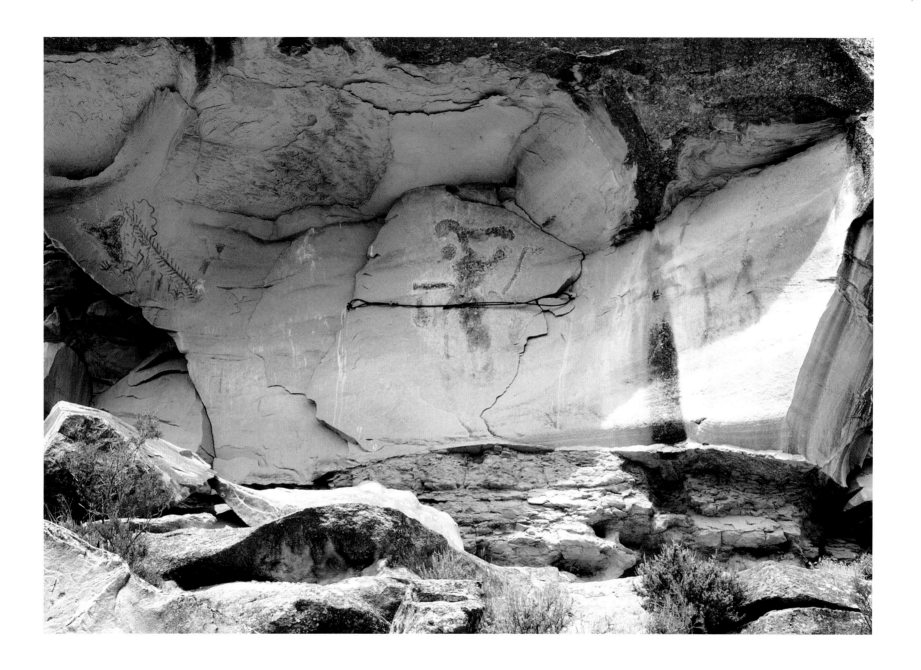

(Sept. 9) Cable-reinforced pictograph in Douglas Creek Canyon, CO.

(Sept. 11) Free-range buffalo, Montrose County, CO.

(Sept. 11) Abandoned storage tanks, Rangely oil fields, Rio Blanco County, CO.

(Sept. ii) Tunnel for electric coal-delivery train and campsite location, Colorado–Utah border.

(SEPT. 12) SCULPTURE AT COLORADO WELCOME CENTER, JUNCTION OF ROUTE 64 AND HIGHWAY 40, DINOSAUR, CO.

Utah: September 13–October 23

Of the four states traveled by the expedition, Utah has acknowledged their passing more than any of the others. Perhaps this is due to the fact that so much time and distance of the route occurred in that state, or that Utah in general has taken a deeper interest in its own history. Utah has honored Escalante by naming a city, river, national monument, canyon, and desert for him. Nothing has been named for Domínguez. Oddly, New Mexico has named nothing for either friar other than an obscure street in Santa Fe named after Escalante.

For the expedition Utah presented the full range of geography: generously wet river-bottom land, a great lake, impenetrable cliffs, marshes, truly long and dry deserts, forested mountains, and finally, sharing with Arizona, the deepest river canyon in North America—along with the challenge of crossing its river.

Of the many major features encountered, the first was the Green River near today's Jensen and Dinosaur National Monument. No mention was made in the diary of its abundant trove of fossil remains (some of which may have been in plain sight). This river, which they named the San Buenaventura ("good fortune"), was the source of several mistaken beliefs as to how far it went west. Maps well into the 1800s show it emptying into the Pacific Ocean. In reality it is a major contributor to the Colorado River farther downstream, which in turn empties into the Gulf of Mexico. They falsely believed that it was reencountered three hundred miles later. Following the Green River south, the guide then took them up the Duchesne River near today's Randlett, which then headed in a straight westerly direction passing just south of present-day Roosevelt and through Myton. At Duchesne, the route essentially follows Highway 40 (old Victory Highway) on an overland trek which crosses several side creeks along the way (camp was made on these creeks) until it reaches what is now the giant Strawberry Reservoir on the east slope of the Wasatch Range.

The guides next lead them over these mountains and down Spanish Fork Canyon into the greatest discovery of the expedition: the huge lake and fertile valley now known

as Utah Lake and the Provo metropolitan area. They were the first Europeans to record seeing it. A large native population lived on the lake's abundant food-producing shores and a precious three days were spent here interacting with these people, attempting to make Christian converts, learning of their customs, and gaining information of lands to the west and, hopefully, Monterey. It was dutifully noted in the diary that this valley had more potential for settlement than Santa Fe.

Leaving the lake, they headed south along deep valleys formed by the San Pitch Mountains, the Pahvant Range, and finally the Hurricane Cliffs as they looked for an opening to the west and Monterey. This route closely follows Interstate 15 passing Payson, Mona, Nephi, and Scipio. By October it was clear that the lateness of the season and lack of provisions would not allow continuing on to Monterey, so a vote was taken in a desert (now called the Escalante Desert) as to whether or not to proceed west or head back to Santa Fe. The latter prevailed. Their guide soon deserted to head back to Utah Lake and home. The trek south passed through present-day Milford, Cedar City, and the entrance to Zion National Park, then Toquerville, La Verkin, and finally Hurricane, where serious shortages of both food and water began. In addition, winter weather was setting in early, with blizzards halting travel. Scattered groups of Indians lived along here so the few encounters were sometimes to conscript a captured native as a reluctant guide, or to trade for meager portions of food. Other encounters just provided verbal descriptions as to how to locate the Colorado River, which they knew they must cross in order to return home.

Leaving Utah and locating and crossing this mighty river canyon without guides was an innovative and heroic achievement. It occurred near present-day Page, Arizona, at a site today known as Padre Bay, now four hundred feet under the waters of Lake Powell.

(September 13)

... This Rio de San Buenaventura is the largest river we have crossed, and is the same one which Fray Alonso de Posada, who in the [past] century was custodian of this Custodia of New Mexico, says in a report, divides the Yuta nation from the Cumanche, according to the data which he gives and according to the distance which he places it from Santa Fé... Its course along here is west-southwest; farther up it runs west to this place. It is joined by San Clemente River, but we do not know whether this is true of the previous streams. Here it has meadows abounding in pasturage and good land for raising crops, with facilities for irrigation. It must be somewhat more than a league wide and its length may reach five leagues. The river enters this meadow between two high cliffs which, after forming a sort of corral, come so close together that one can scarcely see the opening through which the river comes. According to our guide, one can not cross from one side to the other except by the only ford which there is in this vicinity... The ford is stony and in it the water does not reach to the shoulder blades of the horses, whereas in every other place we saw they can not cross without swimming. We halted on its south bank about a mile from the ford, naming the camp La Vega de Santa Cruz. We observed the latitude by the north star and found ourselves in 41° 19' latitude.

(September 14)

We did not travel today, remaining here in order that the animals, which were now somewhat worn out might regain their strength. Before noon the quadrant was set up to repeat the observation by the sun, and we found ourselves no higher than 40° 59' and 24". We concluded that this discrepancy might come from the

declination of the needle here, and to ascertain this we left the quadrant fixed until night for the north stands on the meridian of the needle. As soon as the north or polar star was discovered, the quadrant being in the meridian mentioned, we observed that the needle swung to the northeast. Then we again observed the latitude by the polar star and found ourselves in the same 41° 19' as on the previous night. In this place there are six large black cottonwoods which have grown in pairs attached to one another and they are the nearest to the river. Near them is another one standing alone, on whose trunk, on the side facing northwest, Don Joaquín Laín with an adz cleared a small space in the form of a rectangular window, and with a chisel carved on it the letters and numbers of this inscription— "The Year 1776"—and lower down in different letters "LAIN"—with two crosses at the sides, the larger one above the inscription and the smaller one below it.

Here we succeeded in capturing another buffalo, smaller than the first, although we could use little of the meat because the animal had been overtaken late and very far from the camp. It happened also this morning that the Laguna, Joaquín, as a prank mounted a very fiery horse. While galloping across the meadow, the horse caught his forefeet in a hole and fell, throwing the rider a long distance. We were frightened, thinking that the Laguna had been badly hurt by the fall because when he had recovered from his fright, he wept copious tears. But God was pleased that the only damage was that done to the horse which completely broke its neck, leaving it useless.

(September 16)

. . . we descended to a dry arroyo by a high and very stony ridge, whose slope on the other side is not so bad. As soon as we reached the top we found a trail, one or two days old, of about a dozen horses and some people on foot, and on examining the vicinity, indications were found that on the highest part of the hill they had been lying in ambush or spying for some time without turning their horses loose. We suspected they might be some Sabuaganas who had followed us to steal the horse herd in this place, where it would be likely that we would attribute the deed to the Cumanches rather than to the Yutas, since we were now in the land of the former not the latter. Besides this, it gave us strong grounds for suspecting the guide Silvestre, because the preceding night he casually and without being noticed went off from the camp a short distance to sleep. During the whole journey he had not worn the cloak that we gave him, but today he left the campsite with it, not taking it off during the whole day, and we suspected that he, having come to an understanding with the Sabuaganas, put it on so that he could be recognized in case they attacked us. Our suspicions were increased when he stopped for a time before reaching the peak where we found the tracks, as if thoughtful and confused, wishing first to go along the banks of the river and then to lead us through here. We gave him no indications of our suspicion, dissimulating it entirely, and in the course of our march he gave us emphatic proofs of his innocence…As soon as we halted two companions followed the trail southwest to explore the terrain hereabouts and concluded that the Indians had been Cumanches.

(Sept. 14) Horses at Green River crossing, near Naples, UT.

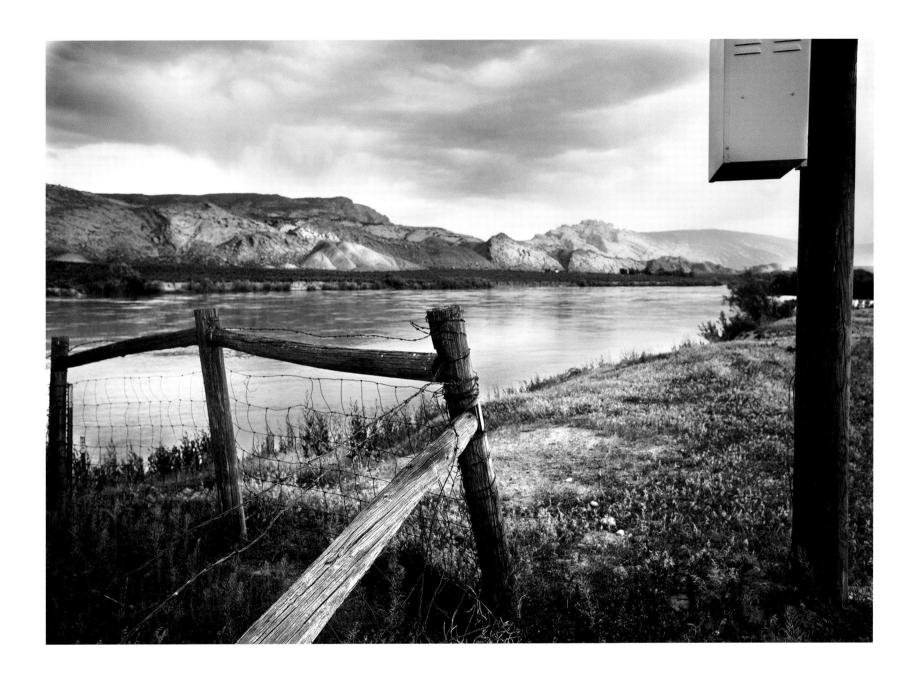

(Sept. 13) Green River crossing site, Dinosaur National Monument, UT.

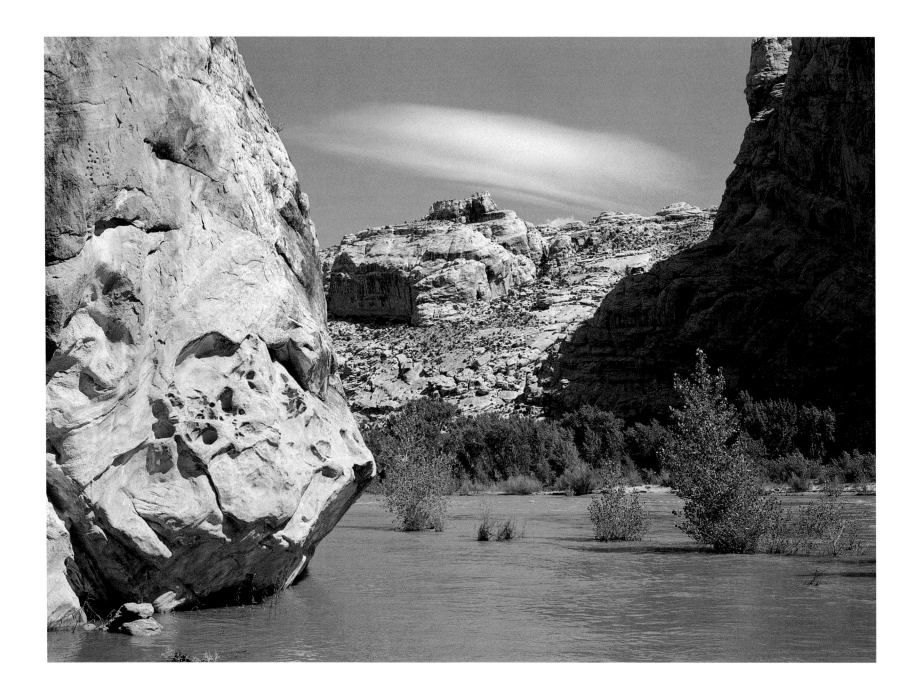

(Sept. 13) Notch through which Green River cuts and exits Yama Plateau, Dinosaur National Monument, UT.

(Sept. 14) Tourist attraction, Green River crossing, near Dinosaur National Monument, UT.

(Sept. 14) Two cottonwood trees at Green River crossing, UT.

(September 20)

We set out from San Eustaquio, leaving for dead one of our strongest horses, the one which had broken his neck at Santa Cruz del Río de San Buenaventura… Tonight it was so cold that even the water which was near the fire all night was frozen in the morning. — Today five leagues.

(September 21)

We set out…the animals sinking and stumbling every instant in the many little holes which were hidden in the grass. Then we descended to a fair-sized river in which there is an abundance of good trout, two of which the Laguna, Joaquín, killed with an arrow and caught, and each one of which would weigh somewhat more than two pounds. This river runs to the southeast through a pretty valley with good pastures, many creeks and pretty groves of white cottonwoods, neither very tall nor large around.

In this valley, which we named Valle de la Purísima, there are all the advantages necessary for a good settlement. The guide Silvestre told us that part of the Lagunas, who used the fish of the river as their customary food, lived in this valley at one time, and that they withdrew for fear of the Cumanches who were beginning their raids into this part of the sierra…The guide, anxious to arrive as quickly as possible, went so fast that at every step he disappeared in the thicket and we were unable to follow him, for besides the great density of the wood, there was no trail, and in many places his track could not be seen, so he was ordered to go slowly and to remain always in our sight. We continued through the grove which became more dense the farther we went, and having traveled half a league west, we emerged from it, arriving at a high ridge from which the guide pointed out to us the direction to the Lake…and descended it to the west, breaking through almost impenetrable thickets of chokecherry and dwarf oak, and then through another grove of cottonwood so dense that we thought the packs would not get through without being unloaded. In this grove the guide again annoyed us by his speed, so that we were forced to keep him back and not let him go ahead alone. In this dense growth Father Fray Atanasio got a hard blow on one of his knees by hitting it against a cottonwood.

(Sept. 16) Fenced Indian statuary, near Myton, UT.

(Sept. 17) Carnival, Highway 40, Uintah and Ouray reservation, near Myton, UT.

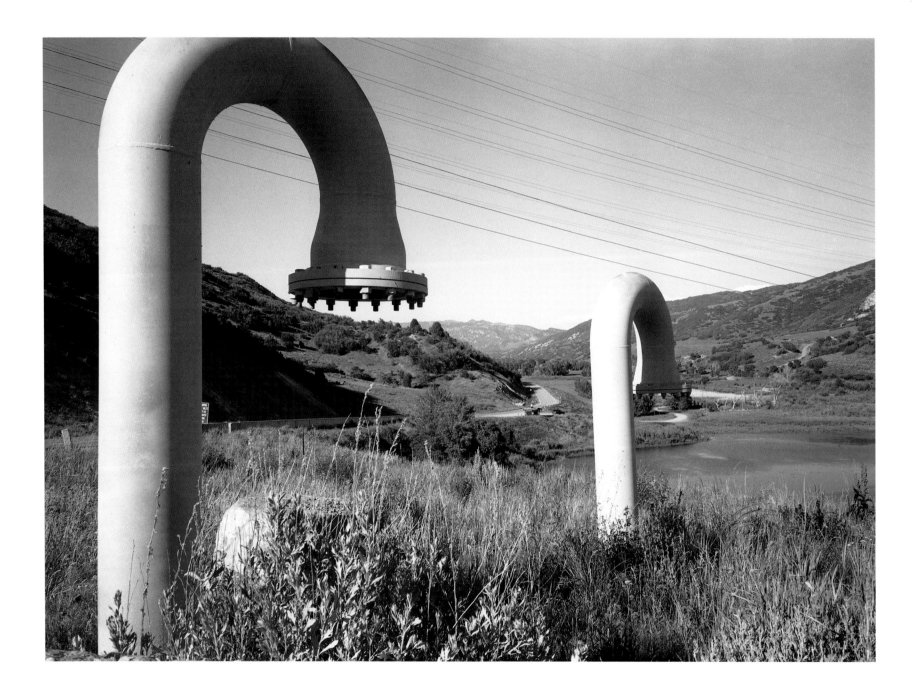

(Sept. 22) Water diversion pipes and trail site in Diamond Fork Canyon, Uinta National Forest, UT.

September 22–30
LAKE TIMPANOGOS AND PROVO VALLEY

When the expedition entered the valley of present-day Provo, they entered a desert paradise unequaled by anything in New Mexico. The lengthy text of that encounter consists of two major parts: first, the exchange with the "fish eaters" as to the expedition's purpose for the visit and testing the natives' interest to become Christians; and second, securing a new guide. It was here they first encountered the bearded Indians, who seem to have thought that the Spanish were visitors from an advanced race who had come to save them from their enemies the Comanche and lead them to a more prosperous life. All that was required was conversion to Christianity, which was eagerly anticipated.

The second part centered on geographical description, which not surprisingly evaluates the potential of this fertile valley for Spanish settlement. Also they were informed of the existence of the Great Salt Lake—it was just to the north but they did not visit it—where seventy years later Brigham Young would lead his great migration and settle in what was still Spanish territory. The Spanish had made exploratory excursions and miners had made illegal inroads to southern Utah in the 1500s and 1600s, and mention of this lake had been made, its location roughly sketched on early maps. But since exploration was forbidden, it was not recorded or described. Nor was its latitude or longitude fixed. Indian mythology portrayed it as the home of the Aztecs before they migrated to Mexico.

(September 22)
... From the top of the last ridge we saw in front of us and not very far away many large columns of smoke arising in the same sierra. The guide Silvestre said they must have been made by his people who were out hunt-

ing. We replied to them with other smoke signals so that if they had already seen us they would not take us to be enemies and thus flee or welcome us with arrows. They replied with larger smoke signals in the pass through which we must travel to the Lake, and this caused us to believe they had already seen us, because this is the most prompt and common signal used in any extraordinary occurrence by all the people of this part of America.

(September 23)
Knowing that we were now arriving at the Lake, in order that the two Indians, Silvestre and Joaquín, might enter their land or settlement feeling happier and more friendly toward us, we again gave each one a vara of woolen cloth and another vara of red ribbon with which they at once set about adorning themselves. The guide Silvestre donned the cloak previously given him, wearing it like a mantle or cape, and the cloth which we now gave him he wore like a wide band around his head, leaving two long ends hanging loose down his back. And so he paraded about on horseback...

We continued northwest half a league, crossed to the other side of the river, climbed a small hill, and beheld the lake and the wide valley of Nuestra Señora de la Merced de los Timpanogotzis, as we shall call it henceforth. We also saw that all around us they were sending up smoke signals one after another thus spreading the news of our coming...

We found that the pasture of the meadows through which we were traveling had been recently burnt, and that others nearby were still burning. From this we inferred that these Indians had thought us to be Cumanches or some other hostile people, and since they had perhaps seen that we had horses, they had attempted to burn the pastures along our way, so that the lack of

grass might force us to leave the plain more quickly. But since the plain is so large and extensive they could not do this in such a short time even though they had started fires in many places. As soon as we camped, therefore, while the rest of our small company remained here, Father Fray Francisco Atanasio set out for the first ranchos with the guide Silvestre, his companion Joaquín and the interpreter, Andrés Muñiz …

Some men came out to meet them with weapons in their hands to defend their homes and their families, but as soon as Silvestre talked to them, the guise of war was changed into the finest and simplest expression of peace and affection. They took them very joyfully to their poor little houses, and after the father [Father Atansio] had embraced each one separately and made known to them that we came in peace and that we loved them as our best friends, he gave them time to talk at length with our guide Silvestre. The latter gave them an account of what he had observed and seen ever since he had joined us and of our purpose in coming, and it was so much in our favor that we could not have wished for a better report. He told them at great length how well we had treated him and of our love for him. Among other things, he told them with great surprise that although the Lagunas had told us that the Cumanches would kill us or steal our horses, we had passed through the regions which they most frequent, and even found their very fresh tracks, but they had not attacked us nor had we even seen them, thus verifying what the fathers had said, namely, that God would deliver us from all our enemies and from these in particular, in such a way that although we might pass through their very territory, they would not detect us nor would we see them. He concluded by saying that only the fathers told the truth, that in their company one could travel through all the land without risk, and that only the Spaniards were good people. They were further con-

firmed in this belief on seeing that the boy Joaquín was on such good terms with us that he paid no attention to his own people. He even refused to leave the father except to care for the horses which they brought. He would scarcely talk to his people or even stay near them, but clung to the father, sleeping at his side during the brief space of time that was left in this night. Such an attitude found in an Indian boy so far from civilization that he had never before seen fathers or Spaniards was an occasion for surprise not only to his own people but to us as well. When they had talked a long time concerning this matter, and many persons had assembled from the nearby ranchos, the father gave all of them something to smoke, and explained to them through the interpreter and Silvestre, who already had some understanding, our reasons for coming. Of these the principal one was to seek the salvation of their souls and to make known to them the only means whereby they could obtain it…Furthermore, if they wished to be Christians he would teach them all this more clearly and at greater length and would sprinkle upon them the water of holy baptism, and that fathers would come to instruct them and Spaniards to live with them, in which case they would be taught likewise to plant crops and raise cattle, and then they would have food and clothing like the Spaniards. For this purpose, if they consented to live as God commands and as the fathers would teach them, everything necessary would be sent by our Captain, who is very grand and rich and whom we call King. For if he saw that they wished to become Christians, he would regard them as his children, and he would care for them just as if they already were his people. Afterwards he [the father] told them that, since we must continue on our way in order to get news of the other padre, our brother [Father Garcés], we needed another of their people to guide us to some other tribe known to them who might furnish us still another guide.

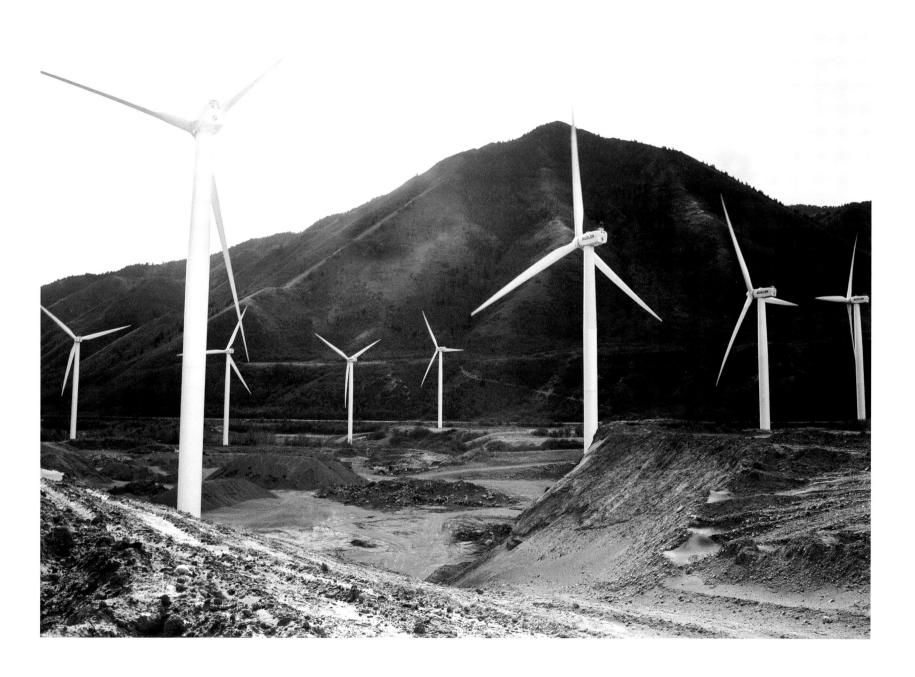

(Sept. 22) Wind turbines and entrance to Utah Lake, Spanish Fork Canyon, UT.

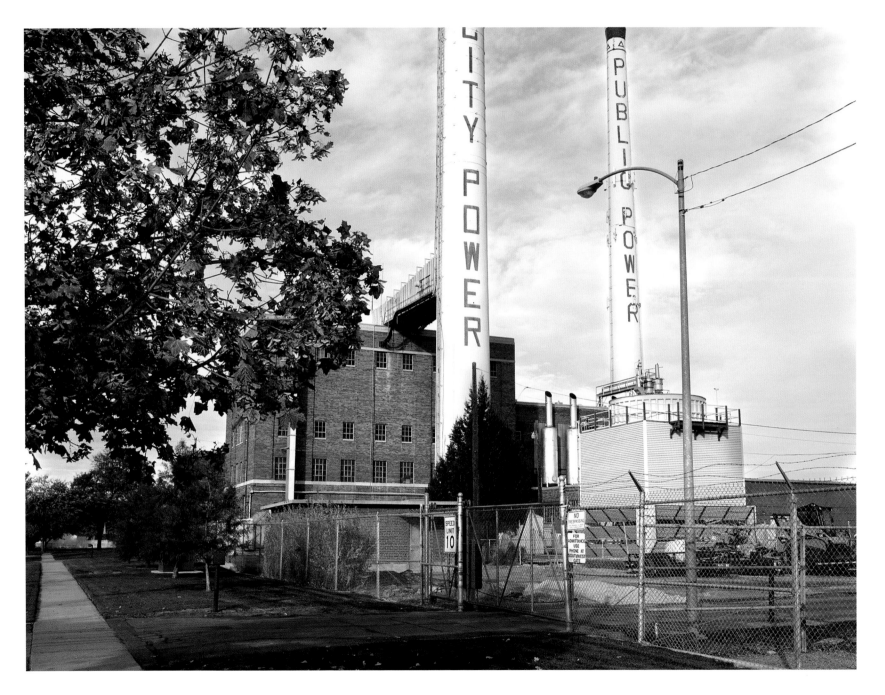

(Sept. 24) Provo City power plant, Provo, UT.

(September 24)

. . . Early in the morning the head-chief came with the two other chiefs, several old men and many other persons. We explained to them at greater length the things already mentioned, and all of them unanimously replied that if the fathers should come, that they [the Indians] would live with the Tatas (as the Yutas call the friars), who would rule and teach them. They offered the Spaniards all their land so they might build their houses wherever they pleased, adding that they would scout through the country and be always on the watch for the inroads of the Cumanches, so that if they tried to enter the valley or the vicinity of the sierra, the Spaniards would be promptly warned and they all could go out together to punish them. Seeing such admirable docility, and having achieved our purpose, we told them that after finishing our journey we would return with more fathers and Spaniards to baptize them and live with them, but that from now forward they must be careful what they said so that later on they might not have to repent. They replied that they were sincere in what they were promising, adding with earnest supplication that we must not delay our return for long. We told them that although our people would believe what we might say about them, they must give us a token showing that they wished to be Christians, et cetera, so we could show it to our Great Captain, and to the rest of the Spaniards, so that by means of it they would be more convinced of their good intentions and be encouraged to come more quickly. We did this the better to sound out their intentions, and they replied that they would very gladly give us the token the next morning.

We then presented the chief, who was a man of good presence, with a hunting knife and strings of beads, and Don Bernardo Miera gave him a hatchet. We gave some white glass beads to the others for which they were happy and grateful, though we could give only a few to each one because the Indians were numerous. Afterward we reminded them of their promise regarding a guide, and we told them that if they were agreed we would take Joaquín who wanted to go on with us. They replied that they had already discussed the matter and had decided that not only Joaquín, but also a new guide should go with us, perhaps as far as our land, and that they should return with us when we came back. They added that none of them knew much about the country in the direction which they knew we had to take, but that with the two, Joaquín and the guide, we should make inquiries of the tribes along our route. This most sincere expression of their sentiments, so clear and satisfactory, filled us with an inexpressible joy and assured us completely that without the least duplicity and with spontaneous and free will, moved by the Divine Grace, they accepted and desired Christianity. We put in front of them the same present which we had given to Silvestre, so that on seeing it the one who was to go with us as guide might make himself known. Immediately one of those present accepted it and became, thereupon, our guide and companion, who from that time we called José María. This being arranged, we decided to continue our journey to the establishments and port of Monterey next day.

They informed us that there was a sick child, in order that we might go to see him and baptize him. We went and, finding that he was rather large and that he was now almost recovered from a long illness, and in no immediate danger, we did not think it desirable to sprinkle upon him the water of baptism. Afterward his mother brought him to where we were, begging us to baptize him, and we consoled her by saying that we should soon return, when everyone, large and small, would be baptized.

Finally, we told them that we now had only a few provisions and would be grateful if they would sell us a little dried fish. They brought it and we purchased a considerable quantity of it. All day and a part of the night they kept coming and conversing with us, and we found them all very simple, docile, peaceful, and affectionate. Our Silvestre was now looked upon with respect, and acquired authority among them for having brought us and being so much noticed by us.

(September 25)

In the morning they again assembled and brought us the requested token, explaining what it contained. As soon as we had asked for it the day before, we warned the interpreter that neither he nor the rest should say anything to the Indians about the matter, in order to see what they of their own accord would produce. When the token was brought, a companion…saw the pictures on it and showing them the cross of the rosary, he explained to them that they should paint it on one of the figures, and immediately they took it back and painted a little cross above each one. They left the rest of it as it was and gave it to us, saying that the figure which on both sides had the most red ochre or, as they called it, the most blood, represented the head-chief, because in the battles with the Cumanches he had received the most wounds. The two other figures which were not so bloody, represented the two chiefs subordinate to the first, and the one which had no blood represented one who was not a war chief but a man of authority among them. These four figures of men were rudely painted with earth and red ochre on a small piece of buckskin. We accepted it, saying that the Great Captain of the Spaniards would be very much pleased to see it, and that when we returned we would bring it with us so that they might see how much we esteemed

their things and in order that the token itself might be a guarantee of their promises and of everything we had discussed. We told them that if, while awaiting us, they should have any difficulty in the way of sickness or enemies they must call upon God, saying, "Oh true God, aid us! Favor us!" But seeing that they were unable to pronounce these words clearly, we told them that they should say only "Jesús María! Jesús María!" They began to repeat this with ease, our Silvestre very fervently leading them, and all the time we were preparing to leave they kept on repeating these holy names. The time for our departure arrived and all of them bade us goodbye with great tenderness. Silvestre especially embraced us vigorously, almost weeping. They again charged us to come back soon, saying they would expect us within a year.

Description of the valley and lake of Nuestra Señora de la Merced de los Timpanogotzis or Timpanocutzis or Come Pescados, all of which names are given to them.

. . . the valley of Nuestra Señora de la Merced de los Timpanocutzis, surrounded by the peaks of the sierra, from which flow four fair-sized rivers which water it, running through the valley to the middle of it where they enter the lake. The plain of the valley must be from southeast to northwest, sixteen Spanish leagues long…and from northeast to southwest, ten or twelve leagues. It is all clear and, with the exception of the marshes on the shores of the lake, the land is of good quality, and suitable for all kinds of crops.

Of the four rivers which water the valley, the first on the south is that of Aguas Calientes, in whose wide meadows there is sufficient irrigable land for two good settlements. The second, which follows three leagues to the north of the first and has more water, could sustain one large settlement or two medium-sized ones with an abundance of good land, all of which can be irrigated. This river, which we named Río de San Nicolás, before

entering the lake divides into two branches, and on its banks besides the cottonwoods there are large sycamores. Three and one-half leagues northwest of this river is the third, the country between them being of level meadows with good land for crops. It carries more water than the two foregoing streams, and has a larger cottonwood grove and meadows of good land, with opportunities for irrigation sufficient for two or even three good settlements…We did not reach the fourth river although we could see its grove of trees. It is northwest of the Río de San Antonio and has in this direction a great deal of level land which is good, judging from what has been seen. They told us that it has as much water as the others, and so some ranchos or pueblos could be established on it. We named it Río de Santa Ana. Besides these rivers, there are many pools of good water in the plain and several springs running down from the sierra.

What we have said regarding settlements is to be understood as giving to each one more lands than are absolutely necessary, for if each pueblo should take only one league of agricultural land, the valley would provide for as many pueblos of Indians as there are in New Mexico. Because, although in the directions indicated above we give the size mentioned, it is an understatement, and on the south and in other directions there are very spacious areas of good land. In all of it there are good and very abundant pastures, and in some places it produces flax and hemp in such quantities that it looks as though they had planted it on purpose. The climate here is good, for after having suffered greatly from the cold since we left the Río de San Buenaventura, in all this valley we felt great heat both night and day.

Besides these most splendid advantages, in the nearby sierras which surround the valley there are plentiful firewood and timber, sheltered places, water and pasturage for raising cattle and horses. This applies to the north,

northeast, east and southeast. Toward the south and southwest close by there are two other extensive valleys, also having abundant pasturage and sufficient water. The lake, which must be six leagues wide and fifteen leagues long, extends as far as one of these valleys. It runs northwest through a narrow passage, and according to what they told us, it communicates with others much larger.

This lake of Timpanogotzis abounds in several kinds of good fish, geese, beaver, and other amphibious animals which we did not have an opportunity to see. Round about it are these Indians, who live on the abundant fish of the lake, for which reason the Yutas Sabuaganas call them Come Pescados [Fish Eaters]. Besides this, they gather in the plain grass seeds from which they make atole, which they supplement by hunting hares, rabbits and fowl of which there is great abundance here. There are also buffalo not very far to the north-northwest, but fear of the Cumanches prevents them [the Come Pescados] from hunting them. Their habitations are chozas or little huts of willow, of which they also make nice baskets and other necessary utensils. In the matter of dress they are very poor. The most decent clothing they wear is a buckskin jacket and long leggings made of the same material. For cold weather they have blankets made of the skins of hares and rabbits. They speak the Yuta language but with notable differences in the accent and in some of the words. They have good features and most of them have heavy beards. In all parts of this sierra to the southeast, southwest and west live a large number of people of the same tribe, language, and docility as these Lagunas, with whom a very populous and extensive province could be formed . . .

The other lake with which this one communicates, according to what they told us, covers many leagues, and its waters are noxious and extremely salty, for the

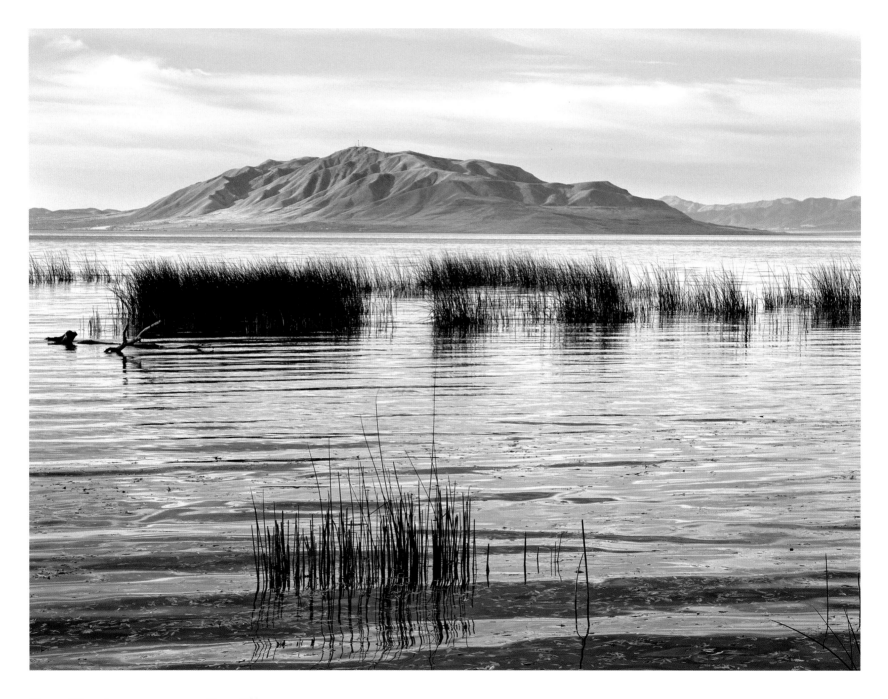

(Sept. 25) Utah Lake, looking south, Provo, UT.

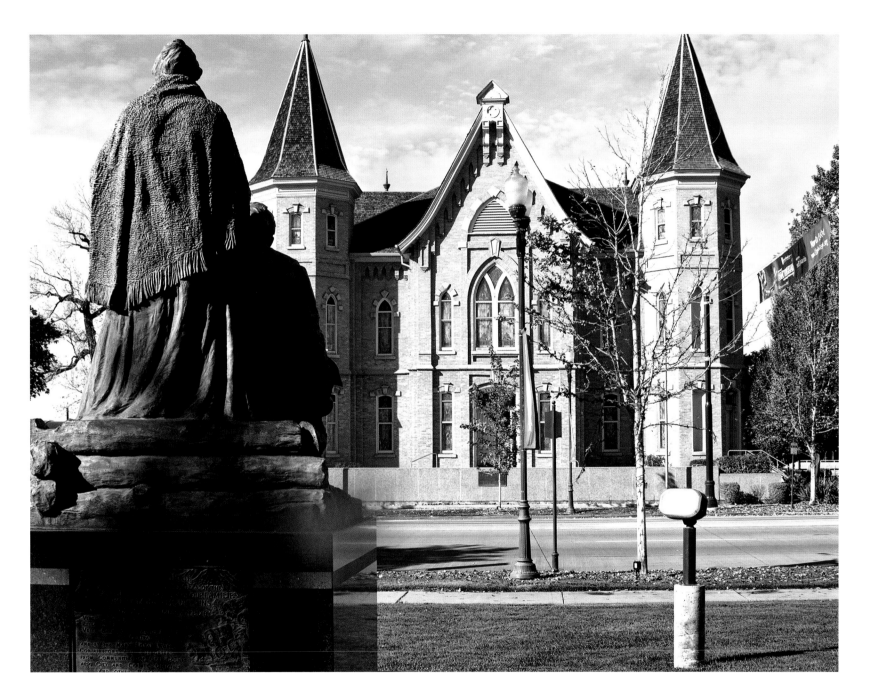

(Sept. 25) Church of Jesus Christ of Latter-day Saints Tabernacle, 100 South University Avenue, Provo, UT.

Timpanois assure us that a person who moistens any part of his body with the water of the lake immediately feels much itching in the part that is wet. Round about it, they told us, live a numerous and peaceful nation called Puaguampe, which in our ordinary speech means "Witch Doctors" and who speak the Cumanche language. Their food consists of herbs. They drink from several fountains or springs of good water which are around the lake, and they have houses of grass and earth (the earth being used for the roofs). They are not enemies of the Lagunas, according to what they intimated, but since a certain occasion when [the Puaguampes] approached and killed one of their men they do not consider them as neutral as formerly.

(September 27)

…we continued south…and entered another large valley. Because the salt flats from which the Timpanois get their salt are very close to this valley toward the east, we called it the Valle de las Salinas…It must be about fourteen leagues long from north to south and five wide from east to west. It is all of level land with abundant water and pasturage, although only one small river flows through it. In it there are large numbers of fowl of the kind which we have already mentioned in this diary. We traveled four more leagues south along the plain of the valley and camped at a large spring of good water which we called Ojo de San Pablo.

As soon as we halted, José María and Joaquín brought five Indians from the nearby ranchos. We gave them something to eat and to smoke, and told them the same things that we had told the others at the lake in-so-far as was appropriate to the circumstances. We found them as docile and affable as the others. Manifesting great joy on hearing that more fathers and Spaniards were coming to

live with them, they remained with us until nearly midnight. —Today six and one-half leagues to the south.

(September 28)

We set out from the Ojo de San Pablo toward the south, and having traveled four leagues we arrived at a small river which comes down from the same eastern part of the sierra in which the salt flats are, according to what they told us. We stopped here a short time in the shade of the cottonwoods on the bank to get some relief from the great heat, and we had scarcely sat down when, from among some thick clumps of willows, eight Indians very fearfully approached us, most of them naked except for a piece of buckskin around their loins. We spoke to them and they spoke to us, but without either of us understanding the other, because the two Lagunas and the interpreter had gone ahead. By signs we gave them to understand that we were peaceful and friendly people. We continued toward the south…

(September 29)

We left San Bernardino, going south-southwest, and immediately met six Indians. We talked with them a long while and preached to them through the interpreter and the Lagunas, and they listened with great docility. Having traveled two and one-half leagues, we swung to the southwest, now leaving Las Salinas which continues on to the south. Here we met an old Indian of venerable appearance. He was alone in a little hut, and his beard was so thick and long that he looked like one of the hermits of Europe. He told us about a river nearby and about some of the country which we still had to traverse. We traveled southwest half a league, swung west-northwest through some little valleys and dry hills, and having traveled a league and a half we arrived at the river not discovering it until we were on its very bank…

A short time after we halted, four Indians arrived at the other bank. We had them cross over to where we were, treated them with courtesy, and they remained with us all the afternoon, telling us about the country which they knew and of the watering place to which we must go the next day.

This river, according to the name which these Indians give it, appears to be the San Buenaventura, but we doubt whether this is the case, because here it carries much less water than where we crossed it in 41° 19'.

What is now called the Sevier River was met and it is where camp was made on September 29. There was discussion as to whether or not this was the same river they had encountered in eastern Utah (the Green River) and if it crossed the entire state. The San Buena Ventura mentioned here later shows up on maps as leading to California. In fact, today the Sevier River ends in a landlocked, sometimes dry lake in the Great Basin area on the Utah-Nevada border. Bearded Indians were met again in this area, and the diary puzzles over whether these are the lost Spaniards.

(September 30)

Very early twenty Indians arrived at the camp together with those who were here yesterday afternoon, wrapped in blankets made of the skins of rabbits and hares. They remained conversing with us, very happily, until nine in the morning, as docile and affable as the preceding ones. These people here have much heavier beards than the Lagunas. They have holes through the cartilage of their noses and they wear as an ornament a little polished bone of deer, fowl or some other animal thrust through the hole. In features they look more like Spaniards than like the other Indians hitherto known in America…They speak the same language as the Timpanogotzis. At this river and place of Santa Ysabel this tribe of bearded Indians begins. It is they, perhaps, who gave rise to the report of the Spaniards that they live on the other side of the Río del Tizón [Colorado]…

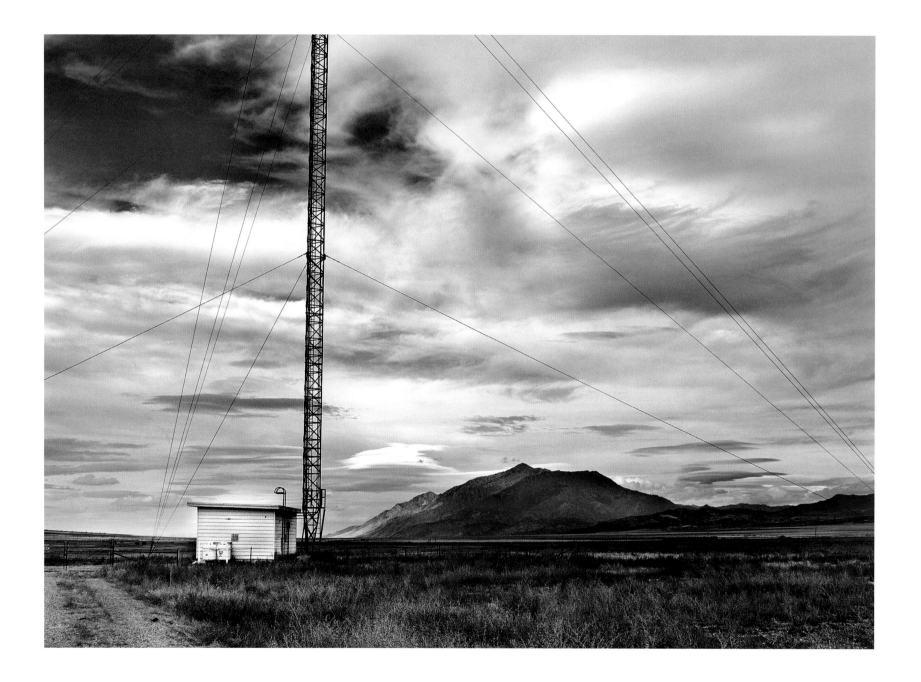

(Sept. 29) Site of meeting Indian in tiny hut, near Levan, UT.

(SEPT. 29) SEVIER RIVER ENCOUNTER SITE WITH THIRTY BEARDED INDIANS, NEAR MILLS, UT.

October 2–7

ESCALANTE DESERT AND PAHVANT BUTTE

Leaving the Sevier River, an overland route leads downhill into the valley and the Escalante Desert. It begins with a hilly terrain of sand dunes and then changes to alkali flat plains which the expedition followed south one hundred miles. Located in its northern end is a lake and marsh that proved difficult to negotiate around. Today it is known as Clear Lake Bird Refuge, just south of Delta. While camped here at the base of Pahvant Butte, the expedition met more bearded Indians. Soon, the guide from Utah Lake, José Maria, would desert.

(October 2)

Morning dawned without our hearing from the five men who had gone with the horses in search of water. One of the two who had remained with the herd came at six o'clock but was unable to tell us anything about the herd, his companion or any of the rest because these two had fallen asleep. Meanwhile the horse herd, driven by thirst, strayed away, and the men waking at various times, each took a different route to hunt for the animals. Immediately Don Juan Pedro Cisneros set out on the trail riding bareback and overtook the herd seven leagues back, that is, midway in the preceding day's march, returning with it only a little before noon. Shortly afterward the men who had gone seeking water arrived, accompanied by some Indians whose ranchos they accidentally reached on the bank of the Río de Santa Ysabel. These were some of the people with long beards and pierced noses who, in their language, are called Tirangapui. The five who first came with their chief had such long beards that they looked like Capuchín or Bethlemite fathers. The chief was an attractive man of mature years but not aged.

They remained very happily talking with us and in a short time they became very fond of us. The chief learned that one of our companions was still missing, and immediately he ordered his four Indians to go as quickly as possible to look for him in the plain and bring him to where we were, each one going in a different direction. This was an action worthy of the greatest gratitude and admiration in people so wild that they had never before seen persons like us. While the chief was giving these orders, he saw that the absentee was already coming and very gladly he told us the news. We preached the Gospel to them as well as the interpreter could explain it, telling them of the Unity of God, the punishment which He has in store for the bad and the reward ready for the good, the necessity of holy baptism, and of the knowledge and observance of the divine law. While this was going on, three of their men were seen coming toward us, and then the chief told us that these also were his people, and that we must suspend the conversation until they arrived in order that they also might hear everything that we were saying for their benefit. When they arrived he told them that we were padres and that we were instructing them in what they ought to do in order to go to Heaven and so they must pay attention. He said this so forcefully that although we understood only a word of Yuta now and then, we gathered what he was telling them before the interpreter had translated it for us, solely by the gestures with which he was expressing himself. We told them that if they wished to obtain the proposed benefit we would return with more fathers so that all might be instructed, like the Lagunas, who already were awaiting religious teachers, but that then they must live together in a pueblo and not scattered as they do now.

They all replied very joyfully that we must return with other fathers, that they would do whatever we might teach and command them, the chief adding that

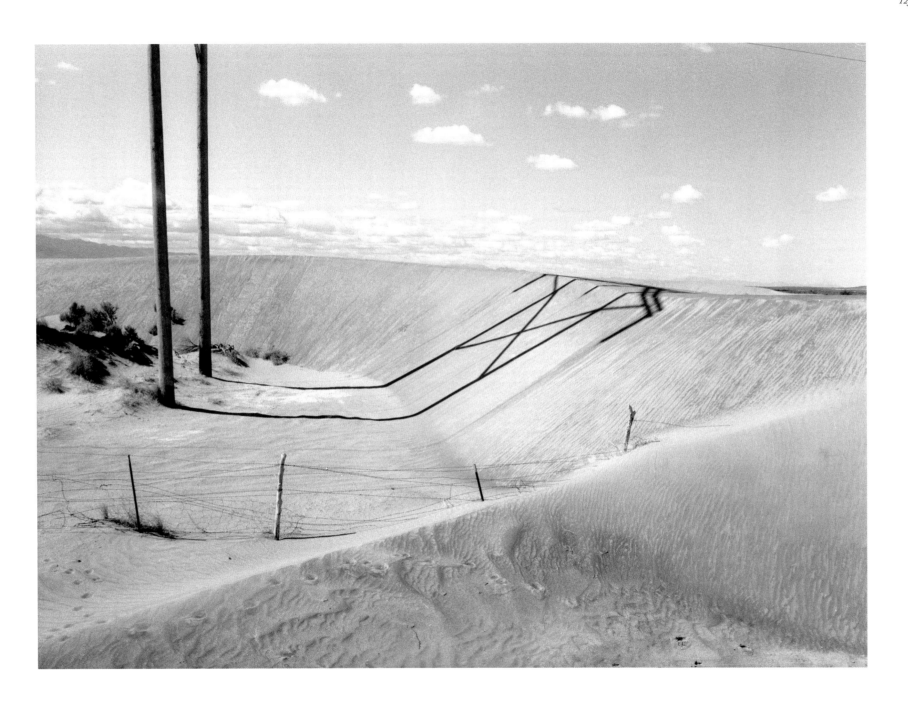

(Oct. 2) Sand dunes, approaching Pahvant Butte, Millard County, UT.

(Oct. 2) Bullet-damaged sign and Pahvant Butte, Escalante Desert, Millard County, UT.

if then we wished and thought it better, they would go to live with the Lagunas (which we had already proposed to him). We said goodbye to them and all, especially the chief, took our hands with great fondness and affection. But the time when they most emphatically expressed themselves was when we were leaving this place. They scarcely saw us depart when all of them, imitating their chief, who set the example, broke out weeping copious tears, so that even after we were a long distance away we still heard the tender laments of these miserable little lambs of Christ who had strayed only for lack of The Light. They so moved us that some of our companions could not restrain their tears…

In the afternoon we continued on our way toward the south-southeast because the marshes and lakes would not permit us to go south, which was the direct route to the pass through which we were to leave the plain. Having traveled three leagues we camped near a small hill which is in the plain, giving the name of El Cerrillo to the campsite, where there were marshes with much pasturage but salty water.

(October 3)

Leaving El Cerrillo we made many turns, because we were surrounded by marshes, so we decided to cut through from the east, crossing the river which abounds in fish and apparently disappears in the marshes and in the other lakes of the plain. The ford was miry, and in it the horse which the interpreter Andrés was riding fell and threw him into the water, giving him a hard blow on the cheek. Having crossed with some difficulty and traveled six leagues south by west over good level land, we arrived at an arroyo which appeared to have much water, but we found only some pools in which it was difficult for the animals to drink. Nevertheless, because

there was good pasturage, we camped here. All along the arroyo there was a sort of white, dry and narrow bank which from a distance looked like stretched canvas, for which reason we named it Arroyo del Tejedor. —Today six leagues south by west.

(October 4)

… After we had left the salty plain we found in this arroyo more and better water than that of yesterday, and beautiful meadows, very abundantly supplied with good pasturage for the animals, which were now badly fatigued because the salty water had done them much harm, and so we camped here, naming the campsite Las Vegas del Puerto.

(October 5)

… This morning before we set out from Las Vegas del Puerto, the Laguna, José María, left us and went back without saying goodbye. We saw him leave the camp but we did not wish to say anything to him nor to have anyone follow him and bring him back, preferring to leave him in complete liberty. We did not know what moved him to make this decision but, according to what the interpreter told us afterward, he was now somewhat disconsolate on seeing that we were going so far from his country. But doubtless the decision was hastened by an unexpected event of the preceding night. This was that when Don Juan Pedro Cisneros sent for his servant, Simón Lucero, in order that with him and the rest they might say the rosary of the Virgin, Lucero objected to coming. Don Juan reprimanded him for his laziness and lack of devotion, whereupon the servant attacked him, and they struggled with each other. From where we were saying the matins of the following day we heard the hullabaloo, and we went over at once, but

(Oct. 3) Marshes near Pahvant Butte, Clear Lake Bird Refuge, Millard County, UT.

(Oct. 5) Dead cattle and Pot Mountain, Escalante Desert, UT.

(Oct. 6) VIEW OF ESCALANTE DESERT, LOOKING EAST, UT.

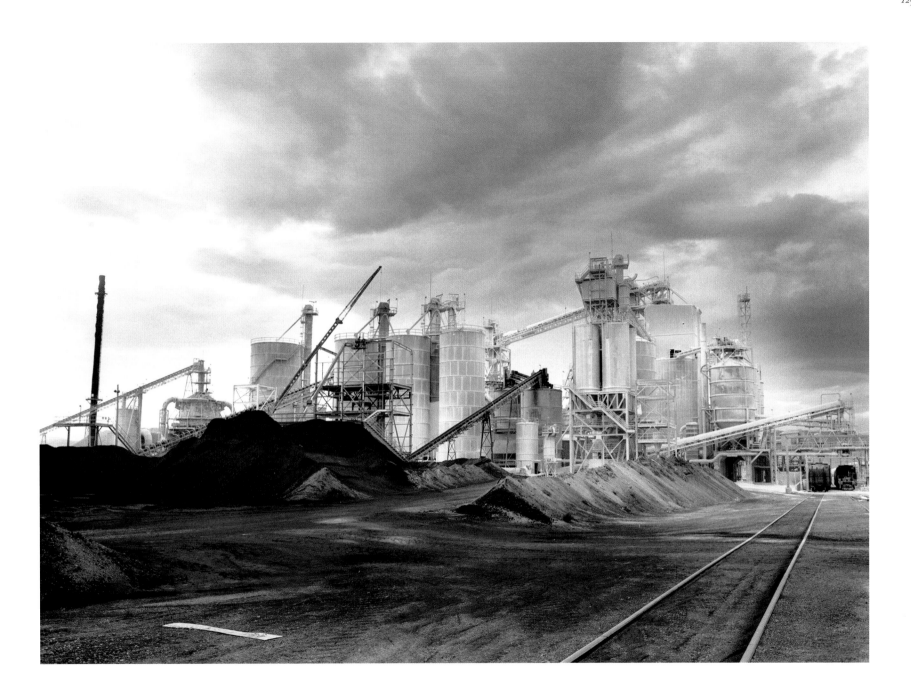

(Oct. 6) Continental Lime plant, Escalante Desert, State Road 257, UT.

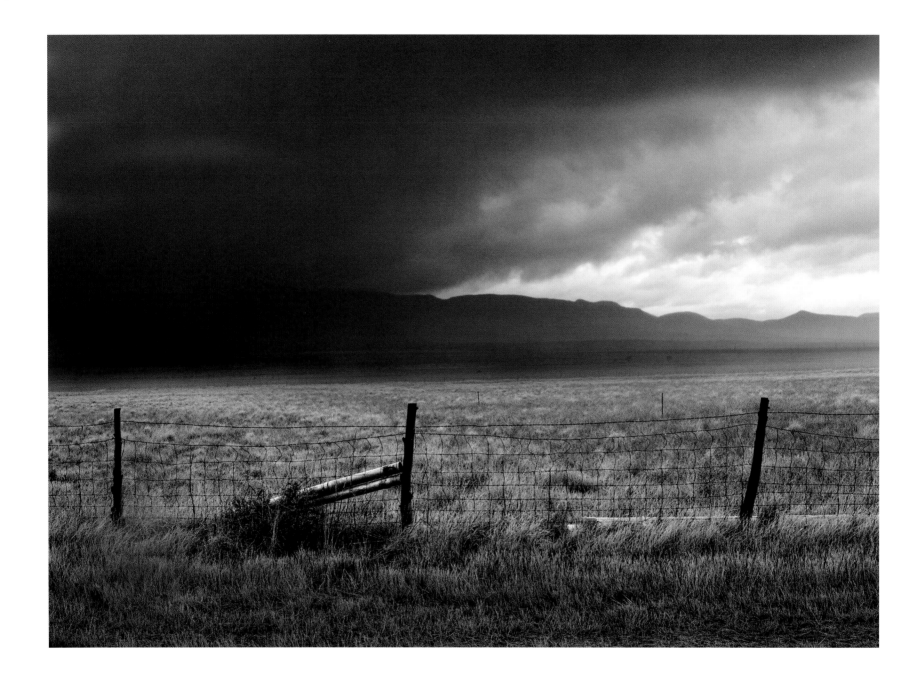

(Oct. 6) Early October snowstorm, Millard County, UT.

not in time to prevent José María's getting a great scare. We tried to convince him that these persons were not angry, saying that although a father might chide his son, as just now had been done, he never would wish to kill him, as he thought, and that therefore he must not be afraid. Nevertheless, he turned back from here, leaving us without anybody who knew the country ahead even from hearsay.

(October 6)
In the morning it was snowing and it continued all day without ceasing, so we were unable to travel. Night came and, seeing that it still did not stop, we implored the intercession of Our Mother and Patroness, saying in chorus the three parts of her Rosary and of all the saints, and singing the litanies, and God willed that at nine o'clock at night it should cease to snow, hail, and rain.

(October 7)
Although we were greatly inconvenienced by the lack of firewood and the excessive cold, we were unable to leave…today either, because, with so much snow and water, the land, which here is very soft, was impassable.

October 8–11

CASTING OF THE LOTS AND SOUTH TO THE HURRICANE CLIFFS

By October 8, the friars were seeing the futility of continuing west to Monterey and decided to turn back toward Santa Fe. Winter was approaching and food was running out. Breaking this news led to dissatisfaction among most of the retinue, especially Miera, who believed that Monterey could be reached in only a week. He had convinced most of the others of this, and in addition he had assumptions of great rewards (though it is not mentioned what these were) when they reached California. The issue was settled by casting lots. If it went in favor of Monterey, Miera would be the new leader. The result ended in favor of returning to Santa Fe. Had it gone the other way they most certainly would have perished. In reality they were still nine hundred miles from Monterey and would have had to cross several mountain ranges in Nevada and the impenetrable snow-packed Sierras of California, which present a four-hundred-mile-long perpendicular barrier with no open winter passes. The site where they made this decision is located south of Milford, in the Escalante Desert, which is now occupied by dozens of commercial automated hog barns and geothermal companies tapping the natural hot springs noted in the diary. Today these springs have proved valuable in checking the accuracy of the expedition's latitude readings.

(October 8)
We set out…through the plain toward the south but traveled only three and one-half leagues with great difficulty because it was so soft and miry everywhere that many pack animals and saddle horses, and even the loose ones, either fell down or mired in the mud . . .

Today we suffered greatly from cold because all day a very sharp north wind never stopped blowing. Hitherto we had intended to go to the presidio and new establishments of Monterey, but thinking them still distant because…there were still many more leagues to the west. Winter had already begun with great severity, for all the sierras which we were able to see in all directions were covered with snow. The weather was

very unsettled and we feared that long before we arrived the passes would be closed and we would be delayed for two or three months in some sierra, where there might be no people nor any means of obtaining necessary sustenance, for our provisions were already very low, and so we would expose ourselves to death from hunger if not from cold. Moreover, we reflected that even granting that we might arrive at Monterey this winter, we would not be able to reach the Villa de Santa Fé before the month of June next year. This delay, together with that which would arise in the regular and necessary pursuit of such an interesting undertaking as the one now in hand, might be very harmful to the souls who, according to what has been said before, desired their eternal salvation through holy baptism. Seeing such delay in what we had promised them, they would consider their hopes frustrated or would conclude that we had intentionally deceived them, whereby their conversion and the extension of the dominions of His Majesty in this direction would be made much more difficult in the future. To this it might be added that the Laguna, Joaquín, terrified and weary of so many hardships and needs, might stray away from us and return to his country, or to other people of whom he might have heard, as was done by the other…Therefore, we decided to continue to the south, if the terrain would permit it, as far as the Río Colorado, and from there proceed toward Cosnina, Moqui, and Zuñi.

(October 10)
We set out…to a small and very low hill in the middle of the plain to ascertain by the view the extent of this valley and plain of La Luz. Ascending the hill we saw that from here it extended southwest more than thirty-

five or forty leagues, for we could scarcely see the sierras where it ends in this direction, although they are very high as we afterward discovered.

We saw also three springs of hot sulphurous water which are on top of and on the eastern slope of these hills, near and below which there are small patches of ground covered with saltpeter.

(October 11)
We set out from San Eleuterio south by east, letting the companions go ahead so that we two might discuss between ourselves the means we ought to adopt to relieve the companions, especially Don Bernardo Miera, Don Joaquín Laín, and the interpreter Andrés Muñiz, of the great dissatisfaction with which they were leaving the route to Monterey and taking this one…We had already told them at Santa Brigida the reasons for our new decision, but instead of listening to the force of our arguments, they opposed our views and so from then on they were very insubordinate. Everything was now very onerous to them and everything insufferably difficult. They talked of nothing but how useless so long a journey would now be. For to them it was of no value to have already discovered so great an extent of country, and people so willing to attach themselves readily to the Vineyard of the Lord and the dominions of His Majesty (God spare him); nor to have become acquainted with such extensive provinces hitherto unknown; nor finally, to bring one soul, now almost assured to the fold of the Church, an achievement more than great, and worth an even longer journey of greater difficulties and fatigues. Moreover, we had already made much progress toward reaching Monterey later. But to all this they paid no attention, for the first of the persons here mentioned, without any cause whatsoever, at least on our part

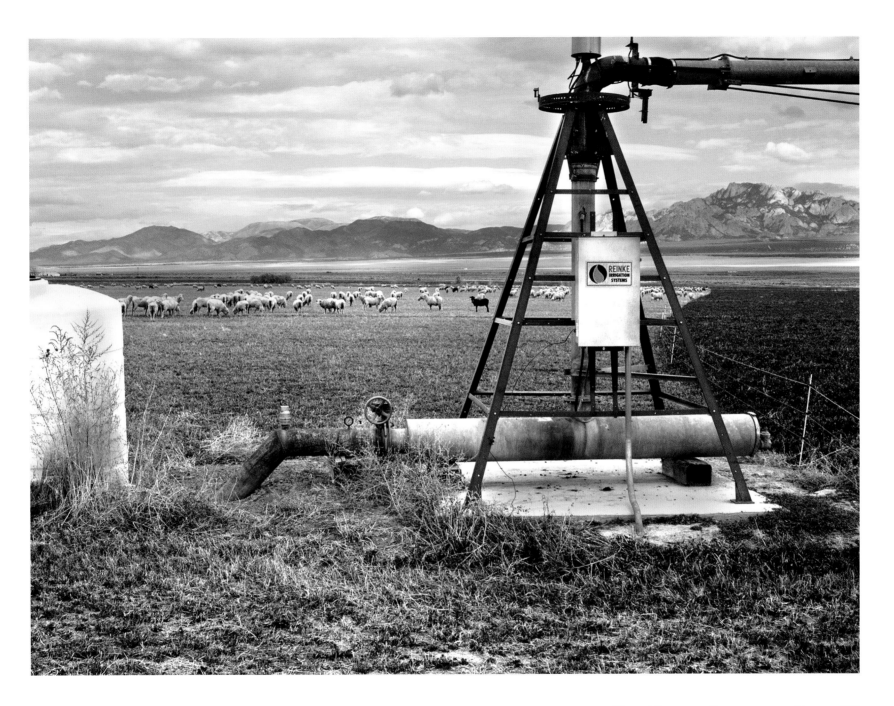

(Oct. 12) Escalante Desert, south of Milford, UT.

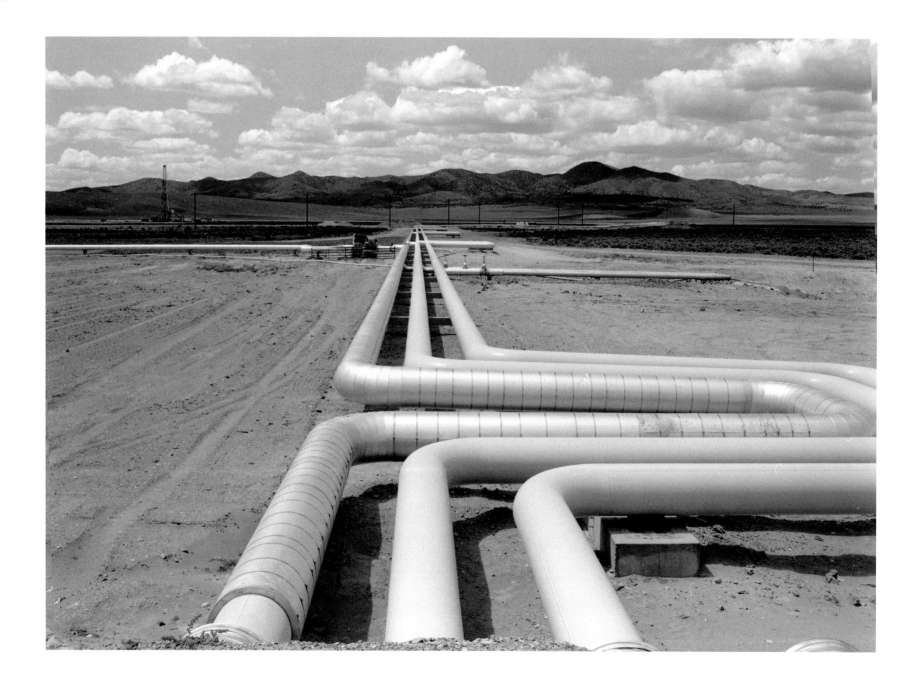

(Oct. 10) Geothermal plant at hot springs, Escalante Desert, UT.

[Don Bernardo Miera], had conceived great hopes of honor and profit by merely reaching Monterey, and had communicated these hopes to the others, building great castles in the air. And now he assured them that we were robbing them of these blessings which they imagined would be so great, with the result that even the servants greatly tried our patience. Shortly before this decision was made, Don Bernardo had said that we had advanced but little toward the west, and that it was still a long distance to Monterey, but now even the servants frequently maintained that we would have arrived within a week. Many times, before leaving the Villa de Santa Fé, we had told each and every one of our companions that in this journey we had no other destination than the one which God might give us, and that we were not inspired by any temporal aim whatsoever; and that any one of them who might attempt to trade with the heathen, or to follow out his personal desires instead of devoting himself to the one purpose of this enterprise…had better not go with us…With all this we were more mortified each day, and we were disconsolate to see that instead of the interests of Heaven, those of Earth were first and principally sought. And so, in order that the cause of God might be better served, and to make them see more clearly that not through fear nor by our own will had we changed our plan, we decided to abandon entirely the heavy responsibility of the foregoing reflections. Having implored the divine clemency and the intercession of our patron saints we decided to inquire anew the will of God by means of casting lots, putting in one the word "Monterey" and in the other "Cosnina," and following the route which might come out.

We now overtook the companions, and had them dismount. When all were assembled, Father Fray Francisco Atanasio set forth to them the inconveniences and difficulties which now prevented our continuing to Monterey; what we would be able to achieve by returning by way of Cosnina; and finally, the mistakes and setbacks which we would have suffered hitherto if God had not interfered with some of their projects. He pointed out to them all the evil which might result from continuing now to Monterey, especially from the straying or the return of the Laguna, Joaquín. He warned them that if the lot fell to Monterey, there would be no other director than Don Bernardo Miera, for he thought it so near at hand, and all this dissatisfaction was a result of his ideas…This concluded, we cast the lot, and it was decided in favor of Cosnina. Now, thank God, we all agreeably and gladly accepted this result.

We now continued on our way, quickening our pace as much as possible…Today ten leagues.

We observed by the polar star and found ourselves in 37° and 33' of latitude.

(Oct. 11) Volcanic formation near site of casting of the lots, Mud Spring Bench, Escalante Desert, UT.

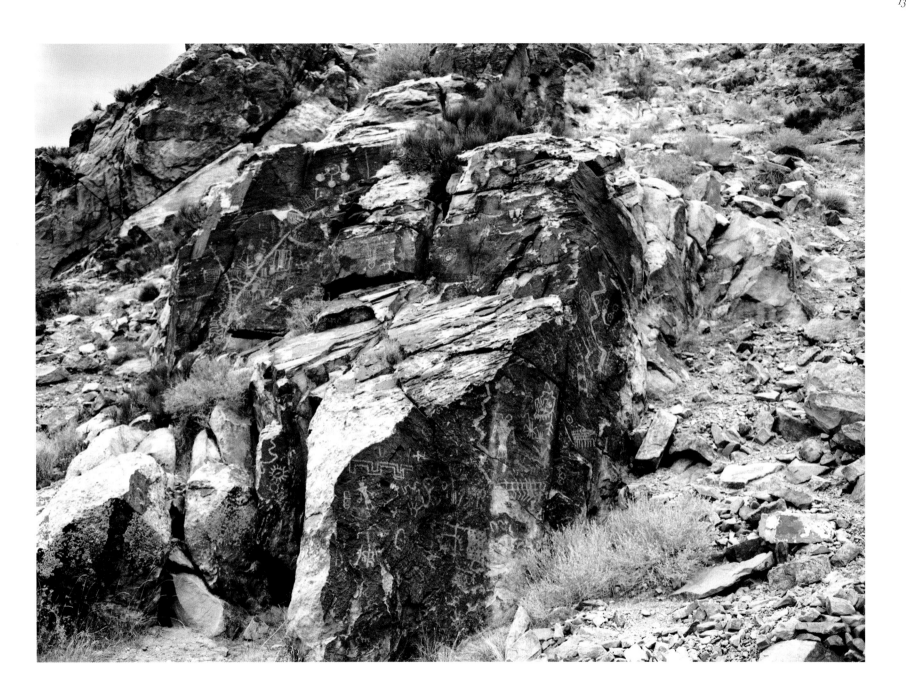

(Oct. 12) Parowan Gap petroglyphs, Escalante Desert, UT.

ALONG THE HURRICANE CLIFFS AND SOUTH

The Hurricane Cliffs began to assert their influence as a forced southward channel of travel at Cedar City, and increased their height to full force as the trail dropped off the high plateau and entered present-day Hurricane. Once off the plateau, water and food became scarce to nonexistent. Along the cliffs scattered bands of curious but frightened Indians were encountered, and in exchanges with them the friars always requested the same things: directions to the Colorado River and finding someone to serve as a guide. No guide was found and only verbal directions resulted. On occasion guides were obtained with bribes but quickly deserted after they had led the expedition safely away from their homes. Several failed attempts were made to gain access up and over the cliffs to allow the necessary eastward progress by their own advance men.

Later these same cliffs would be breached by the historic Mormon Temple wagon road, which ferried lumber from sawmills, located eighty miles south on Mt. Trumbull, to build the first temple of the Latter-day Saints in St. George, Utah. The Honeymoon Trail also ascended the cliffs as it ferried groups of young chaperoned Mormon couples to St. George to exchange wedding vows. Once on top of the cliffs, both trails went south through Pipe Spring near today's Fredonia, a water source so abundant that it later became a thriving ranch and way station, and is now a national monument. Unknown by the friars, they passed just a few miles south of it while constantly searching for water. They were lost.

(October 12)

. . . Having traveled over good terrain four and one-half leagues, we saw that the companions who were some distance ahead of us left the road hurriedly. We quickened our pace to learn the cause, and when we overtook them they were already talking with some Indian women whom they had forcibly detained because they had begun to run away with other Indian women, of whom there were about twenty in number gathering grass seeds in the plain, as soon as they saw them [the companions]. We were sorry to see them so frightened for they could not even speak, and through the interpreter and the Laguna, Joaquín, we tried to relieve them of their fear and timidity…These Indian women were so poorly dressed that they wore only some pieces of buckskin hanging from their waists, which hardly covered what can not be looked at without peril…We continued along the plain and valley of Señor San José, and having traveled three more leagues to the south, we saw other Indians who were running away. We despatched the interpreter with the Laguna, Joaquín, and another companion, to try to bring an Indian to the campsite, which was now nearby, in order to inquire whether the Río Grande [Colorado] was as near as the Indian women had said, and to see if one of them would accompany us as a guide as far as Cosnina. They ran so fast that our men were barely able to stop one of them. Don Joaquín Laín brought that one behind him on his horse…

This Indian whom the companions brought to the camp, as we have just said, was very excited and so terror-stricken that he seemed to be insane. He looked in every direction, watched everybody, and was excessively frightened by every action or movement on our part and to escape what his extreme cowardliness led him to fear, he gave such close attention when we talked to him and responded so quickly that he appeared rather to guess at our questions than to understand them. He quieted down a little, and we gave him something to

eat and a ribbon, putting it on him ourselves. He carried a large net very well made of hemp, which he said he used to catch hares and rabbits. When we asked him where he got these nets, he replied that it was from other Indians who live down the *Río Grande*, from whence, we also learned later, they obtained colored shells…We asked him if he had heard it said that toward the west or west-northwest (pointing in these directions) there were fathers and Spaniards, and he answered, "No," for although many people lived there, they were of the same language and tribe as himself. They showed him a kernel of maize, and he said that he had seen how it was grown, adding that at a rancho to which we would come next day there was a little of this grain, which they had brought from the place where it is raised. We made great efforts to get him to tell us the name of these people who were now planting maize, and to clarify other things of which he was giving a confused account, but we were able to learn only that they lived on this side of the Río Grande on another small river. He remained with us voluntarily all night and promised to lead us to the rancho mentioned.

(October 13)
We set out…accompanied by this Indian, to whom we had promised a hunting knife if he would guide us to where we might find other Indians. We traveled two and a half leagues south and arrived at the rancho mentioned, which belonged to him. In it there were an old Indian, a young man, several children and three women, all of them very good looking. They had very good piñon nuts, dates, and some little sacks of maize. We remained in conversation with the old man for a long time, but he told us only what the others had. We gave the promised hunting knife to the one who had

conducted us to this place, and told them that if any of the three would accompany us to those who they said planted maize, we would pay him well. From the response we saw that they were still very suspicious and much afraid of us, but at the suggestion of the companions we put before them a hunting knife and some glass beads. The old man seized them, and impelled by his great fear, he offered to guide us, in order to get us away from there, as later became evident to us, and to give his family time to reach a place of safety by withdrawing to the nearby sierra.

We continued on our way accompanied by this old man and the Indian who had passed the preceding night with us. We traveled a league and a half to the south, descended to the little Río del Pilar, which here has a leafy cottonwood grove, crossed it, now leaving the valley of Señor San José, and entered a stony cut in the form of a pass between two high sierras. In the roughest part of this cut the two guides disappeared and we never saw them again. We admired their cleverness in having brought us through a place well suited to the sure and free execution of their plan.

(October 16)
We set out…with the intention of continuing south as far as the Río Colorado, but after traveling a short distance we heard some people shouting behind us; turning around to see where the noise came from, we saw eight Indians on the hills near the campsite which we had just left…[We arrived] at the foot of the little hill and told the Indians to descend without fear because we had come in peace and were friends. Thereupon they took courage and descended, showing us for barter some sartas or strings of chalchihuite [stones of an emerald color], each string having a colored shell. This gave us something

(Oct. 12) State Road 130 through Cedar City, UT.

(Oct. 13) Near campsite of captured guide, Kanarraville, UT.

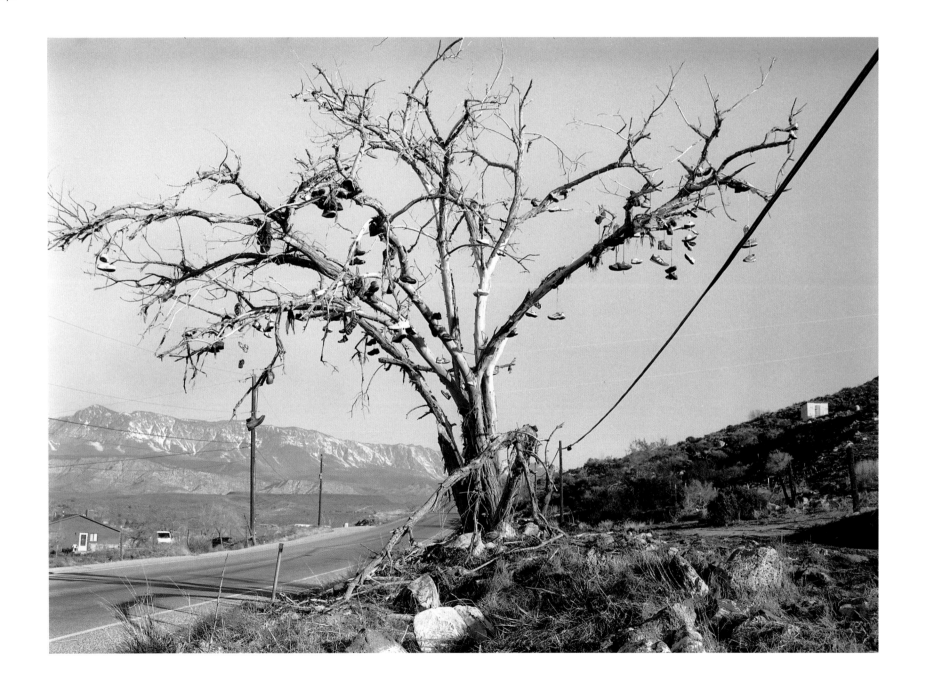

(Oct. 14) On trail, tree with shoes, Toquerville, UT.

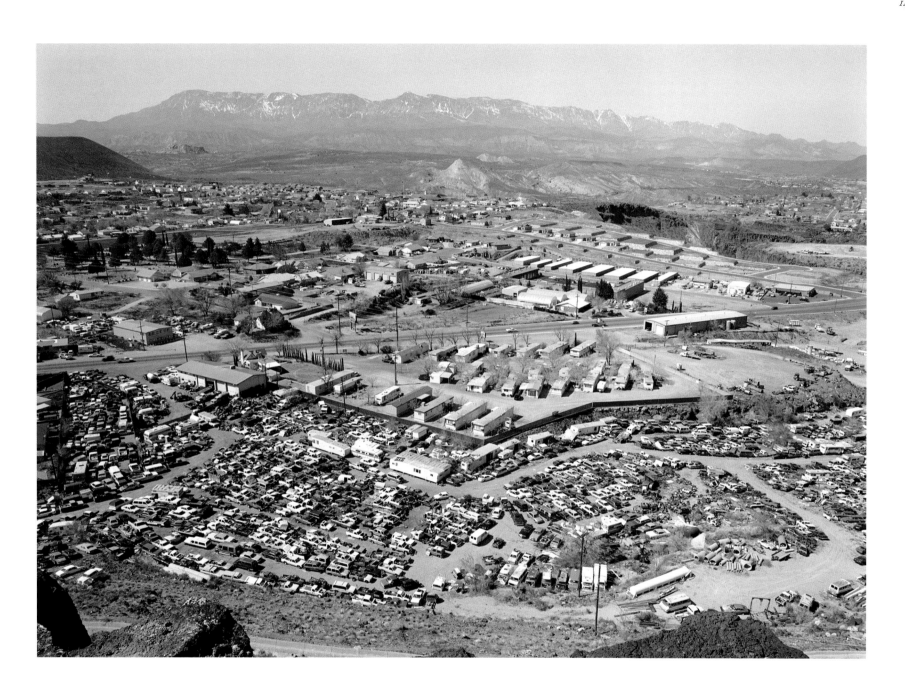

(Oct. 15) View of trail location from top of cliffs, Hurricane, UT.

(Oct. 15) Man preparing for target practice along Hurricane Cliffs, UT.

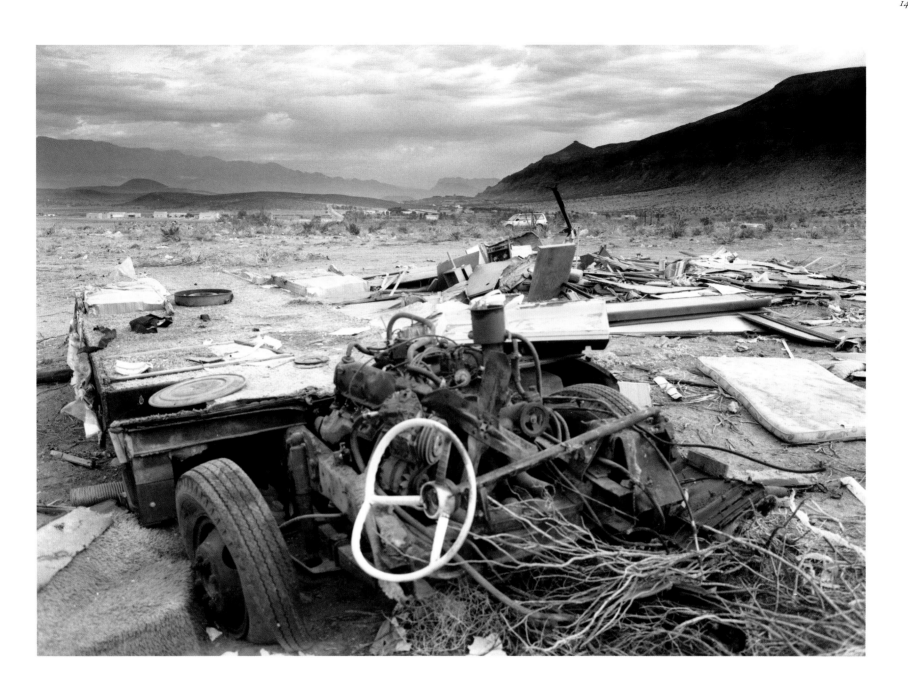

(Oct. 15) Desert litter along Hurricane Cliffs, looking north, UT.

to think about, for from below, the strings of chalchi-huite looked to us like rosaries and the shells like medals of saints. We remained here with them a short time, but they spoke the Yuta tongue so differently from all the rest that neither the interpreter nor Joaquín, the Laguna, could make them understand clearly nor understand much of what they said. Nevertheless, partly by signs, partly because about some matters… They offered their chalchihuites for trade, and when we told them we did not have a thing there, but if they would come with us until we overtook the rest of the companions, we would give them what they asked for and would talk with them at length, all came very cheerfully though with great fear and suspicion on the part of those who appeared the most intelligent. We stopped and talked with them more than two and a half or three hours. They told us that in two days we would reach the Río Grande, but would not be able to go the way we wanted to, because there was no water-ing place, nor would we be able to cross the river in this region because it ran through a great canyon and was very deep and had on both sides extremely high cliffs and rocks, and finally, that from here to the river the terrain was very bad. We gave them a present of two hunting knives and to each one a string of glass beads, and then told them that if one of them would guide us to the river we would pay him. They replied that they would go and put us on the trail through a canyon which was in the mesa east of the plain, and that from there we could go alone, because they were barefoot and could not travel very well…We offered these Indians soles of satchel leather for sandals if they would guide us. They said that two of them would go with us until they had put us on a good straight road. With them we entered the canyon mentioned, traveled through it a league and a half with extreme difficulty, the animals

being hindered by the many pebbles and flint stones and the frequent difficult and dangerous stretches in it. We arrived at a narrow pass so bad that in more than half an hour we were able to make only three saddle animals enter it. This was followed by a rocky cliff so rough that even on foot it would have been difficult to ascend it. The Indians, seeing that we would not be able to follow them, fled, impelled doubtless by their excessive cowardice. Thereupon it was necessary for us to go back and turn once more to the south. Before doing so we stopped a short time in order that the animals might eat a little and drink some of the water which was here, but it was so bad that many of the animals would not touch it. In the afternoon we retraced the full length of the canyon, and having traveled half a league along the plain toward the south, we camped near the southern entrance of the valley, without water for our-selves or for the animals. This night we were in great need, having no kind of food, so we decided to take the life of a horse in order not to lose our own, but because there was no water we deferred the execution until we should have some. Today, in so difficult a journey, we advanced only a league and one-half south.

(October 17)
We continued on our way toward the south…Here we found some of the herbs which they call quelites. We thought it possible by means of them to supply our most urgent need, but were able to gather only a few and these were very small. We continued southeast, and having traveled four and a half leagues over good level country, although it was somewhat spongy, we stopped partly to see if there was water in the washes from the mesa and partly to give Don Bernardo Miera some of these ripe herbs as food, for since yesterday morning we

had not had a thing to eat and he was now so weak that he was scarcely able to talk. We ordered the bags and other containers in which we had brought the supplies ransacked, to see if there were any leftovers, but found only some pieces of calabash which the servants had obtained yesterday from the Parusis Indians, and which they had hidden to avoid having to share them with the rest. With this and a little sugar, which we also found, we made a stew for everybody and took a little nourishment. We did not find water so we could spend the night here and therefore decided to continue the journey toward the south.

(October 18)

. . . There were five Indians spying upon us from a small but high mesa, and as we too passed the foot of it, for we were following behind our companions, these Indians spoke to us. When we turned toward where they were, four of them hid, only one remaining in sight. We saw how terrified he was, but we could not persuade him to come down, and the two of us ascended on foot with very great difficulty. At each step we took toward him he wanted to run away. We gave him to understand that he must not be afraid, that we loved him like a son, and wished to talk with him. There upon he waited for us, making a thousand gestures which showed that he was greatly afraid of us. As soon as we had ascended to where he was we embraced him and, seating ourselves beside him, we had the interpreter and the Laguna come up. Having now recovered his composure, he told us that the other four were hiding near by and that if we desired it, he would call them in

order that we might see them. When we answered in the affirmative, he laid his bow and arrows on the ground, took the interpreter by the hand, and went with him to bring them. They came and we remained about an hour in conversation, and they told us that we now had water near at hand. We begged them to go and show it to us, promising them a piece of woolen cloth and after much urging three of them consented to go with us…

The three Indians mentioned came with us so fearfully that they did not wish to go ahead nor to have us come near them until they questioned Joaquín, the Laguna, but with what he told them about us they quieted down. Greatly surprised at his valor, they asked him, among other things, how he had dared to come with us? He, wanting to rid them of their fears in order to relieve the privation which, greatly to our sorrow, he was suffering, answered them as best he could; and thus he greatly lessened the fear and suspicion they had felt. Doubtless it was because of this that they did not leave us before arriving at the watering place. As soon as we camped we gave them the promised woolen cloth with which they were greatly pleased. Learning that we came without provisions, they told us to send one of our men with one of theirs to their huts which were somewhat distant, and they would bring some food, the rest meanwhile remaining with us. We sent one of the genízaros with Joaquín, the Laguna, giving them the wherewithal to purchase provisions and pack animals on which to bring them. They left with the other Indian, and after midnight they returned, bringing a small supply of wild sheep, dried tuna made into cakes, and grass seeds.

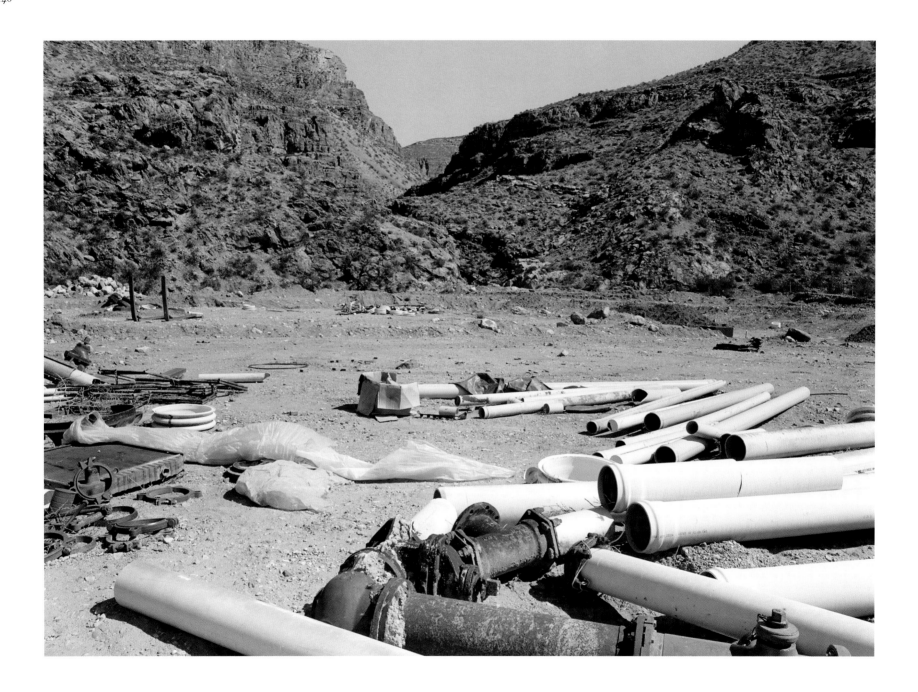

(Oct. 16) Entrance to false ascent of Hurricane Cliffs, UT.

(Oct. 18) Paiute Indian park ranger with Vietnam War "missing in action" tattoo, Pipe Spring National Monument, UT.

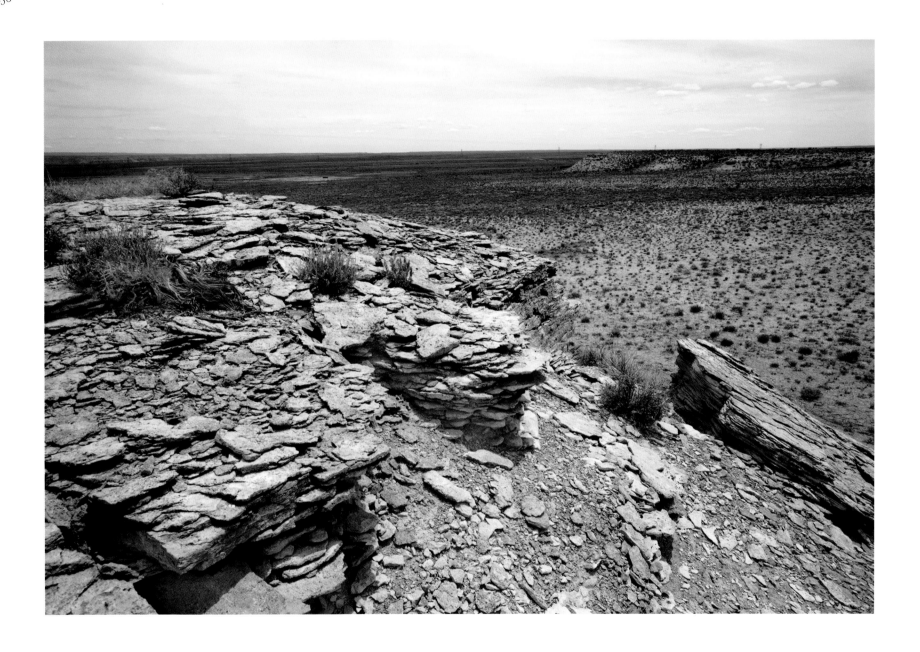

(Oct. 20) View of trail site through Antelope Valley, south of Fredonia, UT.

October 20–23

Don Bernardo Miera, Treated by Ute Medicine Man

On October 20, the expedition set out from San Samuel in a north-northeast direction, toward the ford of the Colorado River, avoiding difficult sandy and stony areas. The previous afternoon Miera had developed a terrible stomach problem, which prevented them from going on until the next day. For two more days they traveled. Water was difficult to find and the horses began to scatter in search of it.

Once again Miera became sick, but they were now among the Pagampachi and the Ytimpabichi, factions of the Ute tribes, who offered to heal him by performing traditional ceremonies and dances. This activity disturbed the two friars immensely; they considered these rituals to be superstitious and pagan, reproaching members of their own company for allowing these ceremonies. The friars then began preaching to a large encampment of Utes, numbering at least a hundred. They stayed for three days while instructing them in Christian doctrine.

(October 19)

. . . Today Don Bernardo Miera was sick at his stomach, so we were unable to leave here this afternoon.

(October 22)

. . . After we had retired, some of the companions, among them Don Bernardo Miera, went to one of the huts to chat with the Indians. They told him that Don Bernardo was ill, and an old Indian, one of those present, either because our men ordered it or because he wanted to, set about doctoring him with songs and ceremonies which, if

not openly idolatrous (for such they might be) were at least entirely superstitious. All of our people permitted them willingly, and among them the sick man, and they applauded them as harmless compliments, when they ought to have stopped them as contrary to the evangelical and divine law which they profess, or at least they ought to have withdrawn. We listened to the songs of the Indian but did not know what their purpose was. Early in the morning they told us what had taken place. We were deeply grieved by such harmful carelessness, and we reprimanded them, telling them that at another time they must not sanction such errors by their voluntary presence nor in any other way. This is one of the reasons why the heathen who deal most with the Spaniards and Christians of these regions, more stubbornly resist the evangelical truth, making their conversion more difficult each day… "The Father says that the Apaches, Navajós and Cumanches who do not become baptized cannot enter Heaven, but go to Hell, where God punishes them, and where they will burn forever like wood in the fire." The Sabuaganas were greatly pleased at hearing themselves thus exempted from and their enemies included in the inescapable necessity either of being baptized or of being lost and suffering eternally. The interpreter was reprimanded, and seeing that his foolish infidelity had been discovered, he reformed…For if, in our company, after having many times heard these idolatries and superstitions refuted and condemned, they witness them, encourage them, and applaud them, what will they not do when they wander two, three or four months among the heathen Yutas and Navajós with nobody to correct and restrain them? Besides this, some of them have given us sufficient cause in this journey to suspect that while some go to the Yutas and remain so long among them because of their greed for peltry, others go and remain with them for that of the flesh, obtaining there its brutal satisfaction.

And so in every way they blaspheme the name of Christ and prevent, or rather oppose, the extension of His faith. Oh, with what severity ought such evils be met. May God in His infinite goodness inspire the best and most suitable means!

(October 23)

We did not travel today, in order to give time for the people here to quiet down and to enable those of the vicinity to assemble. The grass seeds and other things which we had purchased and eaten made us very sick, weakening instead of nourishing us. We were not able to induce these people to sell us any ordinary meat, so we had a horse killed and the flesh prepared so that it could be carried. Today Father Fray Francisco Atanasio was very ill from a pain in the rectum so severe that he was not able even to move.

All day the Indians kept coming from the nearby ranchos, all of whom we embraced and entertained to the best of our ability. These people now gave us a clearer account of the Cosninas and Moquinos, calling them by these very names. They also told us where we had to go to reach the river, (which is twelve leagues from here at most) giving us a description of the ford. We bought from them about a fanega of piñon nuts and gave them as a present more than half a fanega of grass seeds.

Very early the next day twenty-six Indians assembled, among them being some who were with us yesterday afternoon, and others whom we had not seen. We told them of the Gospel, reprimanding and explaining to them the wickedness and idleness of their sins, especially in the superstitious doctoring of their sick. We admonished them to rely in their troubles upon the true and only God, because only He has at His command health and sickness, life and death, and is able to help everybody. And although our interpreter could not explain this to them clearly, one of them, who doubtless had dealt extensively with the Yutas Payuchis, understood it well and explained to the others what he had heard. Since we saw that they listened with pleasure, we told them that if they wished to be Christians, fathers and Spaniards would come to instruct and live with them. They replied that they would like this, and when we asked them where we would find them when we should come they said they would be in this little sierra and on the nearby mesas.

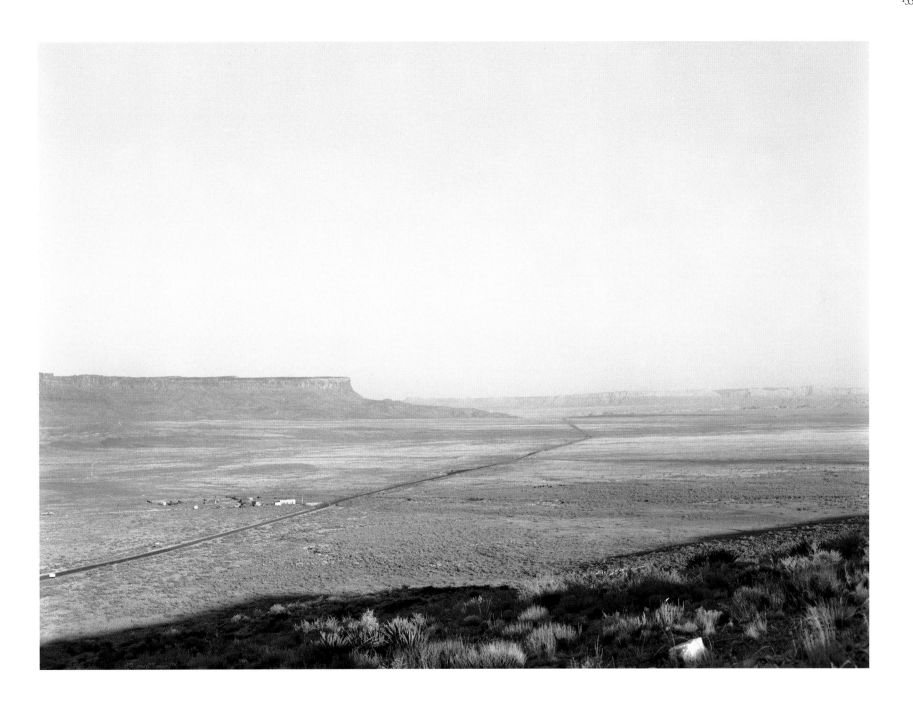

(Oct. 24) Highway 89 following expedition route to Colorado River in distance, AZ.

ARIZONA
TO
ZUNI, NEW MEXICO

☩ Preexisting towns and villas
● Pueblos (preexisting and modern)
● Modern towns and cities
✠ Stops along the route
■ Parks, monuments, sites

Note: map shows possible alternate route near the Utah/Arizona border.

MILES

0 50

OCT. 14
St. George
Virgin River
OCT. 15
Kanab
NOV. 1
OCT. 16
Fredonia
OCT. 26-31
OCT. 21
VERMILLION CLIFFS NAT. MON.
OCT. 17
OCT. 20
OCT. 22-23
OCT. 24
OCT. 18-19
OCT. 25

NOV. 6-7
NOV. 5
NOV. 3-4
NOV. 2
Lake Powell
Colorado R.
San Juan River
NOV. 8
UTAH
ARIZONA
NOV. 9
NOV. 10
Page
NOV. 11
Glen Canyon Dam

Colorado River
GRAND CANYON

NOV. 12
NOV. 13
Tuba City
NOV. 14
NOV. 17
NOV. 18-19
NOV. 16
NOV. 20
NOV. 15
Keams Canyon
NOV. 21
HOPI MESAS (PUEBLOS)
NOV. 22
NOV. 23
ARIZONA
NEW MEXICO

Flagstaff

Little Colorado River

Petrified Forest National Park

Winslow

Holbrook

ZUNI
NOV. 24– DEC. 12

Río Zuni

Great Salt Lake
COLORADO
Utah Lake Provo Jensen Rangely
Nephi
UTAH
Milford
Moab
Montrose
Colorado River
Cedar City
Cortez Durango
Rio Grande
Kanab
Page
GRAND CYN.
Tuba City
NEW MEXICO
Abiquiu
Virgin R.
HOPI VILLAGES
Santa Fe
ARIZONA
ZUNI Albuquerque

CHAPTER 4

Arizona to Zuni, New Mexico:

October 26–November 24

*A*RIZONA SHARES THE COLORADO RIVER crossing saga with Utah as the explorers zigzagged across the state line on the way to the river. The crossing of the Colorado was truly a heroic feat. All one needs for confirmation of this is to visit Glen Canyon Dam, whose location was chosen because of its four-hundred-foot canyon walls. The crossing at the site of today's Padre Bay is nearby. Had they known about the obvious shortcut that present-day Highway 89 follows between Kanab, Utah, and Page, Arizona, which leads straight to their eventual crossing site, many miles of confusion and hardship would have been saved. The Indians they met at Coyote Springs in House Rock valley sent them on the most difficult route possible. One wonders if this was intentional—since the Indians described the crossing site, surely they must have known about the most direct way to get there, just thirty easy miles away, a day and half of travel time. Instead it took twelve days of scrambling over side arroyos, climbing up and out of the river and then back down as failed cross-

ing sites were attempted. Scarcity of food reduced the expedition to eating a horse, toasted hide, a porcupine, and seeds. The cattle, if any, are presumed to have been eaten long ago.

After crossing the Colorado River and ascending the mesa on the south side at what is presently named the Crossing of the Fathers, they found domestic animal tracks and Indian trails but were lost as to which trail to follow. The aim was eastward toward the three Hopi mesas and the villages there. Here the country consists of a confusing variety of high mesas and valleys, currently on Navajo reservation land but at the time unknown to Spaniards. On one mesa they saw Indian encampments of Ute Payuchis, but even as they approached on foot the Indians fled in fear. The interpreter tried unsuccessfully for two hours to persuade them to talk with the Spaniards or sell provisions. The only result was to obtain directions to the proper trail, which meant losing a day of travel as it required retracing their steps to the previous campsite.

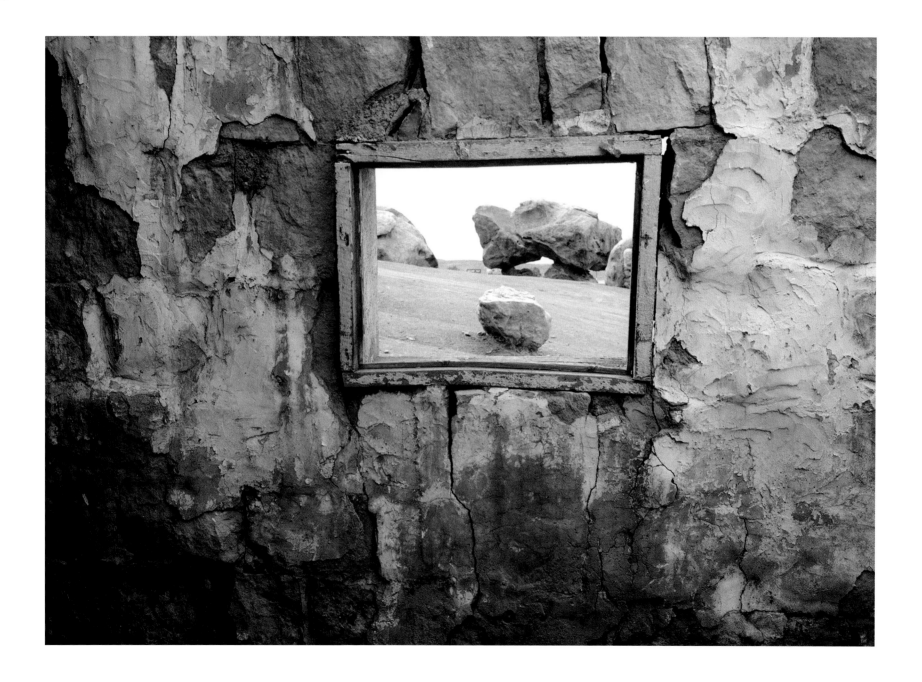

(Oct. 26) View through window of abandoned cliff dwelling, current attraction for selling Indian jewelry, approaching Lees Ferry, AZ.

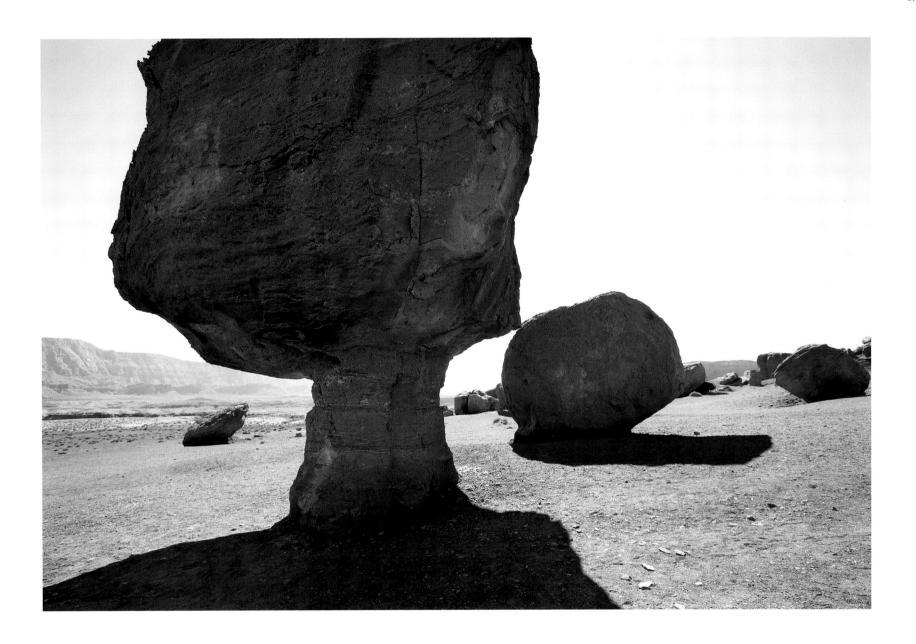

(Oct. 26) On trail, approaching Lees Ferry, AZ.

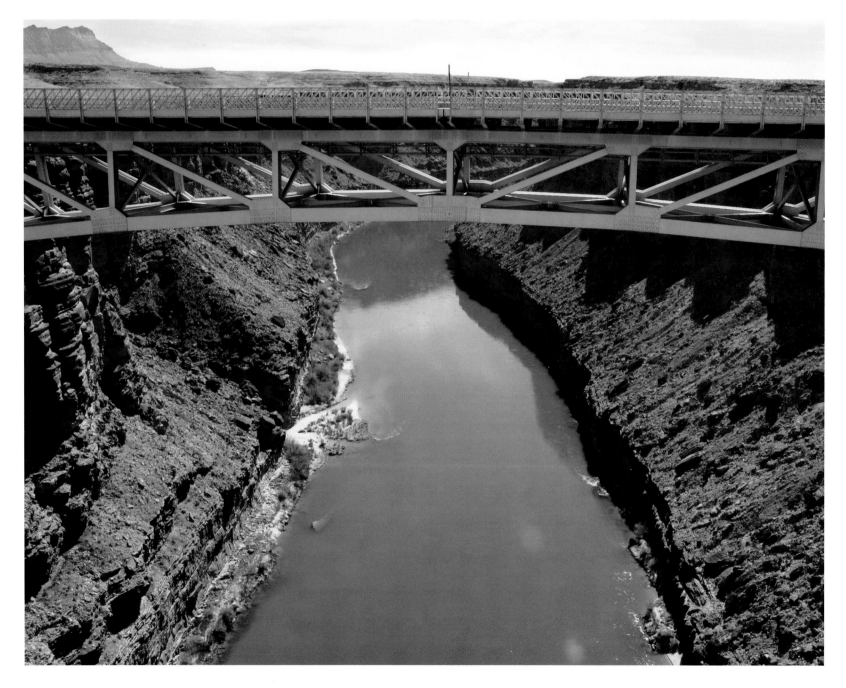

(Oct. 28) Navajo Bridge and beginning of Grand Canyon, looking south, AZ.

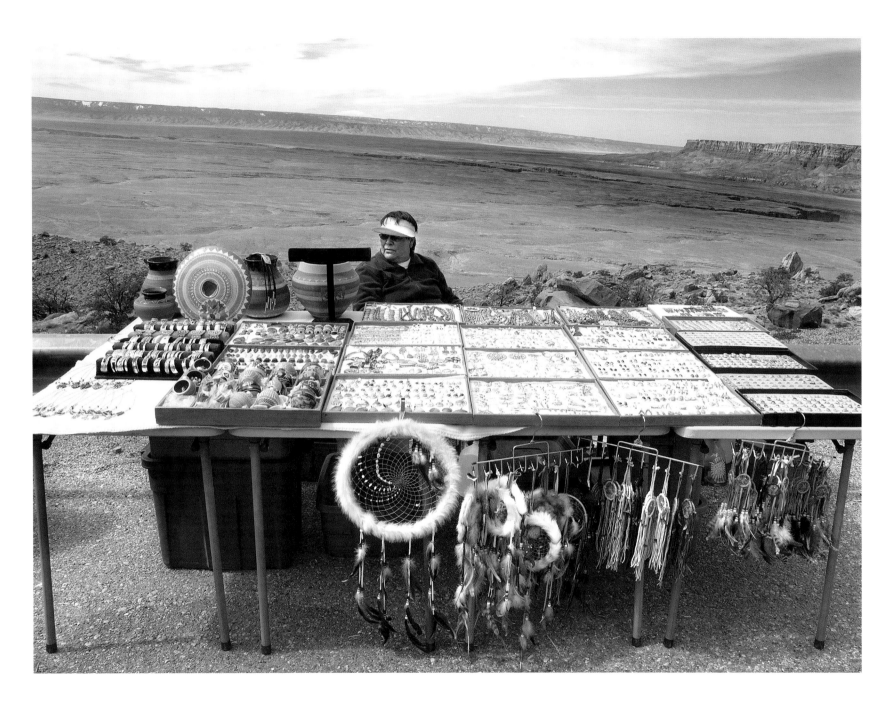

(Oct. 28) Jewelry vender with Colorado River canyon and Vermillion Cliffs in background, AZ.

Once on the correct trail, they headed southeast, passing the present-day Navajo reservation cities of Kaibab, Tuba City, and Moenkopi. The winter was fast approaching, and along the way Miera nearly froze to death, forcing a stop to build a fire and massage him so that he could continue. On November 16, they arrived at the first mesa and Oraibi Pueblo, where they received a cordial though indifferent reception. The next day they went on to the second mesa. Escalante had visited these mesa pueblos in 1775 trying to convert Hopis to Christianity and met with total failure. This time as a gesture of goodwill the friars gave a woolen cloak to a woman, but her brother took it away and threw it back at them. While on the second mesa they met with the head men of Oraibi, Xipaolabi, and Mossonganabi and attempted to win converts with no success. Moving on to the third mesa and Gualpi (Walpi), they met with several head men who requested aid against the Navajo Apache who had raided the pueblos. The friars promised them the requested aid in exchange for receiving padres and becoming Christians. After a long conference, the Indians refused the offer.

Continuing south over familiar country after leaving the mesa pueblos, it snowed all day on November 23, but they pushed on fearing they would freeze if they stopped, splitting into an advance and slower group. Crossing what is now Interstate 40 near Houck, Arizona, they finally arrived at Zuñi Pueblo in New Mexico on November 24.

October 26–28

Hikers at Lees Ferry

Plates TK–TK

The expedition followed the north bank of the Colorado River along the Vermillion Cliffs and entered Marble Canyon. This canyon dead ends at a river bend and descends to one of the few entry points to the river, which is shown here, known as Lees Ferry. Attempts to cross met with failure as the current was too swift. Consequently the small streambed of the Paria River, which empties here, was followed to gain the top of the mesa to search for another crossing site.

This is considered the beginning of the Grand Canyon and today is used as a point of departure for river-rafting trips down the Colorado. Before the construction of nearby Navajo Bridge, it was the only place to cross the Colorado River for 260 miles. It was named after John D. Lee, who started the ferry in 1872 to carry Mormon traffic across the Colorado River into southern settlements. Lee was an official in the Mormon Church and practiced plural marriage (he had nineteen wives and fathered sixty-seven children). In 1857 an emigrant wagon train bound for California was attacked at Mountain Meadows by Mormons dressed as Indians; one hundred and twenty were killed, though seventeen children were spared. In 1874 Lee was tried and convicted of being the leader. He was executed by firing squad in 1877, and with his last words claimed that the Mormon Church was responsible.

(October 26)

. . . We decided to reconnoiter this afternoon to learn whether, having crossed the river, we might continue from here to the southeast or east. On all sides we were surrounded by mesas and inaccessible heights. Therefore, two men who knew how to swim well entered the river naked, carrying their clothing on their heads. It was so deep and wide that the swimmers, in spite of their prowess, were scarcely able to reach the opposite shore, and they lost their clothing in the middle of the river, never seeing it again. Since they arrived very tired, naked, and barefoot they were unable to walk the distance necessary for the reconnaissance and returned after having eaten something.

(Oct. 28) Hikers, Lees Ferry, AZ.

(October 28)

We returned to the same undertaking, but all in vain. In a short time a raft of logs was constructed and with it Father Fray Silvestre, accompanied by the servants, attempted to cross the river. But since the poles which served for propelling the raft, although they were five varas long, failed to touch the bottom a short distance from the shore, the waves caused by the contrary wind drove it back. So it returned three times to the shore it had left, but was unable to reach even the middle of the river. Aside from being so deep and so wide, the river here has on both banks such deep, miry places that in them we might lose all or the greater part of the animals. We had been assured by the Yubuincariri and Pagampachi Indians that the river everywhere else was very deep, but not at the ford, for when they crossed it the water reached only a little above their waists. For this reason and on account of other landmarks which they gave us, we conjectured that the ford must be higher up.

October 29–November 3

HORSESHOE BEND AND THE COLORADO RIVER
Plates TK–TK

Horseshoe Bend, a scenic overlook for tourists, is typical of several such turns in the Colorado River in this vicinity. Somewhere on the opposite side of the river from here Cisneros, after climbing out of Lees Ferry, picked his way across difficult terrain looking for another descent to the river, traveling from left to right on this view. Animals and the rest of the train would soon follow. It took thirteen days of such searching to find the spot they would eventually cross. They descended and ascended the five-hundred-foot cliffs three times before locating the one and only crossing. This was the first recorded crossing of the Grand Canyon by Europeans.

(October 29)

Not knowing when we might leave this place, and having consumed all the flesh of the first horse, and the piñon nuts and other things we had purchased, we ordered another horse killed.

(October 30 and 31)

We remained here awaiting the men who went to look for a pass and a ford.

(November 1)

They returned at one o'clock in the afternoon, saying that they had found a pass, although a difficult one, and a ford in the river. The pass over the mesa was the acclivity which Cisneros had seen, and since it was very high and rugged, we decided to approach it this afternoon. We set out from the bank of the Río Grande and the unfortunate campsite of San Benito de Salsipuedes, followed the Río de Santa Teresa, and having traveled a league northwest we camped on its bank at the foot of this acclivity. —Today one league.

This night, from sunset until seven o'clock in the morning, we suffered greatly from the cold.

(November 2)

We set out from Río de Santa Teresa and climbed the acclivity, which we called Cuesta de las Animas and which must be half a league long. We spent more than

three hours in climbing it because at the beginning it is very rugged and sandy and afterward has very difficult stretches and extremely perilous ledges of rock, and finally it becomes impassable. Having finished the ascent toward the east, we descended the other side through rocky gorges with extreme difficulty.

(November 3)

We set out from San Diego to the east-southeast, and having traveled two leagues we came a second time to the river, that is to say, at the edge of the canyon which here serves it as a bed, whose descent to the river is very long, high, rough and rocky, and has such bad ledges of rock that two pack animals which went down to the first one were unable to climb up it in return, even without the pack saddles. The men who had come here previously had not told us of this precipice, and we now learned that they had neither found the ford, nor in so many days even made the necessary reconnaissance of such a short stretch of country, because they spent the time seeking some of the Indians who live hereabouts, and accomplished nothing. The river was very deep here…but for a long distance it was necessary for the animals to swim. The good thing about it was that they did not mire, either going in or getting out. The companions insisted that we should go down to the river, but on the other side there was no way to go forward after having crossed the river, except by a deep and narrow canyon of another little river which here joins it.

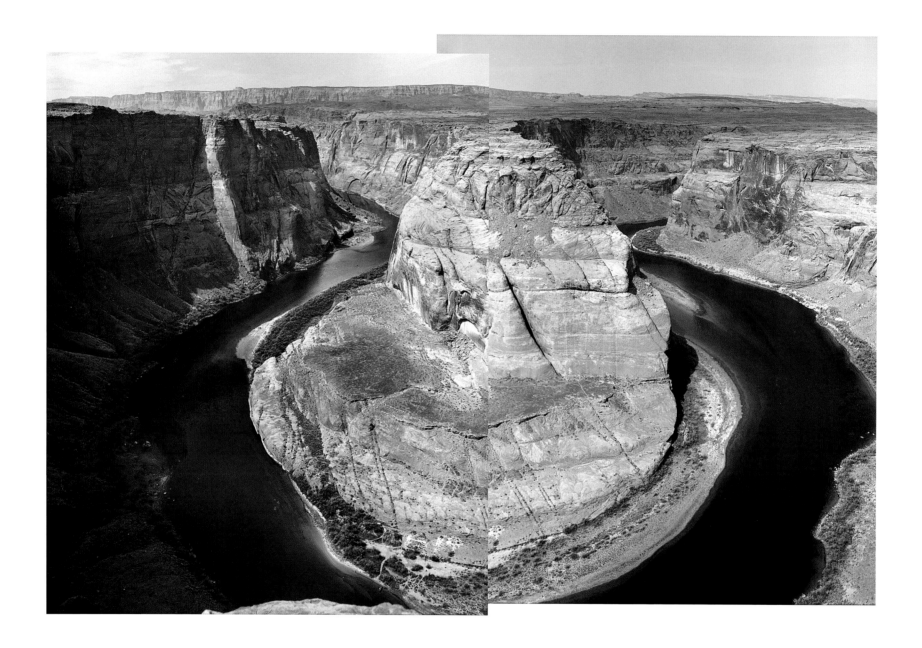

(Nov. 2) Horseshoe Bend and Colorado River overlook, looking north, AZ.

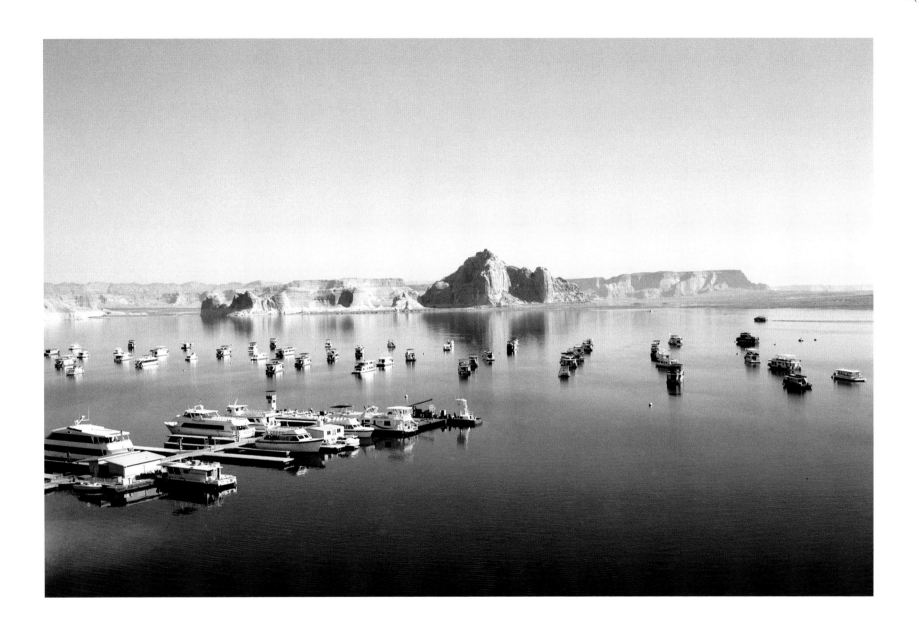

(Nov. 2) Lake Powell Wahweap Marina, location of flooded campsite, AZ.

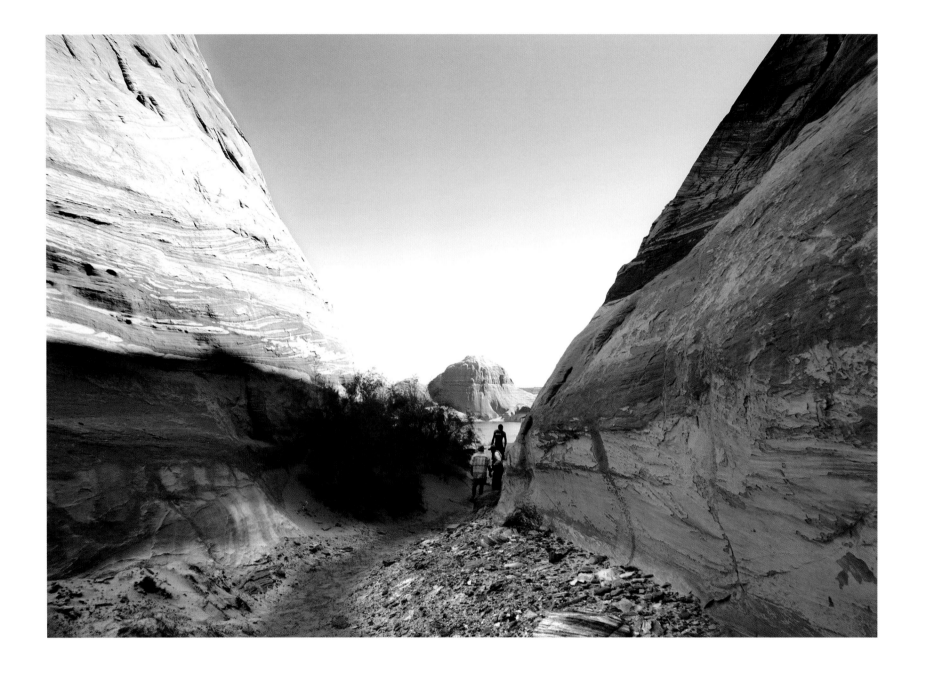

(Nov. 4) Gᴜɴsɪɢʜᴛ Pᴀss ᴀɴᴅ Iɴᴅɪᴀɴ ᴛʀᴀɪʟ ᴀᴘᴘʀᴏᴀᴄʜɪɴɢ ᴄʀᴏssɪɴɢ ʟᴏᴄᴀᴛɪᴏɴ,
Gʟᴇɴ Cᴀɴʏᴏɴ Nᴀᴛɪᴏɴᴀʟ Rᴇᴄʀᴇᴀᴛɪᴏɴ Aʀᴇᴀ, Lᴀᴋᴇ Pᴏᴡᴇʟʟ, AZ.

November 4–15

GLEN CANYON GRAFFITI

In September 2006, a group of volunteers who were part of the Glen Canyon National Recreation Area (GCNRA) graffiti removal team happened upon what appeared to be an inscription made by the expedition. A faint PASO POR AQUI ANO 1776 (passed by here year 1776) was chiseled into a sandstone wall and covered by contemporary graffiti dating from 1978. It is in the location of Padre Bay and the Crossing of the Fathers on Lake Powell, but located high above the canyon floor and original river bottom. The modern obscuring graffiti is the work of boaters who have been able to dock near this site since the rising of the waters behind Glen Canyon Dam, which began in 1963, reached full pool in 1980. There would be no reason to be this high on the canyon wall in prior years, hence its late discovery. The site is located in a protected narrow slot which now offers boaters shade from an intense sun and in the case of the expedition, it is theorized, protection from the intense thunderstorm noted in the journal. Exhaustive testing using laser scanning, lichen-growth comparisons, handwriting style, lead analysis, and rock-varnish comparisons have led to the conclusion that the inscription dates prior to the twentieth century and is likely to be two or three hundred years old. The GCNRA is currently pursuing having it listed in the National Register of Historic Places. If authentic, this is the only known extant marking of the expedition's passing.

(November 4)

Day broke without our getting news of the two we sent yesterday to make the reconnaissance. We had used up the flesh of the second horse, and today we had not taken any nourishment whatsoever, so we broke our fast with toasted leaves of small cactus plants and a sauce made of a berry they brought from the banks of the river. This berry is by itself very pleasant to taste, but crushed and boiled in water as we ate it today it is very insipid. Since it was already late, and the two emissaries had not appeared, we ordered that an attempt should be made to get the animals down to the river, and that on its banks another horse should be killed. With great difficulty they got the animals down, some of them being injured because, losing their footing on the rocks, they rolled down long distances. Shortly before nightfall the genízaro, Juan Domingo, returned, declaring that he had not found an exit, and that the other emissary, leaving his horse in the middle of the canyon, had followed some fresh Indian tracks. Thereupon we decided to continue upstream until we should find a good ford and passable terrain on both banks.

(November 5)

. . . Tonight it rained heavily here and in some places it snowed. At day break it was raining and continued to do so for several hours. About six o'clock in the morning Andrés Muñiz arrived, saying his brother had not appeared. This report caused us great anxiety, because by now he had traveled three days without provisions and with no more shelter than a shirt for he had not even worn trousers. Although he crossed the river on horseback the horse swam for a long stretch and where it faltered the water reached almost to its shoulders.

(November 6)

The rain having ceased we set out from Santa Francisca toward the northeast, and having traveled three

leagues we were stopped for a long time by a heavy storm and a torrent of rain and large hail, with horrible thunder and lightning. We chanted the Litany of the Virgin in order that She might ask some relief for us and God was pleased that the storm should cease. We continued half a league toward the east and camped near the river because it continued to rain and our way was blocked by some boulders. We named the campsite San Vicente Ferrer. —Today three and a half leagues.

(November 7)
We went very early to inspect the canyon and the ford, taking along the two genízaros Felipe and Juan Domingo, so that they might ford the river on foot since they were good swimmers. In order to lead the animals down the side of the canyon mentioned it was necessary to cut steps in a rock with axes for the distance of three varas or a little less . . . We went down to the canyon and having traveled a mile we descended to the river and went along it downstream about two musket shots sometimes in the water, sometimes on the bank, until we reached the widest part of its current where the ford appeared to be. One of the men waded in and found it good, not having to swim at any place. We followed him on horseback a little lower down, and when half way across, two horses which went ahead lost their footing and swam a short distance. We waited, although in some peril, until the first wader returned from the other side to guide us and then we crossed with ease, the horses on which we crossed not having to swim at all. We notified the rest of our companions, who had

remained at San Vicente, that with lassoes and ropes they should let the pack saddles and other effects, down a not very high cliff to the bend of the ford, and that they should bring the animals by the route over which we had come. They did so and about five o'clock in the afternoon they finished crossing the river, praising God our Lord and firing off a few muskets as a sign of the great joy which we all felt at having overcome so great a difficulty and which had cost us so much labor and delay, although the principal cause of our having suffered so much since we reached the Parusis was our lack of someone to guide us through such bad terrain. For through lack of an experienced guide we went by a very roundabout route, spent many days in such a small area, and suffered hunger and thirst…But doubtless God disposed that we should not obtain a guide, perhaps as a benign punishment for our sins, or perhaps in order that we might acquire some knowledge of the people who live in these parts. May His holy will be done in all things and His holy name glorified.

(November 8)
. . . Today we found many tracks of Indians but saw none. Through here wild sheep live in such abundance that their tracks are like those of great flocks of domestic sheep. They are larger than the domestic breed, of the same form, but much swifter. Today we finished the horse meat we had brought, so we ordered another horse killed. Tonight we felt much colder than on the other bank.

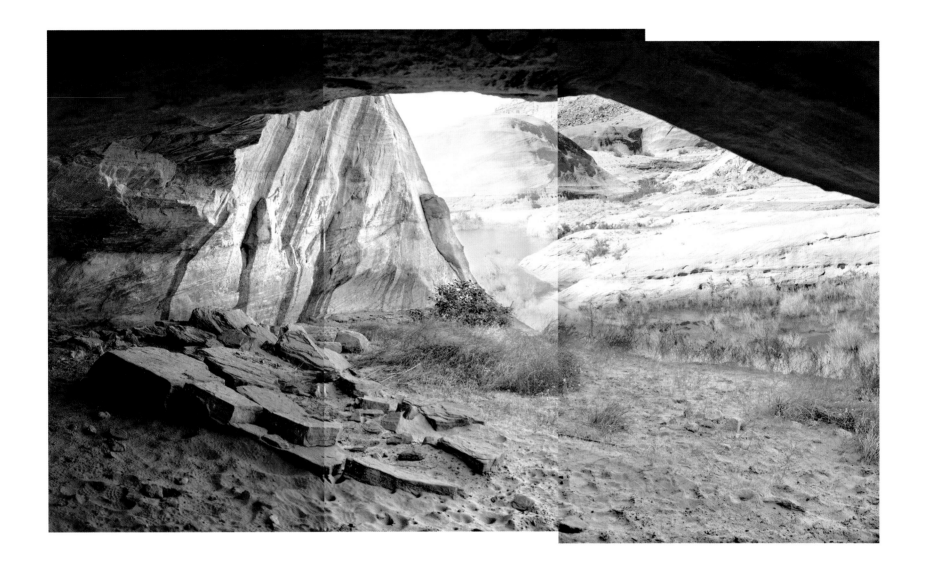

(Nov. 6) Cave shelter (near inscription) believed to have been used during thunderstorm, AZ.

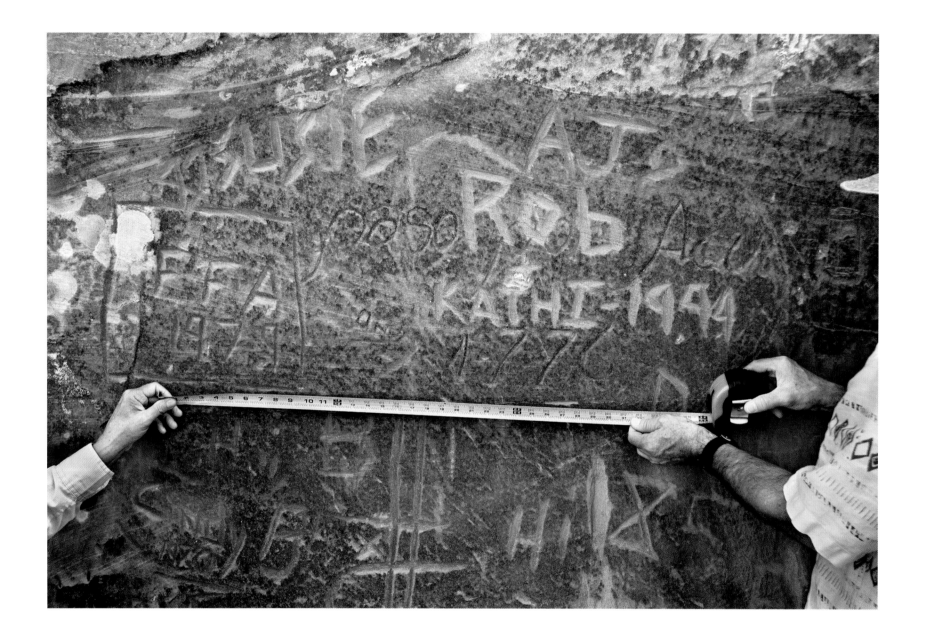

(Nov. 6) Inscription, Glen Canyon National Recreation Area, AZ.

(Nov. 7) Depth finder searching for crossing site, Padre Bay, Lake Powell, AZ.

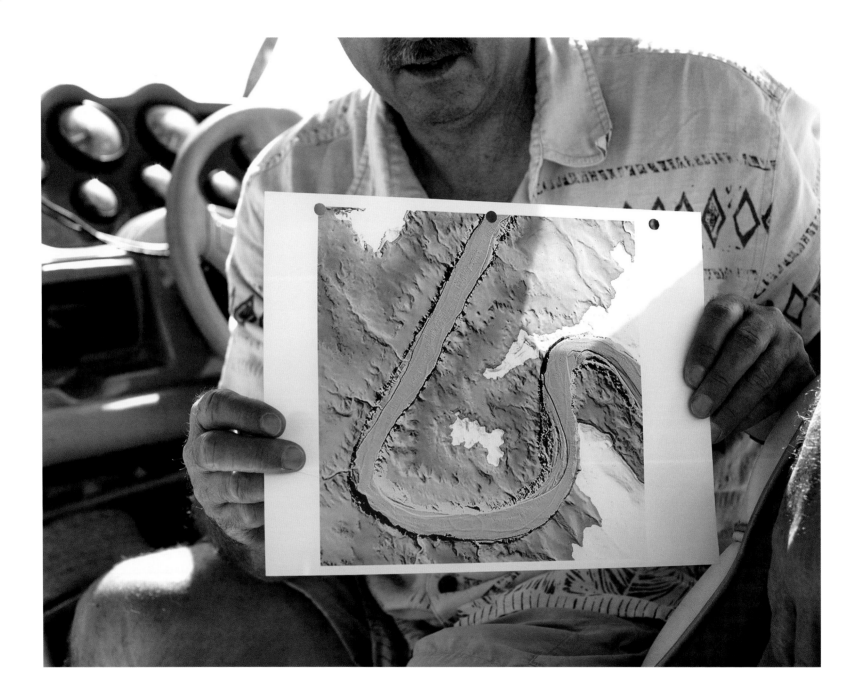

(Nov. 7) Aerial photograph of crossing site before Glen Canyon Dam, AZ.

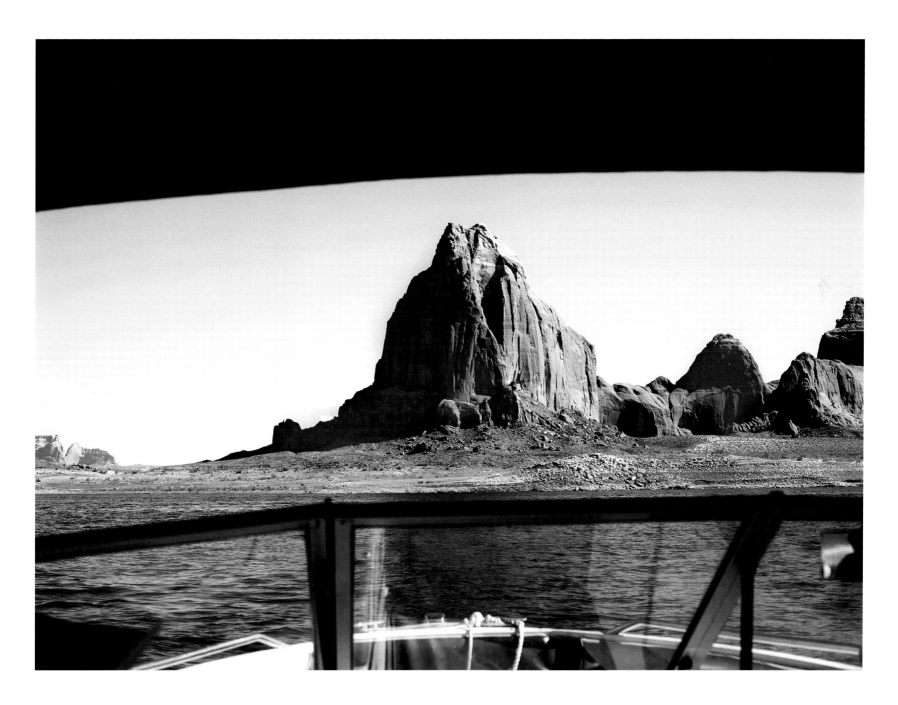

(Nov. 7) Boat approaching recently named Domínguez Butte, Padre Bay, Lake Powell, AZ.

264

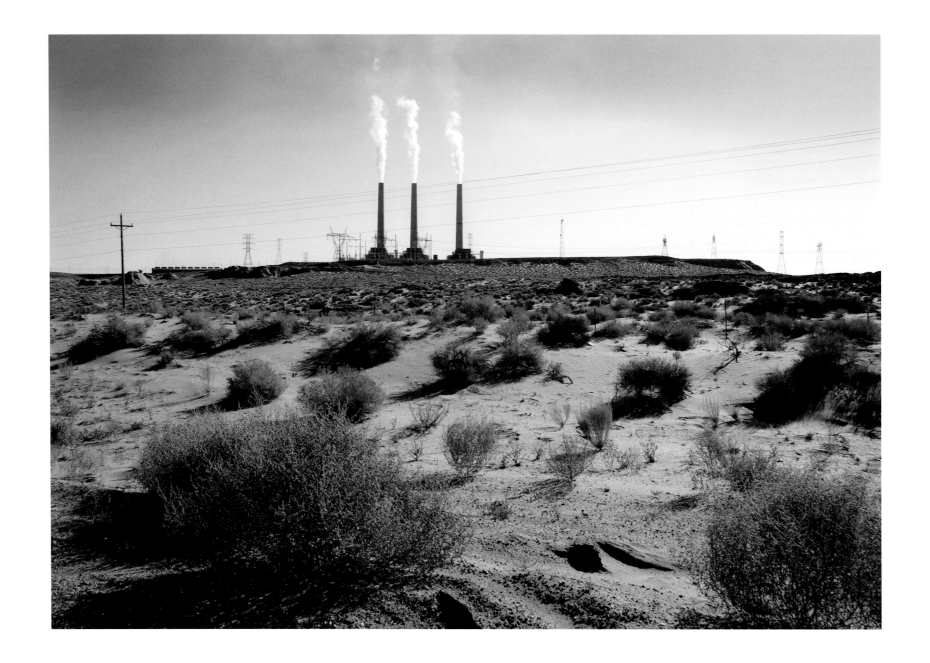

(Nov. 7) Navajo generating station, Page, AZ.

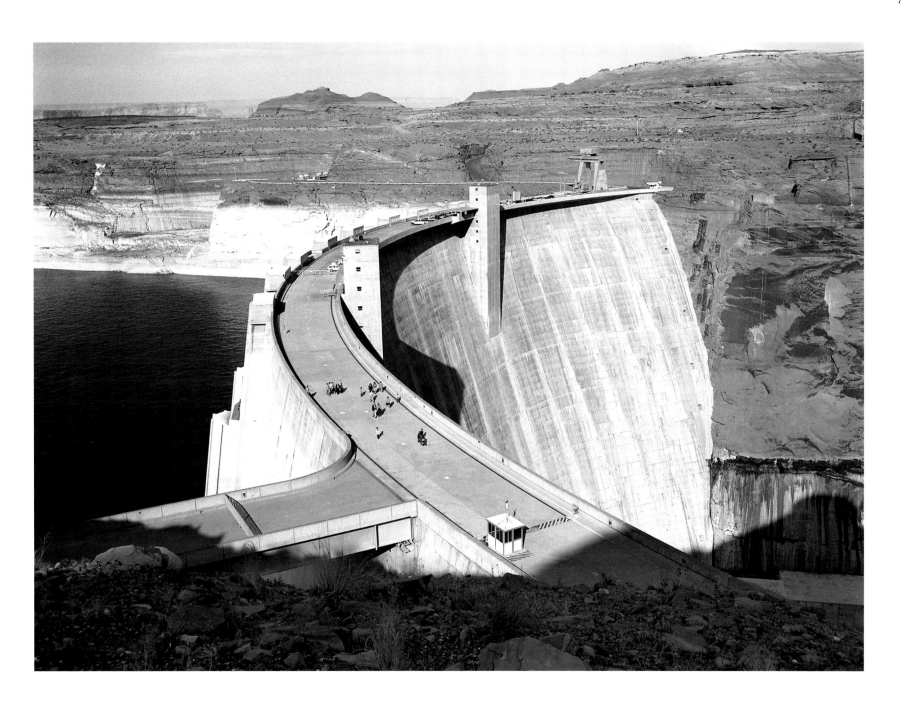

(Nov. 7) Glen Canyon Dam, Page, AZ.

(Nov. 7) Floating restaurant and swimming platform 200 feet above river bottom, Page, AZ.

(Nov. 7) Antelope Recreation convenience store, Page, AZ.

(November 9)

We lost the trail and…obliged us to halt on a mesa without being able to take a step forward. Near this mesa we found some ranchos of Yutas Payuchis, neighbors and friends of the Cosninas. We made great efforts through the Laguna and other companions to induce them to come near to where we were, but either because they suspected that we were friends of the Moquinos, toward whom they are very hostile, or because they had never seen Spaniards and greatly feared us, we were unable to induce them to come.

(November 10)

Very early we two went with the interpreter and the Laguna to their ranchos, but we were unable even on foot to get to the place where they were. We sent the two persons mentioned away, we ourselves remaining on an elevation from which we saw them and were seen by them, in order that seeing us alone they might approach with greater willingness and less fear. After the interpreter had urged them for more than two hours, five of them came, but when they were about to reach us they turned and fled, and we were unable to stop them. The interpreter went back to see if they would sell us some provisions but they replied that they had none. They told him that the Cosninas lived very near here, but at present were wandering not far away in the woods, gathering piñon nuts, and that a short distance from here we would find two roads, one leading to the Cosninas and the other to the Pueblo of Oraybi, in Moqui.

(November 12)

We set out from San Proto to the south-southeast. We traveled now over an open road and good terrain for

three leagues, and right on the road we found a small spring of good water from which, after we had broken the ice, all the men and all the animals drank…

Because of the great cold part of us stopped for a while, the rest of the companions going forward, to make a fire and massage Don Bernardo Miera, who was now about to freeze on our hands, for we feared he could not withstand such extreme cold. For this reason the rest of the companions arrived at the above-mentioned spring ahead of us, and before we overtook them they went on without putting water in the vessels which they carried for this purpose, for which inadvertence we suffered great thirst tonight.

(November 14)

… We continued southeast, and having gone three-fourths of a league, we entered a canyon in which four springs of good water rise. We traveled along it half a league to the southeast and arrived at a small farm and some ranchos of the Cosninas, which were very beautiful and well arranged. This farm is irrigated by the four springs mentioned and two other large ones which rise near it. This year the Cosninas planted maize, beans, calabashes, water melons and cantaloupes on it. When we arrived they had already gathered their harvest, and judging from the refuse or remains which we saw of everything, it was abundant, especially the beans…The farm was surrounded by peach trees, and, besides several huts made of branches, there was a little house very well made of stone and mud. In it were the baskets, jars, and other utensils of these Indians. Judging from the tracks, they had been absent for several days, perhaps to seek piñon nuts in the high sierra close by toward the south-southwest.

(Nov. 9) On trail after crossing Colorado River in shadow of Domínguez Butte, looking south, Padre Bay, Lake Powell, AZ.

(Nov. 14) Traditional Indian maize and planting pattern, Navajo reservation, Moenkopi, AZ.

(Nov. 14) Approaching Navajo reservation, Tuba City, AZ.

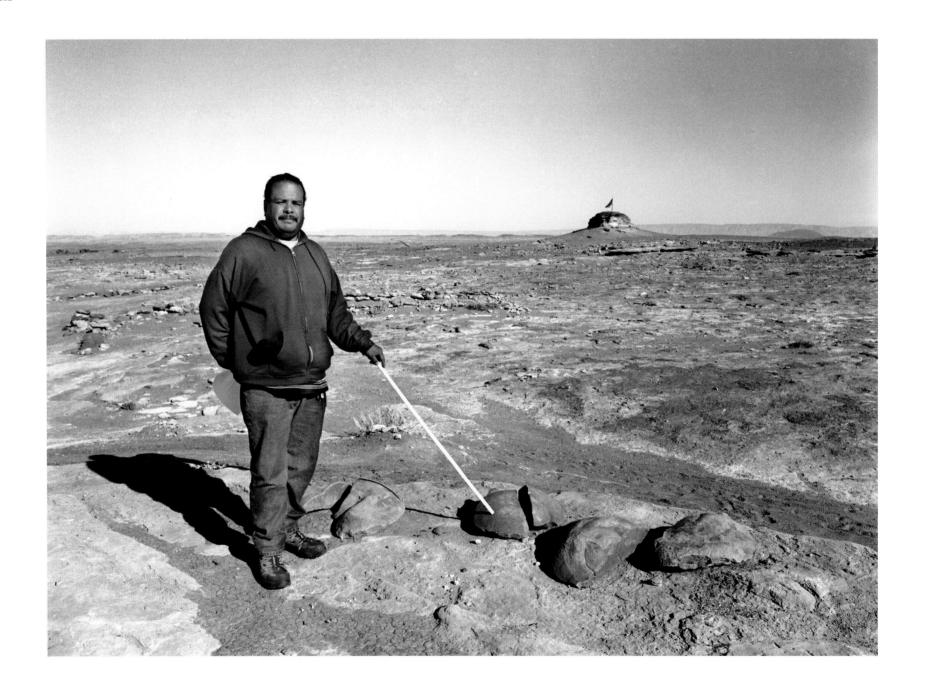

(Nov. 14) Petrified dinosaur dung, tourist attraction, near Tuba City, AZ.

(November 15)

We left the Cuesta de los Llanos, going east-southeast, traveling along the plains nine leagues without finding water in the whole day's march…

We [the fathers] had nothing for supper tonight because the horse meat which we had did not suffice for all. Here there were large herds of cattle, and all the companions wished to kill a cow or a calf, impatiently urging us to permit them in this way to relieve the hunger we all were suffering. Considering that we were now near the pueblo of Oraybi and that this might stir up some trouble for us with the Moquinos and defeat our purpose, which was to use again the means of the evangelical light and meekness to combat their willful blindness and inveterate obstinacy, we ordered another horse killed, and that no one should go near the cattle even though they might be strays or common stock, as the companions assured us they were.

November 16–24

THE HOPI MESAS

Escalante was no stranger to the three Hopi mesas and their seven pueblos located on very high and defendable plateaus—strung out in an east-west direction for several miles—which offered logical way stations and departure points for any proposed trails west to California. Furthermore they were located south of the Grand Canyon thus eliminating any need to cross it. In 1775, he had traveled the one hundred and sixty miles from his base in Zuni for purposes of gaining knowledge of trails west and the nec-

essary conversion of the Hopi to Christianity. The Hopi Nation had a long history of stubbornly refusing any such notions and predictably refused to allow him to preach. In his 1775 report to Governor Mendinueta, the young friar's anger is clearly evident:

> Understanding that the Moqui [Hopi], although rebels, are really vassals of our sovereign, that they bowed for some time their arrogant heads beneath the gentle yoke of our Lord, Jesus Christ…it appears to me that the proper means that can and ought to be taken is as follows: with forces of the projected expedition they be subdued by arms to the dominion of their legitimate sovereign; that they be brought down from the pueblos to a plain and proper site…
>
> Although at first view the pueblos present themselves as almost impregnable because of the inaccessible eminence of their respective situations, they have only the supplies near them. By our seizing and defending the water holes of which they daily avail themselves, because of thirst and need their flocks, they will be forced to surrender without great fatigue of ourselves. No more than the single unexpected sight of an armed force like that which may be formed is capable of surprising them so much that they may yield on the spot and without resistance, as probably would have been done in the year 1727 if we had proceeded with more precaution.

Nothing had changed when the expedition stopped here in 1776.

(Nov. 16) Third Mesa, Hopi reservation, Old Oraibi, AZ.

(November 16)

. . . We arrived at the mesa of the Pueblo of Oraybi. Ordering the companions to halt at the foot of the mesa, and that no one except those who were accompanying us in the ascent should go to the pueblo until we should instruct them to do so, we ascended without incident and on entering the pueblo we were surrounded by a great number of Indians, large and small. In a language which they did not understand we asked them for the cacique and the chiefs, and when we wished to go to the house of the cacique [leader], they restrained us, one of them saying in the Navajó tongue that we must not enter the pueblo. Don Juan Pedro Cisneros, in the same tongue spiritedly asked if they were not our friends. Thereupon they quieted down, and an old man led us to his house and made us welcome in it, assigning us a room in order that we might pass the night there, and giving us the viands which they eat. —Today seven leagues.

Tonight the cacique and two old men came to visit us, and after having given us to understand that they were our friends, they offered to sell us the provisions we might need, as we had intimated that we would be grateful for them.

(November 17)

Very early in the morning they brought for us to the lodging some baskets or small trays of flour, beef tallow, guavas, and other kinds of food. We purchased promptly all we could because of the most necessary things they brought us the least. For lack of an interpreter we were unable to take up the matter of their conversion, as was desirable and as we wished to do, but we explained some things to them, especially to the cacique and to our host and benefactor. They listened attentively but said nothing except that they wanted to maintain friend-

ship with the Spaniards. The cacique told us he had already sent word to the other pueblos in order that they might offer us hospitality and sell us the provisions we might need until we reached Zuñi. We gave them to understand that we were very grateful for this favor and the others we had received at their hands. In the afternoon we set out from Oraybi for the pueblo of Xongopabi, and having traveled about two and a quarter leagues to the southeast we arrived after sunset, and they welcomed us courteously, promptly giving us lodging. —Today two and a quarter leagues to the southeast.

(November 18)

After the principal Indians of this pueblo and of the others nearby, Xipaolabi and Mossonganabi, had assembled…we preached to them, partly by signs and partly in the Navajó tongue. They replied that they were unable to answer us because they did not understand the Castilian tongue…

This over, we gave to the Indian who had lodged us and extended to us many courtesies a woolen cloak for his wife, thinking that in this way they would better understand our gratitude and become more attached to us. But it did not turn out the way we expected, for although the Indian woman gladly accepted the cloak, a brother of hers took it away and threw it toward us with a deep frown…Then the Indian, wishing to make amends for the affront he had shown us, although his guilt was not as grave as it appeared, put us in another predicament even worse than the first…he pointed out Father Fray Silvestre and Don Pedro Cisneros and said in Navajó that he had heard what took place in Oraybi when the fathers Fray Silvestre and Don Juan Pedro had been there in the summer of the previous

year, and he had been present in Gualpi when the Cosnina talked to Father Fray Silvestre and told him about the road from Moqui to the Cosninas, and that now we had come by this same road; that he would not permit his brothers-in-law and brothers to accept the cloak, because if they did so their relatives and neighbors would be angry with them. He said this to satisfy us, but we were unable to understand clearly the other thing regarding which he wished to tell us, although it is not very difficult to infer it from the foregoing events. This afternoon we left for Gualpi…

After we had rested for a short time, we were told by an apostate Indian named Pedro, from the pueblo of Galisteo in New Mexico, who was now old and had great authority in this pueblo of the Tanos at Moqui, that they were now at fierce war with the Navajó Apaches, who had killed and captured many of their people. For this reason, he added, they were hoping that some fathers or Spaniards would come to these pueblos in order through them to beg from the Señor Governor some aid or defense against these enemies. So they had been especially delighted when they learned that we were coming to visit them because they hoped we would aid and console them. This appeared to us to be one of the finest opportunities to induce them to submit to the Faith and to enter the dominions of His Majesty, God spare him. So we replied, giving them great hopes and telling them they must summon the chiefs of the three other pueblos to come to Gualpi.

(November 19)
The chiefs of Mossonganabi came, and when they were assembled with the caciques and chiefs of these pueblos of the mesa of Gualpi in a kiva of the Tanos…They related everything they had discussed before we arrived at the kiva, and said they had agreed that the apostate Pedro should go with us to the Villa of Santa Fé in order that in the name of all he might ask the Señor Governor for aid against the Navajó Apaches, and establish friendship with the Spaniards, and they begged us to do everything possible in their behalf. We replied to them that we would take their part in every way, because we loved them like children, and were very sorry for their troubles, but that since only God is all powerful and rules all, so long as they remained in their infidelity and until they ceased to offend Him, they would not be able to free themselves from suffering these troubles . . .We told them also that if they would submit, they would have constant and sure help from the Spanish arms against all the heathen who might attempt to attack them, as did the Christian pueblos of New Mexico…Three times we urged them, exhorting them to enter the fold of the Holy Church, impugning and proving false and insubstantial their arguments for not accepting the Faith. Regarding the first, they replied that they knew the governors were sending the fathers to persuade them to submit to their authority but that they had not and still did not wish to. Regarding the second, they gave us to understand that, since there were many more heathen nations than Christian, they wanted to follow the more numerous party, and that besides this, they lived in country which was very inconvenient for the service which, once converted, they would have to render the Spaniards…

…the men of the assembly talked a long time, each in turn, beginning with those of the greatest authority and continuing in the order of their importance. And although each one spoke individually, he expressed himself in the form of a dialogue, and concluded his discourse by asking various questions of the others, who replied by assenting or denying respectively according to

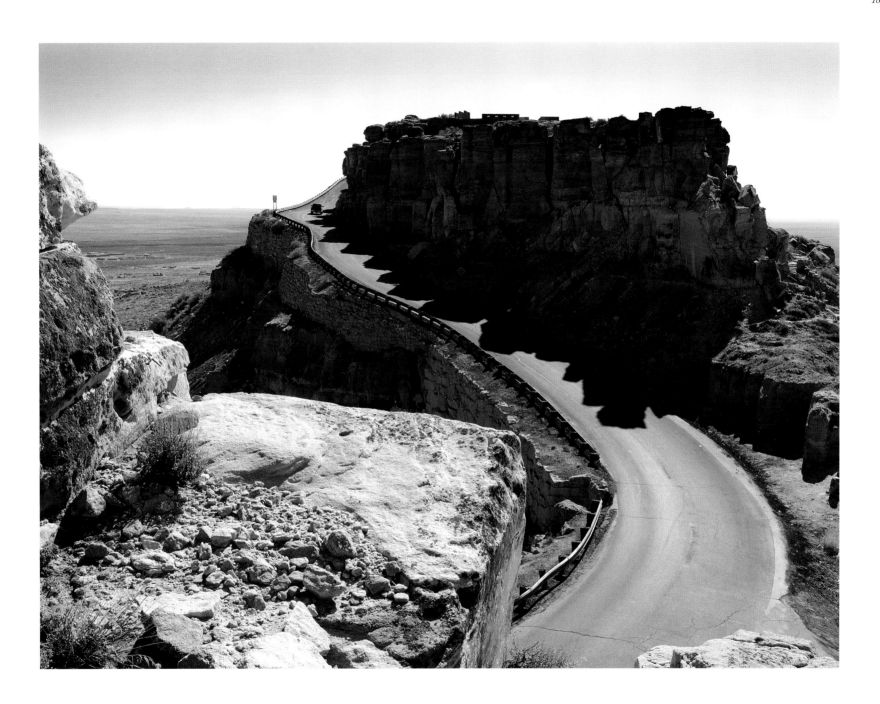

(Nov. 19) Second Mesa, Hopi reservation, Walpi, AZ.

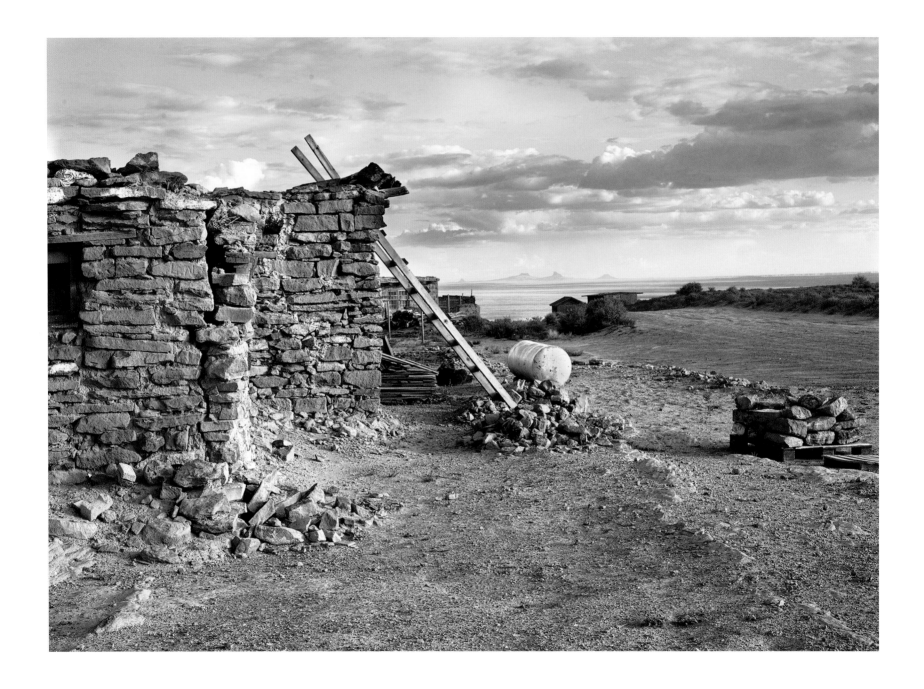

(Nov. 19) First Mesa looking south, Hopi reservation, Sichomovi, AZ.

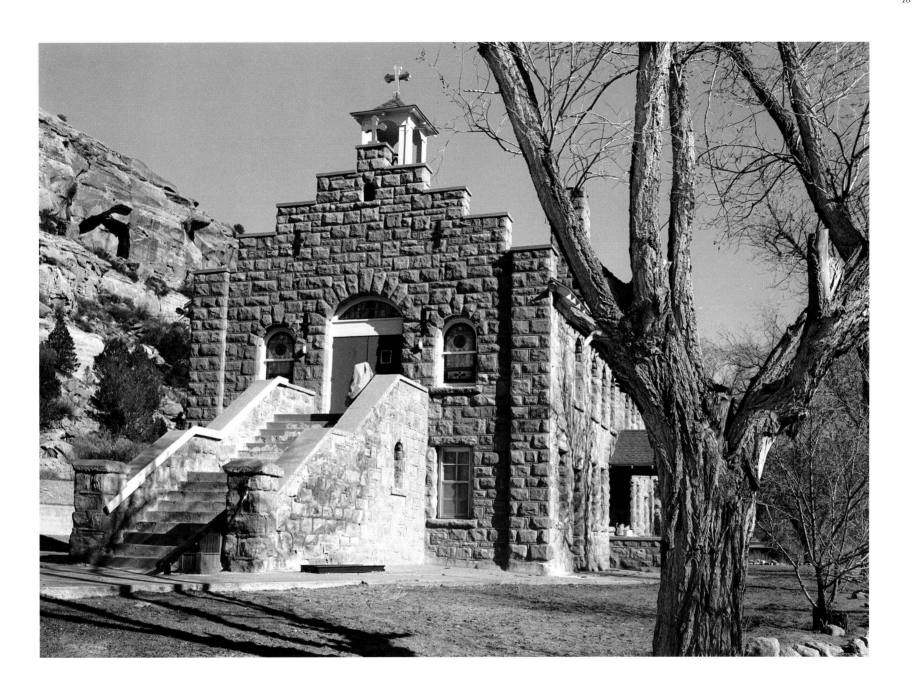

(Nov. 20) Campsite of November 20; Keams Canyon, St. Joseph Mission Catholic Church, Hopi Administration Center, AZ.

(Nov. 20) Restaurant tables and mural, Keams Canyon, AZ.

the nature of the questions…So they replied that they wished only our friendship but by no means to become Christians, because the old men had told them and counseled them never to subject themselves to the Spaniards. We tried to make them see the foolish impiety of such traditions and counsels but without any success whatsoever.

(November 22)
We left the companions with the rest of the animals, which were now worn out, in order that they might follow slowly to Zuñi, and we with three of the companions set forth in light order, and having traveled nine leagues east by southeast, we arrived at the place called Cumáa. Here we rested a while, and then continued two more leagues to the east. The animals were now exhausted and we had to halt. —Today eleven leagues.

(November 23)
We continued our journey although it snowed all day with troublesome flurries, and having traveled on the gallop for twelve leagues, we camped at the place called Kianatuna or Ojo de San José. Tonight we suffered greatly from the cold. —Today twelve leagues almost all toward the east.

(November 24)
As soon as it was daylight we left the Ojo de Señor San José, going southeast, and having traveled two leagues we halted for a time to make a fire with which to warm ourselves, because it was so cold that we feared we should freeze in this valley. We continued southeast more than three leagues, traveled two more east-northeast, and halted to change horses at a watering place which the Zuñis called Okiappá. We continued on our way, and

having traveled five leagues to the southeast, we arrived after nightfall and greatly fatigued at the pueblo and mission of Nuestra Señora de Guadalupe de Zuñi. —Today twelve leagues.

Not having sufficient strength to continue immediately to the Villa de Santa Fé, we reported to the Señor Governor our happy arrival at this mission, together with a brief account of the contents of this diary.

INTERSTATE 40

Interstate 40 might also be called the Indian Road. Leaving Albuquerque heading west, travelers essentially follow a route that connects with all the major pueblos beyond the Rio Grande Valley—Isleta, Zia, Laguna, Acoma, Zuni—and to the Navajo reservation and Hopi. This was the path taken by Escalante and Domínguez on their return trip, when they and their comrades were utterly exhausted, hungry, managing somehow to make their way back to Santa Fe. Between the Hopi mesas and Zuñi, their route crosses Interstate 40, near Houck, Arizona.

Today signs summon travelers along Interstate 40 to faux villages with genuine Native American objects for sale. These objects and their implied aura of romance, history, and nostalgia have fueled commerce along this route since the 1930s and 1940s when it was the old Route 66. These roadside villages appeal to tourists for what appears to be some vestige of an unobtainable cultural history. It can be found again when lodging at motels built to resemble tepees or purchasing the handmade artifacts.

Buying objects produced by Native Americans brings a kind of interconnectedness with the "other," the noble Indians. Often this is the only contact most people will have with Native Americans as they rush to points west.

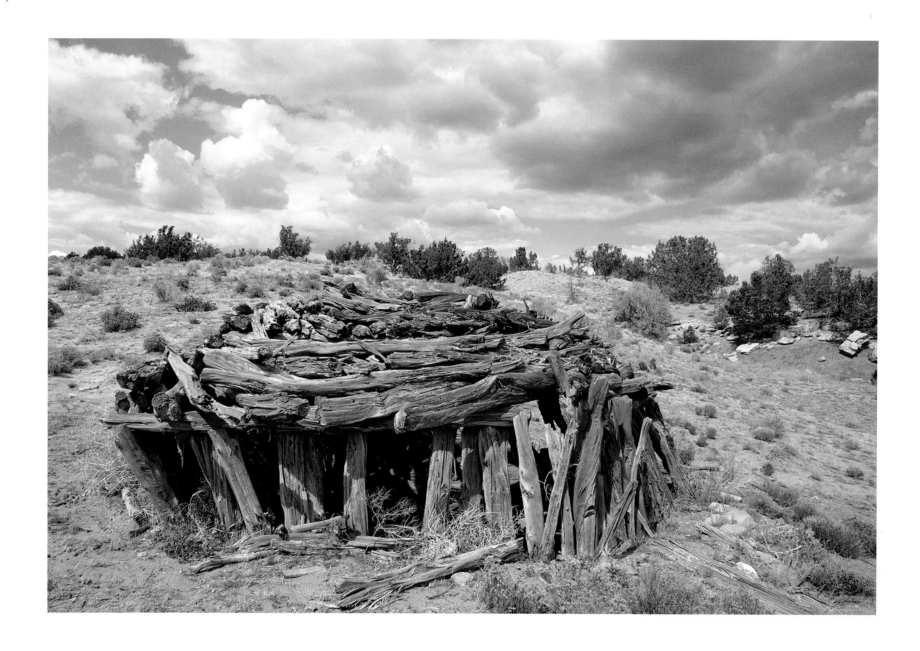

(Nov. 22) On trail, abandoned hogan, Navajo reservation, Wide Ruins, AZ.

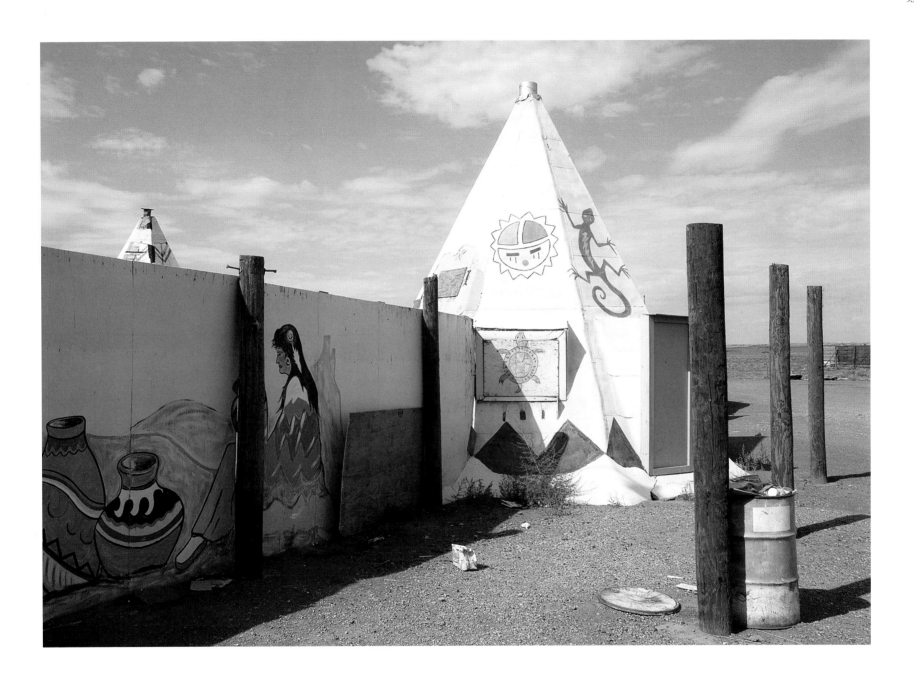

(Nov. 23) Interstate 40, tourist attraction, AZ.

(Nov. 23) Nine-foot-high "dream catcher" at Indian City tourist shop, Interstate 40 corridor, Indian City, AZ.

(Nov. 23) Yellowhorse Trading Post, Interstate 40 at the New Mexico border, Lupton, AZ.

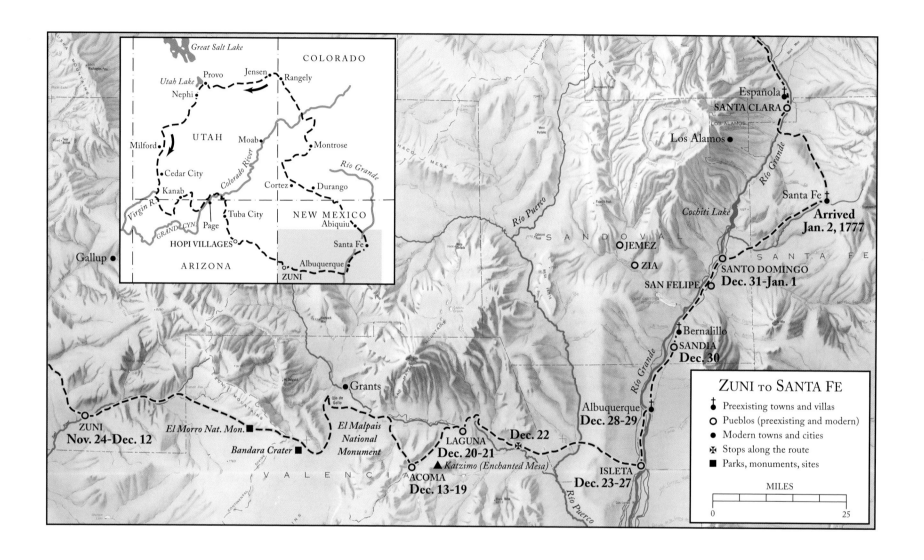

ZUNI TO SANTA FE

†	Preexisting towns and villas
○	Pueblos (preexisting and modern)
●	Modern towns and cities
✸	Stops along the route
■	Parks, monuments, sites

MILES

0 25

Inset map labels:

COLORADO

Great Salt Lake

Provo Jensen Rangely

Utah Lake

Nephi

UTAH Moab

Milford Montrose

Cedar City

Kanab Cortez Durango

Río Grande

Virgin R. *Colorado River*

Tuba City NEW MEXICO

GRAND CYN. Page Abiquiu

HOPI VILLAGES Santa Fe

Gallup ARIZONA Albuquerque

ZUNI

Main map labels:

Española †

SANTA CLARA

Los Alamos

Río Grande

Santa Fe †

JEMEZ *Cochiti Lake* **Arrived Jan. 2, 1777**

ZIA

SANTO DOMINGO

SAN FELIPE **Dec. 31–Jan. 1**

SANDOVAL

Río Puerco

† Bernalillo

SANDIA

Dec. 30

Río Grande

Grants

Albuquerque

Dec. 28–29

ZUNI

Nov. 24–Dec. 12

El Morro Nat. Mon. ■

El Malpais National Monument

Bandara Crater ■

LAGUNA

Dec. 20–21

Dec. 22

ACOMA

Dec. 13–19

▲ *Katzimo (Enchanted Mesa)*

ISLETA

Dec. 23–27

VALENCIA

Río Puerco

ZUNI TO SANTA FE: DECEMBER 13–JANUARY 3

THE JOURNAL HAS VERY LITTLE TO SAY about the travel between Zuñi and Santa Fe as this was already a well-known piece of geography. Starting with Vásquez de Coronado in 1541, and for most Spanish explorers, it was a major entry to the Rio Grande valley from Mexico. It was also used in the reconquest of New Mexico after the 1680 Pueblo Revolt. Several Christian missions had been established at pueblos along its route: first Laguna and Acoma, and once the Rio Grande was reached, Islete, Albuquerque, Sandia, Alameda, San Felipe, Santo Domingo, Cochiti, and finally Santa Fe. Escalante had traveled it many times as he communicated between his post at Zuni and Santa Fe. Interstate 40 (old Route 66) and the Burlington Northern Santa Fe Railway closely follow this same route today, and casinos abound on most of the pueblo lands.

After resting at Zuni for seventeen days "on account of various incidences," the expedition left on December 13 by a trail which follows Route 53, passing Inscription Rock with no diary mention. Inscription Rock (El Morro) is a well-known permanent water source and the site of graffiti that dates from the earliest Spanish explorers to twentieth-century cowboys. It is now a national monument complete with an abandoned native pueblo ruins on top. Next came a detour around the Malpais lava fields, which were created by the eruptions of the Bandera Volcano (now a national monument), and then passing nearby Grants on the way to the storied Acoma Pueblo, where the expedition spent four nights because of heavy snow.

Easy overland travel, crossing and sometimes paralleling the Rio Puerco ("filthy river"), took them past Laguna Pueblo and on to Isleta Pueblo by the Rio Grande, where they stayed five nights.

Traveling north along the Rio Grande they arrived in Santa Fe on January 3, 1777, five months and four days after leaving and traveling a total of about 1,800 miles.

Zuni

In early March 1539, Fray Marcos de Niza, with his guide Estebanico, the black Moroccan slave attached to Cabeza de Vaca, were sent north with a large contingency of Indians to explore the regions of what today is New Mexico. (Estebanico, along with Cabeza de Vaca and two other Spaniards, survived a tortuous journey after reaching Florida in 1528, as castaways. Following a long arduous overland trek, they reached Chihuahua, Mexico, on Christmas 1535, seven years later.) After a somewhat lengthy journey, Fray Marcos decided to stay in a settlement called Vacapa and gather information. He ordered Estebanico to go ahead of the main party to investigate rumors of a large trading center called Cíbola.

Estebanico, an extravagant dresser who wore bells around his ankles and arms, played the part of shaman and a man of mysterious powers, and was always accompanied by a couple of greyhounds and a coterie of Indians. Upon seeing at a distance the village of Hawikuh (Zuni), one of the Seven Cities of Cíbola, he sent the head man of the village a symbol of his authority: a ceremonial gourd with strings of bells and two feathers, one white, the other red. After receiving this token, the leader sent word to Estebanico that he should not enter the village, to turn back. Estebanico disregarded the warning and came anyway, reaching the village at sunset. He was ordered not to enter the town but to sleep outside the town proper, and the next morning he was taken captive. He was considered by the Zunis to be a liar. How could he represent a powerful people who were white, when he was black? He must be a spy, sent to conquer them. He also had angered the Zunis when he demanded turquoise and women as a tribute. He was killed and torn into many pieces.

As Fray Marcos neared the first village of Hawikuh at Zuni, he saw only the snow-covered rooftops, and he ceased any further advance when he heard the news of Estebanico's death. He later reported to his superiors that he had seen the glittering Seven Cities of Cíbola, sparkling with gold. No further encouragement would be needed for the Spanish onslaught to begin, especially when gold was mentioned.

The following summer of 1540 Coronado attacked the Zunis with two hundred horsemen, sixty footmen, and a thousand Mexican Indian allies. Within an hour, they had defeated the defenders of Hawikuh. Finding no gold, Coronado, who was seriously wounded during the battle, accused Fray Marcos of lying.

The Zunis had their first encounter with Spaniards in the form of Estebanico. His arrogance presented them with a vision of future Spanish confrontations. He was a harbinger, an omen of things to come. This was an event that would become engrained in tribal memory.

Over the next centuries, the Zunis would have numerous traumatic encounters, battles, and religious conflicts with the Spaniards. These years also saw the destruction of the missions where Escalante served as friar in his youth and as an elder priest. In 1775 Miera, the gifted cartographer of the expedition, painted an altar screen at Zuni, remnants of which are now at the Brooklyn Museum in New York. It must also be remembered that the Zunis gave shelter and food to the band of stragglers in the winter of 1776. The weary explorers were returning from their harsh 1,800-mile journey, staying at Zuni to recover from exhaustion from November 24 through December 13. They may have had the opportunity to observe the ancient Shalako winter solstice ceremony that is performed every December—a transformative experience that defies description.

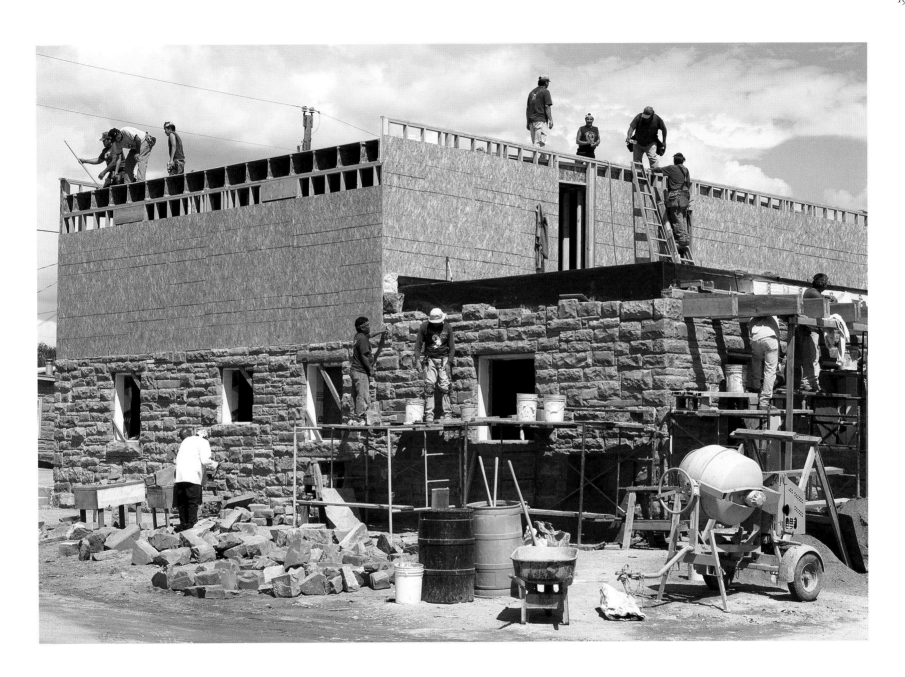

(Nov. 24) Construction of community house by clan members, Zuni, NM.

(Nov. 24) PLYWOOD CUTOUT EFFIGIES, NEAR ZUNI, NM.

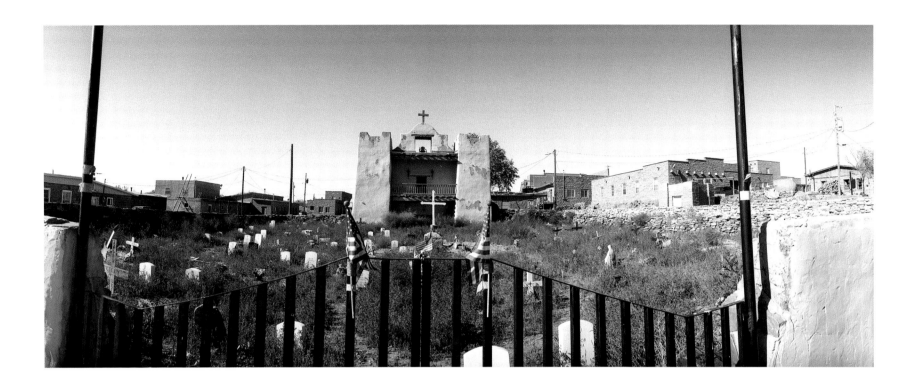

(Nov. 24) OLD MISSION CHURCH AND CEMETERY, ZUNI, NM.

Morro Rock

Located directly on the trail from Zuni to the Rio Grande Valley and Santa Fe, this large cliff outcropping contained at its base a rare year-round shaded water supply in the form of a rainwater-refreshed pool, where all travelers stopped. Because about two thousand signatures, dates, messages, and petroglyphs are carved into its walls, it is also known as Inscription Rock. The earliest carvings are from the occupants of the abandoned pueblo on top which contained up to 875 rooms; then for three hundred years Spanish inscriptions appear; and finally, beginning in 1849, American soldiers, immigrants, freighters, and adventurers left their mark. The earliest mention of the site was in the journal of the Espejo expedition in 1583. The oldest carving is from 1605 by Don Juan de Oñate, the first governor of New Mexico, during a trip to the Gulf of Mexico. He had previously passed the rock in 1598 without leaving a carving. The dark pencil outline, which makes the script more readable, was done in the 1920s. It was not removed when the site became a national monument. The translation of Oñate's inscription reads: PASSED BY HERE THE GOVERNOR DON JUAN OÑATE FROM THE DISCOVERY OF THE SEA OF THE SOUTH ON THE 16 OF APRIL, 1605.

Acoma

Acoma and the Hopi mesas are among the oldest continuously inhabited pueblos in North America. The 360-foot-high Acoma mesa is a veritable fortress. In 1540, the first Spanish sighting by Coronado's Captain Alvarado describes it as "the strongest position ever seen in the world." On January 22, 1599, Acoma was the site of a fierce battle, in which many lives were lost on both sides. After taking the citadel of Acoma, Oñate decreed, as punishment of the defiant Acomas, that each of the surviving two dozen men above the age of twenty-five would have one foot severed and serve twenty years as a slave; males between the ages of twelve and twenty-four and women would also serve twenty years as slaves. Only one brief mention in a document verifies that Oñate's order was ever carried out.

Fray Francisco Atanasio Domínguez,
from *The Missions of New Mexico, 1776*

Father Claramonte tells me that in the year 1768, when he was missionary of Laguna and was taking care of this Acoma mission because of Father Pino's death, the census of the Acoma Indians numbered 1,114. Only those whom we shall soon see now remain in the pueblo out of so large a number. The reason for this great decrease is that many have died since then, some from natural causes in epidemics or from other diseases, others at the hands of Apaches so insolent that if this pueblo were not by nature defensible, perhaps nothing would now remain of it. The present mission father also states that still others are wandering about and that some have fled to Moqui for fear of the famines and wars they have suffered in a few years.

An equally monumental mesa is Katzimo, also known as the Enchanted Mesa. It stands as an imposing giant, only three miles northeast of Acoma. There is a tragic story of loss and devastation associated with this mesa. Katzimo was the original home of the Acomas. One summer, when most of the inhabitants went down into the fields to plant crops, a raging storm came and washed away the sandy sediment supporting a very large boulder that had steps

carved into it (their only access to the mesa top or the fields). When the villagers realized that those who were left on top and those below were forever cut off, they decided to abandon Katzimo and build on top of their current mesa. A few desperate members on the mesa top hurled themselves to the ground rather than die alone.

Rio Puerco

The Rio Puerco rarely flows with abundance, but when it does, it is a torrent of uninviting muddy water, running through a bed of black clay and depositing quicksand. Domínguez's description is equally derogatory: "It is called the Rio Puerco because its water is as dirty as the gutters of the streets." In the 1700s, the Spanish settlement of Navajo was a community of ranches primarily sustained by raising cattle, located six leagues northwest of Albuquerque. This community was abandoned in 1774 due to Navajo hostility. Don Diego de Vargas in 1692 named the Rio Puerco "La Torriente de los Alamos," presumably because it was a dry riverbed when he first crossed it, but upon his return it was a raging river that could only be crossed with great difficulty. He also noted that along its banks were large growths of cottonwoods (alamos).

Today the Rio Puerco defines the farthest eastern boundary of Laguna Pueblo and runs through the Navajo reservation as well. On July 16, 1979, at the site of the United Nuclear Corporation's Church Rock uranium mill, the collapse of an earthen dam sent eleven hundred tons of radioactive wastes and ninety million gallons of highly radioactive fluids (a wall of radioactive water) into the Rio Puerco. More radiation was released in that spill than in the Three Mile Island reactor failure on March 28, 1979, in Harrisburg, Pennsylvania. The impact of this tragedy has left the Navajos, Lagunas, and all the downstream users in danger of long-term contamination.

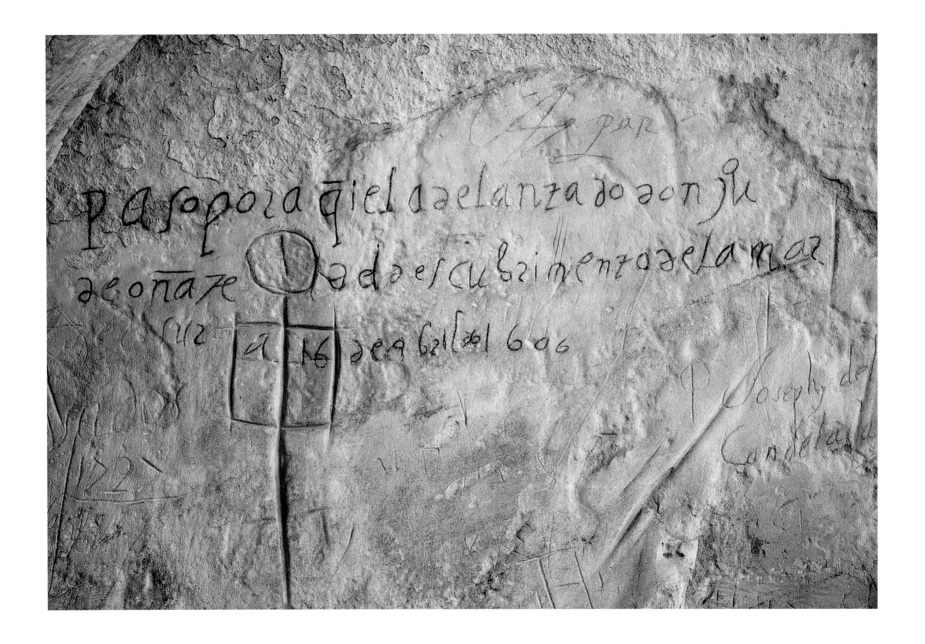

(Dec. 13) Don Juan de Oñate message, Inscription Rock, NM.

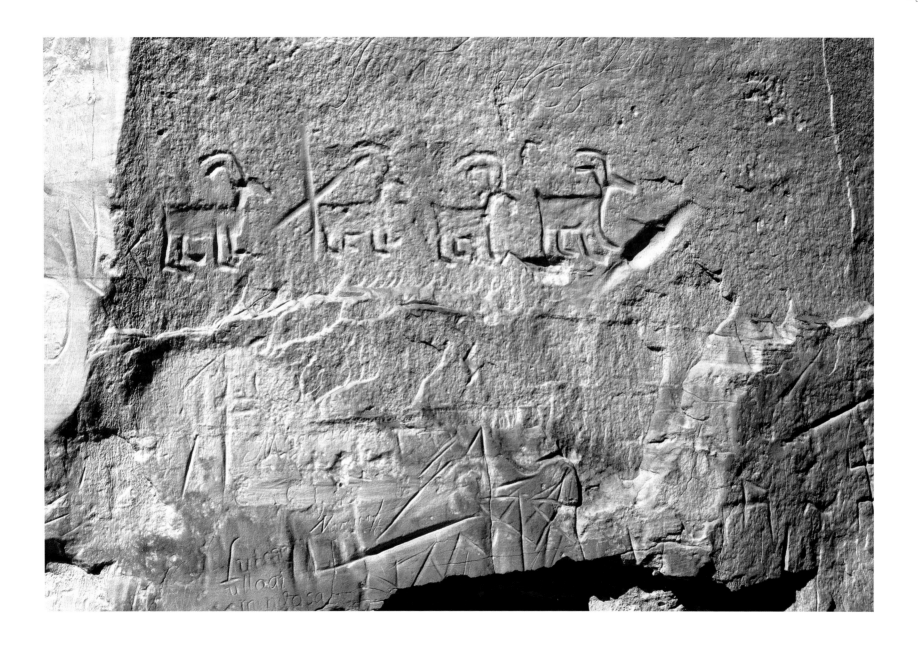

(Dec. 13) Pueblo Indian petroglyphs, Inscription Rock, NM.

(Dec. 14) Bandera Crater, El Malpais National Monument, NM.

(DEC. 16) VIEW FROM TOP OF MESA, LOOKING NORTHWEST, ACOMA PUEBLO, NM.

(Dec. 16) Katzimo (Enchanted Mesa), approaching Acoma Pueblo, NM.

(Dec. 16) Tourists, Acoma Pueblo, NM.

ISLETA

(December 23)

We set out from here, and having traveled five leagues east by east-southeast, we arrived at the mission of San Angustín de la Isleta. —Today nine leagues.

Thirteen miles south of Albuquerque with a present population of five thousand, Isleta Pueblo was established in the 1300s and is located at an important crossroad of north-south travel along the Rio Grande and east-west travel to the pueblos of Acoma, Zuni, and Laguna to the west. Isleta was large compared to other pueblos and after the Spanish colonial period grew even larger as the smaller nearby pueblos dissolved and occupants relocated here.

It is located on the bottomland of the Rio Grande, and the ample water supply created an agrarian culture, with irrigated fields producing maize, beans, squash, and cotton. On August 10, 1680, the nearby pueblos of Alameda, Sandia, and Puaray joined in the Pueblo Revolt, which drove the Spanish out of northern New Mexico. About three hundred and eighty Spanish colonists and twenty-one of thirty-two missionaries were killed. Isleta Pueblo became a stronghold of fifteen hundred refuges who would later retreat three hundred miles south to El Paso. The Rio Grande Valley remained in Indian control until the reconquest of 1692.

With the arrival of the railroad to Albuquerque in the late 1900s, Isleta became a popular destination for tourists as well as anthropologists and archaeologists, among them Adolph Bandelier and Charles Lummis, who would later create the Southwest Museum of the American Indian in Los Angeles. Consequently Isleta's culture, architecture, and historic record were thoroughly documented.

PUEBLO

FRAY FRANCISCO ATANASIO DOMÍNGUEZ,
The Missions of New Mexico, 1776

The little rise on which the pueblo stands is…on the very meadow of the Río del Norte [Rio Grande], which sometimes overflows its bed up above the pueblo when it is very high and forms a very wide branch at a distance from it. This cuts off the settled part as if it were an island, which is doubtless the reason why it was named Isleta…This Isleta is about a musket shot and a half from the aforesaid river. It enjoys a very fine and pleasant view in all directions, especially downstream to the south, where a sierra which is some 20 leagues to the south can be seen…

The pueblo consists of three beautiful blocks of dwellings, separated from one another at the corners, which are located in front of the church and convent, and form a very large plaza there to the south of them…Everything is of adobe, very prettily designed and much in the Spanish manner…

Its Lands and Fruits: The Indians of this pueblo have arable lands of every quality for a league upstream, a league downstream, and as far on either side as such lands extend. As has been said, they are irrigated from the afore-mentioned river, and from all of them they get very copious crops of everything planted. There are many orchards of fruit trees as well as vinestocks, and they usually make a little wine…

Adults and children, men and women, use, speak, and understand Spanish…With regard to their particular customs, I say that they are well inclined to Spanish customs, for many use mattresses on their beds, and there are many bedsteads.

CENSUS: 114 FAMILIES WITH 454 PERSONS

(Dec. 22) Interstate 40 overpass, Rio Puerco, Laguna, reservation, NM.

(Dec. 22) Route 66 Casino and Hotel, Laguna reservation, NM.

(Dec. 22) Burlington Northern Santa Fe Railway approaching Isleta Pueblo, NM.

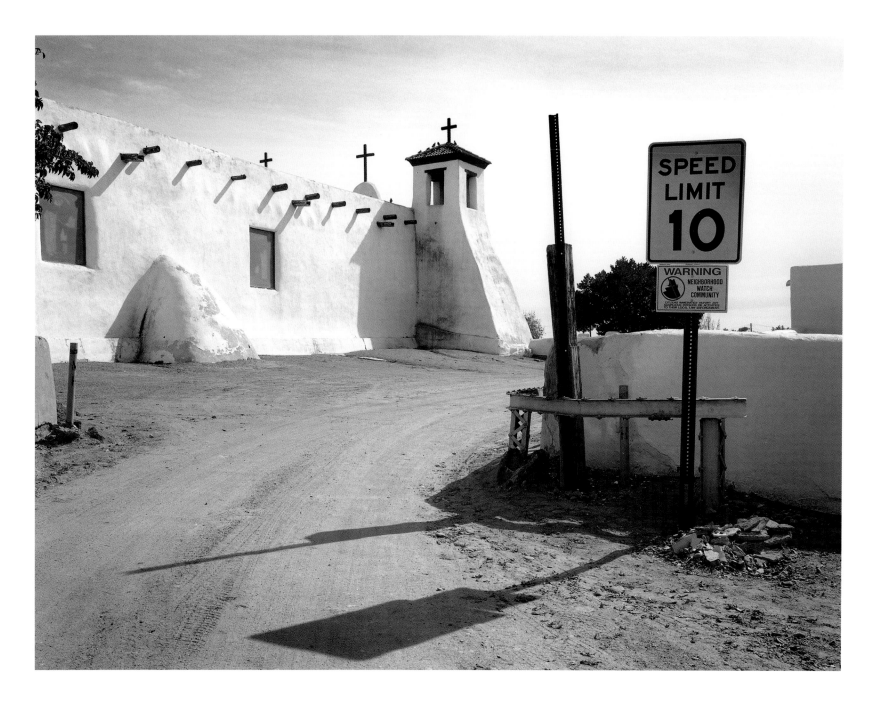

(Dec. 23) Entering Isleta Pueblo, NM.

(Dec. 28) State Road 314, looking north, leaving Isleta Pueblo, NM.

Albuquerque

Albuquerque was originally a settlement of about twenty farms founded in 1632 on the banks of the Rio Grande. Today's Old Town occupies this same spot. In 1705 Francisco Cuervo y Valdéz was appointed temporary governor of the province by the viceroy of New Spain, the duke of Albuquerque. Without proper permission Cuervo declared the settlement a villa (city) by grossly exaggerating its condition and astutely named it after the duke, thereby enhancing its chances for post approval.

(April 23, 1706)
I, don Francisco Cuervo y Valdéz, Knight of the Order of Santiago, Governor and Captain General of this Kingdom and the province of New Mexico...certify... That I have founded a Villa on the margin and meadows of the River of the North in a place of good fields, waters, pastures, and timber, distant from this Villa of Santa Fe about twenty-two leagues...There are now thirty-five families located there, comprising 252 person, adults and children. The Church has been competed [sic]...and appropriate, with part of the dwelling for the government buildings have been begun, and other houses of the settlers are finished with their corrals, irrigation ditches running, fields sowed, all without any expense to the Royal Treasury.

In 1775 Domínguez wrote the following as part of his evaluation:
The villa itself consists of twenty-four houses near the mission. The rest of what is called Albuquerque extends upstream to the north, and all of it is a settlement of ranchos on the meadows of the said river for the distance of a league from the church to the last one upstream. Some of their lands are good, some better, some mediocre. They are watered by the said river through very wide, deep irrigation ditches, so much so that there are little beam bridges to cross them. The crops taken from them at harvest time are many, good, and everything sown in them bears fruit.

There are also little orchards with vine-stocks and small apricot, peach, apple, and pear trees. Delicious melons and water-melons are grown. Not all those who have grapes make wine, but some do. The citizens are of all classes and walks of life as in the other places I have mentioned, and they speak the local Spanish.

Census: 157 families with 763 persons

Oñate Sculpture, Old Town, Albuquerque

Don Juan de Oñate was a conquistador and explorer who led the first colonizing settlements into northern New Mexico. Born in Zacatecas, Mexico, into a family of Spanish nobility, he was married to the great-granddaughter of the Aztec emperor Moctezuma Xocoyotzin.

In 1595 Oñate was instructed by King Philip II of Spain to colonize the upper Rio Grande in New Mexico, where three years later he led 175 soldiers, their families, and settlers along with 5,000 sheep and cattle. He declared possession of the territory for Spain in 1598. By 1602 the colonies were failing, and food shortages, troubles with native raids, and the failure to find silver and gold led to desertions back to Mexico. Harsh treatment of deserters created a backlash. In 1606 Oñate was removed as governor and sent back to Mexico City on charges of mistreatment of Indians and abuse of power. He was fined, permanently banished from New Mexico, and banished from Mexico City for four years. After being sent back to Spain, the king appointed him the inspector of mines.

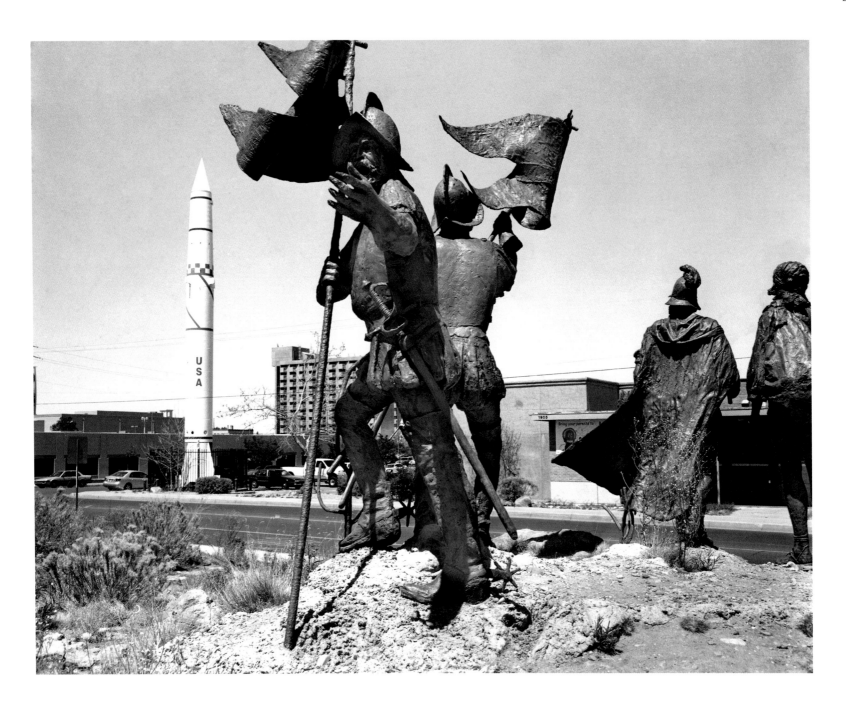

(Dec. 28) Oñate sculpture and rocket, Old Town, Albuquerque, NM.

December 28–January 3

ALBUQUERQUE TO SANTA FE

The journey from Albuquerque north along the Rio Grande was without diary notation except to mention where nightly stops were made. There are several pueblos along this route that, unlike many reservations in the west, are located on some of the best bottomland and have abundant water supply for agriculture. Today the pueblos of San Felipe, Sandia, Alameda, Santo Domingo, and Cochiti occupy the fifty miles to Santa Fe. The land is noticeably empty of commerce, billboards, and houses once leaving Albuquerque because Indian lands are much less likely to develop commercial enterprise, the exception being three casinos along the way, which service the metropolitan areas of Santa Fe and Albuquerque. A large earthen dam is situated at the Cochiti Pueblo, which backs up the Rio Grande as it exits the La Bajada cliffs. The Santa Fe River cuts through these cliffs, and the expedition followed along this river canyon to Santa Fe, where the river passes through the center of the city. Interstate 25 and the recently completed Rail Runner commuter railroad ascend the cliff to the south where the slope is less steep.

(Jan. 2) Sandia Resort and Casino amphitheater, NM.

(Jan. 2) Cochiti Dam and reservoir, Sandoval County, NM.

(Jan. 2) Rail Runner tunnel construction at La Bajada escarpment, Santa Fe County, NM.

(Jan. 2) Celebrating Cinco de Mayo, El Rancho de las Golondrinas, Santa Fe, NM.

(Jan. 3) Commuter train backing into rail depot, Santa Fe, NM.

Santa Fe and the Palace of the Governors

In 1598 the Spanish established the first capital of New Mexico at the confluence of the Chama River and the Rio Grande. In 1610 the provincial capital was moved to its present location along a small year-round river, the Santa Fe ("holy faith"), on the site of an abandoned pueblo. One attraction of this site was, perhaps, its altitude: at 7,000 feet there are few biting insects, and the summers are temperate. It is America's oldest state capital. The 1790 census reflected 2,540 inhabitants, and the city was described then as squalid and ugly, located in a harsh and marginal land. It was fought over many times, first by Indians in the Pueblo Revolt, next during the Spanish reconquest, then in the 1830s there was an internal Spanish revolt over taxes, and next in 1846 it was taken by the Americans when General Kearny marched into the plaza declaring it American property during the Mexican-American War. Finally, in the 1860s during the American Civil War it was occupied by the Confederate Army later expelled by Union forces.

The building seen here is the Palace of the Governors, which has been the center of government since the inception of the city. It was the site of most battles and negotiations, and was the residence of the governor.

After arriving in Santa Fe on January 2, 1777, the friars Dominquez and Escalante presented to the governor the Laguna boy, Joaquín, along with the painted hide obtained from the bearded Indians at Utah Lake.

(January 3)

We presented this diary, the token of the Lagunas of which mention is made, and the Laguna Indian. And because everything stated in this diary is true and faithful to what happened and was observed in our journey, we signed it in this mission on the third of January of the year 1777.

—Fray Francisco Atanasio Domínguez
Fray Silvestre Vélez de Escalante

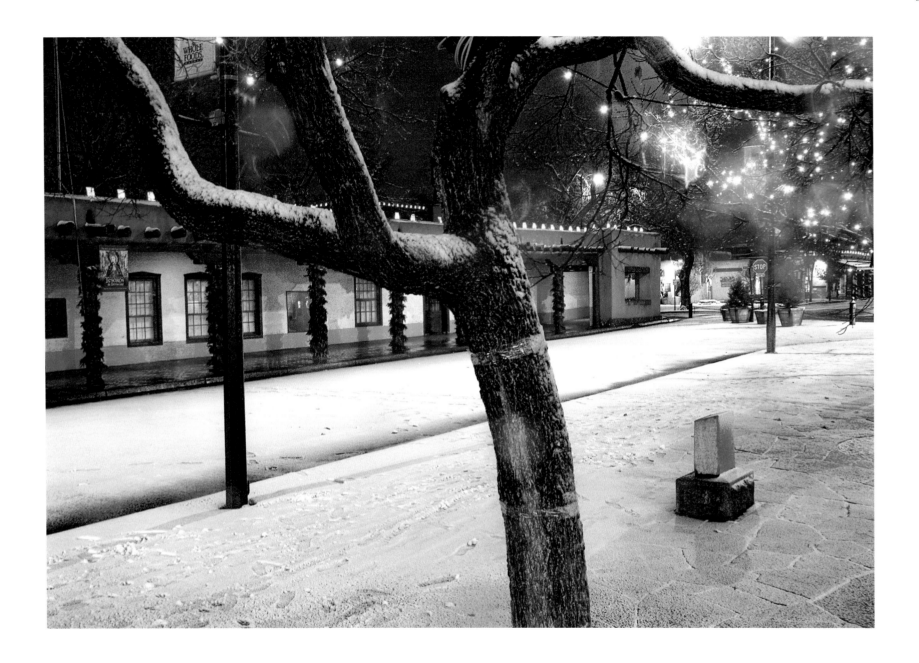

(JAN. 3) PALACE OF THE GOVERNORS AND PLAZA, SANTA FE, NM.

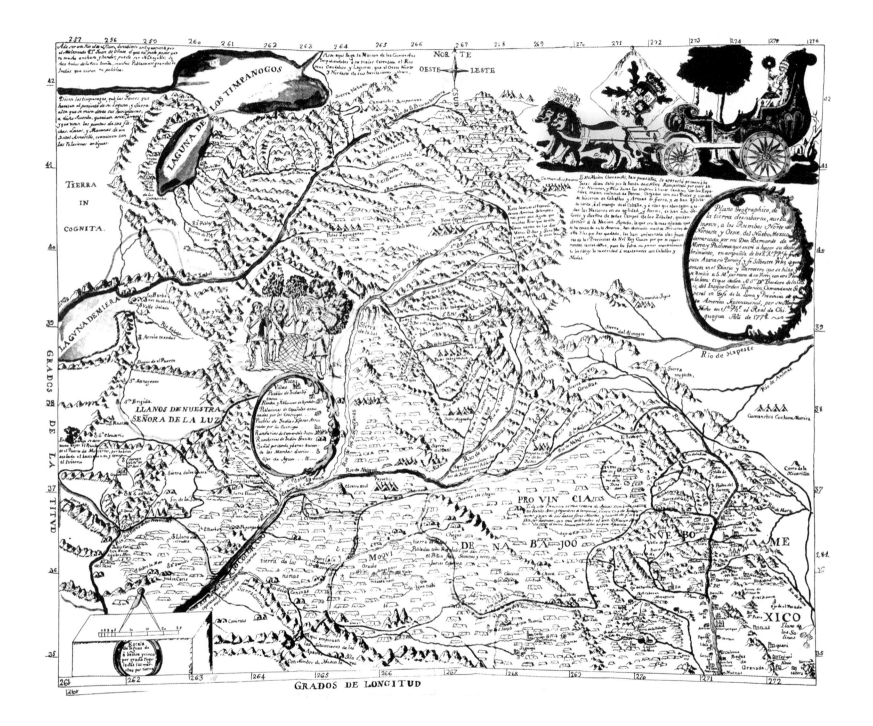

Epilogue

After the expedition, Escalante returned to his duties as priest at Zuñi Pueblo. His chronic kidney problems caused him to return to Mexico City in 1780, where he died along the way at the town of Parral on the El Camino Real at the age of thirty.

Domínguez spent his last thirty years defending himself from charges by angry priests whose missions he had evaluated in his report on the missions of New Mexico. He was relegated to frontier duty, shuttled from one isolated mission to another, and deprived of further advancement in his order. He died at the age of sixty-five in Mexico City.

Miera produced his map of the country traversed. It was the most definitive yet of the northern territories. The map was copied by hand seven times, each being embellished differently depending upon the cartographer's taste.

Map of Dominguez-Escalante Expedition, by Don Bernardo Miera y Pacheco, illustrated in Herbert E. Bolton's book, Pageant in the Wilderness, *published 1972, courtesy Utah State Historical Society. Salt Lake City.*

The one shown here is known as the Bearded Indian version because of the figures in the center section. Some versions had the addition of bright paint in the upper right and figure areas. The map was not published for more than a century but existed in Mexico City for study by other cartographers and explorers. It placed the Colorado, San Juan, and Gunnison rivers as well as their tributaries in their proper positions, and mountain ranges and their connections were unscrambled. Also, Utah Lake, the Great Salt Lake, and Sevier Lake were correctly located.

However, it contained a flaw that was the source for one of the longest-lasting myths in trans-Mississippi history. Miera claimed that the rivers north of the Colorado River drained into the lakes mentioned and then continued westward to the Pacific Ocean—the famed Buenaventura River. An example is the uppermost river on the map (the Green River) seen emptying into the Laguna de Miera (today's Sevier Lake). There is also another river leaving the left edge of Los Tompanogos (Great Salt Lake) and heading west. This mistake was elaborated

upon by other cartographers and even believed by Baron Alexander von Humboldt when he examined the map in Mexico City as he created his maps of the American West. Lewis and Clark, traveling to the north in 1804, included it as truth, and Zebulon Pike used it in his 1806 journeys. Maps of 1826 clearly show it crossing the Great Basin, magically hopping over the nine invisible mountain ranges in Nevada, and drilling through the mighty Sierra Nevada in California headed straight to the Pacific Ocean. In 1841 John Bidwell, who led the first immigrants overland into California, was advised to take tools and build boats when he reached this point in order to float the remaining distance.

It wasn't until Captain John C. Frémont (nicknamed "the Pathfinder") visited the Great Salt Lake in 1843 that the myth began to unravel. Even then members of his party, seeing no river west, believed that there must be a whirlpool in the center which sucked the water into an underground tunnel and delivered it to the ocean nine hundred miles away. The next year, as he camped on the same banks of Utah Lake as Domínguez and Escalante, he declared that there was no such river to the west, and changed the map to reflect this.

Bibliography

Adams, Eleanor B. "Fray Francisco Atanasio Domínguez and Fray Silvestre Vélez de Escalante." Salt Lake City: Utah Historical Quarterly 44 (winter 1976).

Adams, Eleanor B., and Fray Angelico Chavez, trans. and annotated. *The Missions of New Mexico, 1776: A Description by Fray Francisco Atanasio Domínguez, with Other Contemporary Documents*. Albuquerque: University of New Mexico Press, 1956.

Auerbach, Herbert S., ed. *Father Escalante's Journal with Related Documents and Maps*. Salt Lake City: Utah State Historical Society, 1943. vol. xi, nos. 1–4.

Ayer, Mrs. Edward E., trans. *The Memorial of Fray Alonso de Benavides, 1630*. Annotated by Frederick Webb Hodge and Charles Fletcher Lummis. Albuquerque: Horn and Wallace, 1965.

Bolton, Herbert E. *French Intrusions into New Mexico 1749–1752*. New York: Macmillain, 1917.

———. *Pageant in the Wilderness: The Story of the Escalante Expedition to the Interior Basin, 1776*. Salt Lake City: Utah State Historical Society, 1950, reprinted 1972.

———. ed. *Spanish Exploration in the Southwest, 1542–1706*. New York: Barnes and Noble, 1963.

Briggs, Walter. *Without Noise of Arms: The 1776 Domínguez-Escalante Search for a Route from Santa Fe to Monterey*. Flagstaff, AZ: Northland Press, 1976.

Byrkit, James. "The Roads Not Taken Via the Courses of Least Resistance from New Mexico to California: The 1775–1776 Letters of Fr. Silvestre Vélez de Escalante and Fr. Francisco Garcés." *Spanish Traces* Vol. 11, no. 2 (Spring 2005).

Cash, Marie Romero. *Santos: Enduring Images of Northern New Mexican Village Churches*. Boulder: University Press of Colorado, 1999.

Castleberry, May, ed. *Perpetual Mirage: Photographic Narratives of the Desert West*. New York: Harry N. Abrams, 1996.

Chapman, Charles Edward. *Founding of Spanish California: The Northwestward Expansion of New Spain*, 1687–1783. New York: Macmillan Company, 1916.

Chávez, Thomas E. *An Illustrated History of New Mexico*. Boulder: University Press of Colorado, 1992.

Cushing, Frank Hamilton. *My Adventures in Zuñi*. Palmer Lake, CO: Filter Press, 1998.

———. ed. and trans. *Zuni Folk Tales*. New York: Alfred Knopf, 1931.

Eichstaedt, Peter H. *If You Poison Us: Uranium and Native Americans*. Santa Fe, NM: Red Crane Books, 1994.

Gutiérrez, Ramon A. *When Jesus Came, the Corn Mothers Went Away: Marriage, Sexuality, and Power in New Mexico, 1500–1846*. Stanford, CA: Stanford University Press, 1991.

Kessell, John L. *Spain in the Southwest*. Norman: University of Oklahoma Press, 2002.

Kubler, George. *The Religious Architecture of New Mexico in the Colonial Period and Since the American Occupation*. Albuquerque: University of New Mexico Press, 1972.

Lyman, Edward Leo. "The Actual Objectives of the Dominguez and Escalante Expedition." *Spanish Traces* vol. 12, no. 3 (fall 2006).

Matheson, Alva L., ed. *Proceedings of the National Spanish Trails Association Symposium*. Cedar City, UT: Old Spanish Trail Association, October 2007.

Nichols, Tad. *Glen Canyon: Images of a Lost World*. Santa Fe: Museum of New Mexico Press, 1999.

Nobel, David Grant, ed. *Santa Fe: History of an Ancient City*. Santa Fe, NM: School for Advanced Research Press, 1989.

Ostapuk, Paul, et al. "Authenticating Efforts Related to a 1776 Spanish Inscription at Glen Canyon." Proceedings paper for National Spanish Trails Symposium organized by Old Spanish Trail Association. Cedar City, UT, October 2007.

Platt, Lyman. "The Spanish in Utah Prior to 1776." Proceedings paper for National Spanish Trails Symposium organized by Old Spanish Trail Association. Cedar City, UT, October 2007.

Sánchez, Joseph P. *Explorers, Traders, and Slavers: Forging the Old Spanish Trail, 1678–1850*. Salt Lake City: University of Utah Press, 1997.

Sandweiss, Martha A., ed. *Denizens of the Desert*. Albuquerque: University of New Mexico Press, 1988.

Thomas, Alfred B., ed. and trans. *Forgotten Frontiers: A Study of the Spanish Indian Policy of Don Juan Bautista de Anza, Governor of New Mexico 1777–1787*. Norman: University of Oklahoma Press, 1932.

Warburg, Aby, et al. *Photographs at the Frontier: Aby Warburg in America 1895–1896*. London and New York: Merrell Holberton, 1998.

Warner, Ted J., ed. *The Domínguez-Escalante Journal: Their Expedition Through Colorado, Utah, Arizona, and New Mexico in 1776*. Translated by Fray Angelico Chavez. Provo, UT: Brigham Young University Press, 1976. Salt Lake City: University of Utah Press, 1995.

Acknowledgments

*T*HE AUTHORS wish to express gratitude to two persons who greatly added to this project. First, Paul Ostapuk, Arizona director of the Old Spanish Trail Association, who generously spent a day with us on a guided river trip up Glen Canyon from Page, Arizona, to the inscription site on the Glen Canyon walls. And Colonel Alva Matheson, director of the Utah chapter of the Old Spanish Trail Association, who provided an intensive tour and explanation of the confusing country north of Cedar City, Utah, into the Escalante Desert and the site of the casting of the lots.

Repeated conversations with Dr. Joseph P. Sánchez, author of the introduction for this book, were essential in clearing up facts of related history and conflicting information. Mary Anne Redding, curator of the New Mexico State Photographic Archives, provided generous time in helping us locate historical photographs.

Acknowledgment is extended to the Utah State Historical Society for allowing the use of Herbert E. Bolton's translation of the journal, as well as for providing the map from the 1976 research of the trail and the two historic photographs included in this book.

Gratitude is expressed to the Old Spanish Trail Association for granting permission to use the expedition route map by Tom Jonas.

Thanks to Edward Krayer for his insightful comments and editing contributions, and to Leo Lyman, who accompanied us on the Glen Canyon inscription search and shared insightful historical information. Thomas Jaehn at the New Mexico State Archives helped us finalize choices for the historical maps included here.

We gratefully acknowledge the contributions of the talented staff at the Museum of New Mexico Press—Anna Gallegos, director; Mary Wachs, editorial director; and David Skolkin, art director—who shepherded the raw material of this project into its final book form.

PHOTOGRAPHERS' CREDITS

SIEGFRIED HALUS

Pages 2, 11, 12, 14, 18 (bottom), 39, 41, 42, 45, 46, 59, 64, 65, 68, 72, 73, 74, 75, 77, 78, 82, 85, 88, 91, 93, 102, 103, 106, 107, 111, 123, 124, 126, 127, 129, 136, 137, 144, 145, 149, 156, 165, 166, 170, 174, 176, 177, 181, 184, 190, 192, 193, 194, 195, 199, 200, 201, 204, 205, 207, 208, 209, 210, 211.

GREG MAC GREGOR

Pages 13, 18 (top), 19, 20, 40, 47, 48, 50, 51, 52, 53, 58, 60, 61, 63, 67, 69, 84, 89, 92, 94, 95, 100, 101, 104, 108, 112, 116, 117, 120, 121, 128, 130, 133, 134, 140, 141, 142, 143, 148, 150, 153, 157, 158, 159, 161, 164, 169, 171, 172, 173, 175, 179, 180, 182, 188, 189, 206, 212, 213, 214, 215, 217, 219, 220, 221, 222, 223, 224.